ATROPOS PRESS
new york · dresden

Quantum
Art

*Mimesis, Uncertainty,
and the Infinite*

By Amber Scoon

Second Edition

2017

General Editor:
Wolfgang Schirmacher

Editorial Board:
Giorgio Agamben
Pierre Alferi
Hubertus von Amelunxen
Alain Badiou
Judith Balso
Judith Butler
Diane Davis
Martin Hielscher
Geert Lovink
Larry Rickels
Avital Ronell
Michael Schmidt
Frederich Ulfers
Victor Vitanza
Siegfried Zielinski
Slavoj Žižek

© by Amber Scoon
Think Media is supported by the European Graduate School

ATROPOS PRESS
New York • Dresden

151 First Avenue # 14, New York, N.Y. 10003

Cover Design by Sarah Cassella

All rights reserved

ISBN 978-1-940813-36-3

The Second Edition of *Quantum Art* is dedicated
to John Berger.

I wish to thank Wolfgang Schirmarcher, Gregory Bray,
Sharif Abdunnur, my parents, my brothers, Jocelyn, and
all my best friends. I love you guys.

"I am learning quite a lot, really! And it's a very concentrated piece of speculation and questioning and I follow you and congratulate you and go on!"

- John Berger, December 26, 2014

"The idea of the moral and ethical implications of the observer changing the observed and vice-versa has never been applied to art and is a stunningly original concept."

- Margaret Grimes, January 24, 2015

"There is no hesitation, no superfluity, no posturing in either Ms. Scoon's works or in her method. She has tunneled deeply-fearlessly-through themes of human biology, frailty, pathology, creation, destruction, and, more recently, the indefinable nimbus limning the very act of art making…. Her book, "Quantum Art" is the most original analysis I have read about the mimetic nature of all human creativity. Her ideas about the fundamental unknowableness of the human art instinct—its incantatory yet incoherent power and seductions—speaks to Rilke's injunction that "our task is to love that which we don't understand."

-Paul Salopek, Bishkek, Kyrgyzstan, 2016

Table of Contents

Introduction:
Choosing Uncertainty

By Paul Salopek

An artist treads a featureless desert without visible land-marks—without cairns, without guides, without pole-stars, without waypoints.

The compass, whether it is old or newfangled, proves wrong: it points to mirages. (Art theory, criticism, contemporary politics, grand "Truths" either classical or subversive, or, the most dubious wisp of them all, a show in a gallery in Chelsea.) Yet as Amber Scoon reminds us so wisely, so patiently, so generously, in these eloquent pages, rebelling against false bearings is also a dead end:

> The contemporary artist is not a victim. She is not beleaguered and oppressed by outside rules and rituals. The hipster's claim to struggle in the face of consumerism, pluralism and a host of other imag-inary enemies, is a farce . . . The quantum artist is not hindered by methods of evaluation or procla-mations of truth, certainty or newness.

Because the making of "quantum art," as Scoon characterizes the 100,000-year-old human impulse to create symbol, is the act of walking. It is the open-ended journey itself.

We have all walked this trail, at least in play, at least as young children. It is a universal restlessness. There is

nothing hallowed about it. And as she points out with refreshing insight, we undertake it, if we are honest, precisely to become lost. This too is deeply human. When we are lost—"entangled" Scoon calls it—we are at our most alert. We move at the very rim of our creative horizon. We are awake. Seeking clues, we draw maps in the dust. We scan the distant, smoke-colored ridgelines, looking inward. Being found is no such place. It is a cul-de-sac.

Paul Salopek
Djibouti, April 2013

Preface

Quantum art asks the question, *What is the being of art?* and finds that the being of art relates to mimesis, uncertainty and Wolfgang Schirmacher's concept of *Homo generator.*[1] The being of art does not refer to the meaning or function of the artifact, but the nature of the instinct to make art.

The contemporary understanding of art is grounded in a Platonic paradigm. Plato divides the world into the ideal, the real and the imitation.[2] He asks, what is real and truthful and what is not? What is the art object's relationship to understanding? With regards to art, Plato's question is not, *What is art?* but rather *Is art worthwhile?* His answer is no. The art object is not truth.

The contemporary art world has altered Plato's understanding in a minor way. Art is commonly understood to be the relative truth (a multiple) that helps the artist and public understand or realize the Truth (the singular). The contemporary art object is understood to be new information, in the form of an object, which is imbued with language, content and the ability to communicate.

The Platonic paradigm, in its contemporary form, is understood through a Newtonian, or classical, picture of the world. In this world, events are separate, singular, causal and progressive. In such a world, it makes sense to ask which events are real and which are not? Further, why do artists create events, knowing that these events are not the real events, but a mere representation of events? (Here, "representation" refers to any creation, whether it be in the form of abstraction, realism, appropriation or other). Do these non-real, non-true, re-pre-

sented events relate to truth? Contemporary art answers whether these non-real events (art objects) are not simply the activity of mimesis or representation. They are events that endeavor toward understanding, communication and transformation. These art events create the possibility of transcendence. It is the Christian idea of transcendence and the scientific idea of progress which saves art from its fate of "non-truthiness."

The dominant paradigm of contemporary art, consists of the Platonic treatment of art, a classical worldview, the market, academia and the scientific method. Each ensures truth, progress and newness. The copy is treated as a re-creation or manipulation of a known, static and singular event (reality). The copy itself is of little value unless it communicates new information. This is the reason that the dominant paradigm attempts to replace the art object with pure information.

The dominant paradigm cannot account for the relationship between mimesis and an uncertain reality: potential and infinite. Quantum art suggests that the instinct to make art is rooted in the desire to mimic, but that mimesis, as it exists in the quantum realm, has yet to be understood. Our world is not static, but simultaneous and uncertain. It is far more mysterious than we have been trained to believe.

Quantum art suggests that mimesis is a creative, becoming activity. It is the activity of mimesis that creates consciousness and connects us to our world. Mimesis is not an act of copying the known, but an act of observing the uncertain, imagining the uncertain and creating the uncertain. The world itself is uncertain,

potential and infinite. The quantum artist plays with the desire and capacity to mimic an uncertain, unknown and infinite world.

Introduction to the Second Edition of Quantum Art

In 1965, John Berger wrote:

> Physicists are always at great pains to point out that
> Quantum mechanics only become significant on
> an atomic extremely small scale. They are right to
> do this, because the whole paradox of the Quantum
> Theory depends upon the fact that the experiments
> are planned-and have to be-according to the large-
> scale but approximate calculations of classical physics,
> whereas the results of these experiments have to be
> interpreted according to Quantum mechanics. Yet,
> in another sense, it is unimportant that the theory
> only becomes significant on a certain scale. It was the
> macrocosmic view of the solar system which helped
> to liberate man from his belief in a God-controlled
> world. It is the microcosmic view of the atom and its
> nucleus which is now helping to liberate him from
> the frustrating and static utilitarianism of his own
> system of categorizing: a system which in itself is
> a reflection of the essential opportunism of the
> capitalist phase of history. Opportunism implies, by
> definition, a blindness to underlying connexions.
> The planets brought us to the threshold of self-con-
> sciousness, the atom is bringing us to the threshold of
> a consciousness of the indivisibility of all reality. This
> is what is important, regardless of the scale involved.

> Quantum mechanics demonstrate that, on an
> atomic scale, it is impossible to distinguish, even

in definition, between a wave and a particle. This
led Niels Bohr to his theory of complementarity,
whereby both statements, apparently contradictory,
might at any moment be equally true. It led Heisen-
berg to his Uncertainty Principle, which states
that, on the same scale, it is impossible to divide
the potential from the actual. Further discoveries
may change these theories. But what the process-
es themselves do prove is that, when the scale is
small and basic enough, the indivisibility of nature
manifests itself in simultaneity. The qualities of
a wave are the opposite of those of a particle. Yet
under certain circumstances an electron behaves as
though it were both simultaneously.[3]

In 2017, we are approximately one century past the
initial conception of Quantum Theory. Yet its implications
have not reached our most general, common sense un-
derstanding of the universe. Quantum Theory will change
the way that we understand reality, our relationship to the
environment, fellow humans and animals. It will funda-
mentally change the way in which we think about art.

Quantum Theory is a theory as profound as the Coper-
nican Revolution - the revolution that told us that Earth is
not the stationary center of the universe. What a shock! To-
day, we have a new shock. The Quantum Revolution is here.

Quantum Art explores the artist's relationship to
art, in the midst of the paradigm shift: the shift between
a Newtonian World View and a Quantum World View.
Quantum Art suggests that the paradigm shift is an
opening, in which art can become itself.

Chapter One:
Introduction and
Methodology

1.1 What is art?

Artists operate within a belief system about the being of art. The belief system is so well accepted that it goes unnoticed. It has become common sense. Yet, the question *What is Art?* is difficult to answer. In fact, asking this question is already considered a violation of contemporary art's beliefs. Artists assume that art exists yet cannot be defined. Asking the question *What is Art?* puts the contemporary artist in a vulnerable situation: if she defines art, it loses something. What does it lose? And if she cannot define it, how can she validate it?

The contemporary system of aesthetic values and beliefs, within which artists create, is an extension, reflection and/or reaction to Plato's paradigm. In order for the contemporary artist to create, she must be able to differentiate between her own desires and the demands of the dominant paradigm. Only then can she create her own philosophy and environment for art. To accomplish this task, she must first understand the Platonic paradigm. Then she must have the courage to ask questions about the being and function of art from the perspective of her own interests and desires.

Plato judges human activity by its ability to illuminate Truth and claims this ability as the highest human endeavor. In Book V of *The Republic*, Plato writes:

If curiosity makes a philosopher, you will find
many a strange being will have a title to the name.
All the lovers of sights have a delight in learning,
and must therefore be included. Musical amateurs,
too, are a folk strangely out of place among philos-
ophers, for they are the last persons in the world
who would come to anything like a philosophical
discussion, if they could help, while they run about
at the Dionysiac festivals as if they had let out their
ears to hear every chorus; whether the performance
is in town or country—that makes no difference—
they are there. Now are we to maintain that all
these and any who have similar tastes, as well as the
professors of quite minor arts, are philosophers?

Certainly not, I replied; they are only an imitation.[4]

Having created a distinction between those who
merely love to learn (artists) and those who are capable
of profound thought (philosophers), Plato goes on to
distinguish between the absolute and singular Truth and
the many imitations and variations:

He said: Who then are the true philosophers?

Those, I said, who are lovers of the vision of truth.

That is also good, he said; but I should like to know
what you mean?

To another, I replied, I might have a difficulty in
explaining; but I am sure that you will admit a
proposition which I am about to make.

What is the proposition?

That since beauty is the opposite of ugliness, they
are two?

Certainly.

And inasmuch as they are two, each of them is one?

True again.

And of just and unjust, good and evil, and of every other class, the same remark holds: taken singly, each of them one; but from the various combinations of them with actions and things and with one another, they are seen in all sorts of lights and appear many?

Very true.

And this is the distinction which I draw between the sight-loving, art-loving, practical class and those of whom I am speaking, and who are alone worthy of the name of philosophers.

How do you distinguish them? he said.

The lovers of sounds and sights, I replied, are, as I conceive, fond of fine tones and colours and forms and all the artificial products that are made out of them, but their mind is incapable of seeing or loving absolute beauty.

True, he replied.

Few are they who are able to attain to the sight of this.

Very true.[5]

Plato goes on to separate and oppose reality and representation as well as truth and imitation. He writes:

And he who, having a sense of beautiful things has no sense of absolute beauty, or who, if another lead him to a knowledge of that beauty is unable

to follow—of such an one I ask, Is he awake or in a dream only? Reflect: is not the dreamer, sleeping or waking, one who likens dissimilar things, who puts the copy in the place of the real object?

I should certainly say that such an one was dreaming.

But take the case of the other, who recognizes the existence of absolute beauty and is able to distinguish the idea from the objects which participate in the idea, neither putting the objects in the place of the idea nor the idea in the place of the objects—is he a dreamer, or is he awake?

He is wide awake.[6]

The artist, according to Plato, loves the many and the imitation in place of the singular, absolute truth, which is the beautiful. Only the philosopher is able to envision the truth. In Plato's *Allegory of the Cave*, Plato illustrates a world in which men are fooled and enslaved by false truths.[7] To find truth, the source of all goodness and beauty, men must come out of the cave and encounter the original truth, as opposed to mere representations (shadows) of truth. Plato writes:

But, whether true or false, my opinion is that in the world of knowledge the idea of good appears last of all, and is seen only with an effort; and, when seen, is also inferred to be the universal author of all things beautiful and right, parent of light and of the lord of light in this visible world, and the immediate source of reason and truth in the intellectual.[8]

Plato's truth is the ideal form, an underlying and universal idea, on which earthly forms are based. The artist then, is the imitator of earthly forms, which derive from the ideal form. In Book X of *The Republic*, Plato writes:

> Well then, here are three beds: one existing in nature, which is made by God, as I think that we may say—for no one else can be the maker?
>
> No.
>
> There is another which is the work of the carpenter?
>
> Yes.
>
> And the work of the painter is third?
>
> Yes.
>
> Beds, then, are three kinds, and there are three artists who superintend them: God, the maker of the bed, and the painter?[9]

Plato sets up a hierarchy, in which the idea or the ideal form is highest, followed by the practical, everyday form. The imitation (the artist's work) is the lowest. The ideal form is the only truth which is singular and absolute. All other forms are non-singular and therefore only imitations, copies or versions of the truth:

> Yes, there are three of them [beds].
>
> God, whether from choice or from necessity, made one bed in nature and one only; two or more such ideal beds neither ever have been nor ever will be made by God.

Why is that?

Because even if He had made but two, a third
would still appear behind them which both of them
would have for their idea, and that would be the
ideal bed and not the two others.

Very true, he said,

God knew this, and He desired to be the real maker
of a real bed, not a particular maker of a particular
bed; and therefore He created a bed which is essen-
tially and by nature one only.

So we believe.[10]

Plato gives God the title of author, but God is the one
and only true artist. All other makers are mere imitators.
The real crime of the artist is the creation of an object
which can be mistaken for the true. Plato writes:

Shall we, then, speak of Him as the natural author
or maker of the bed?

Yes, he replied; inasmuch as by the natural
process of creation He is the author of this and
all other things.

And what shall we say of the carpenter—is not he
also the maker of the bed?

Yes.

But would you call the painter a creator and maker?

Certainly not.

Yet if he is not the maker, what is he in relation to
the bed?

I think, he said, that we may fairly designate him as the imitator of that which the others make.

Good, I said; then you call him who is third in the descent from nature an imitator?

Certainly, he said.

And the tragic poet is an imitator, and therefore, like all other imitators, he is thrice removed from the kind and from the truth?

That appears to be so.[11]

Plato's concept of God as the true artist is the origin of contemporary aesthetic philosophy's concept of authenticity. Authentic (good) art must be singular and true. It could be made by no other and in no other way. Its necessity is its proof that the maker created the one, singular form of that particular truth. Contemporary artists would displease Plato, for they appear to be playing God. Regardless, the contemporary artist still adheres to Plato's standards. Plato treats art is the imitation and the many. This idea sets art in opposition to the true and the singular. Plato evaluated art's worth in relation to truth. Evaluating art in the Platonic Paradigm is, therefore, a procedure based on access to knowledge of absolute truth. Plato writes:

Ath. Very true; and may we not say that in everything imitated, whether in drawing, music, or any other art, he who is to be a competent judge must possess three things;—he must know, in the first place, of what the imitation is; secondly, he must know that it is true; and thirdly, that it has been well executed in words and melodies and rhythms?

Cle. Certainly.[12]

By inserting the philosopher as viewer and judge, Plato introduces the concept of truth-based evaluation. In addition, Plato assumes that because artists are imitators and thus incapable of truth, they cannot evaluate their own works. Plato writes:

> The imitative artist will be in a brilliant state of intelligence about his own creations?
>
> Nay, very much the reverse.
>
> And still he will go on imitating without knowing what makes a thing good or bad, and may be expected therefore to imitate only that which appears to be good to the ignorant multitude?
>
> Just so.
>
> Thus far then we are pretty well agreed that the imitator has no knowledge worth mentioning of what he imitates.[13]

Plato thus initiates the necessity for the evaluation of art by a non-artist. He suggests that the philosopher fill this role.

Philosophers, like artists, have since manipulated and altered Plato's paradigm, but never abandoned his foundation. The ontological questions asked of art are couched in the language of the philosopher-viewer-judge, who tends to the following questions: To which category does art belong? What is art's relation to truth and therefore ethics, politics, religion, economics, health, psychology and reality? How is art to be judged

Each era's understanding of art's ontology reflects Plato's demands and suspicions in addition to the dominant needs of that culture. Plato believes that art's function is imitation or mimesis.[14] He therefore asks, what is the relationship between mimesis, truth and democracy?

Ficino, an aesthetic philosopher of the Renaissance asks: what is the relationship between mimesis, love and religion?[15] Ficino concludes that Love (and therefore God) guides the artist. He writes:

> We shall easily understand that He is indeed the teacher of the arts if only we consider that no one can ever discover or invent a new art except as the pleasure of investigation and the desire of finding [the truth] motivate him; and except as he who teaches loves his students, and as those students most eagerly thirst after that learning.
>
> Moreover, Love is justly called Ruler of the Arts, for a man fashions works of art carefully and completes them thoroughly, who esteems highly both the works themselves, and the people for whom they are made. There, then, this fact, that artists in each of the arts seek after and care for nothing but love.[16]

Georg Hegel asks, What is the relationship between mimesis, truth and philosophy?[17] Hegel concludes that art has been replaced by thought (philosophy). Michael Inwood describes Hegel's view in his *Introduction to Hegel's Introductory Lectures*. He writes,

> Art reveals the absolute, and so, in their different ways, do religion and philosophy. Art thus expresses

the same 'content' as religion and philosophy, but
in a different 'form.' It expresses its content in a
sensory form, while religion does so in the form
of pictorial imagery (*Vorstellung*) and philosophy
in the form of conceptual thought. Philosophy is
higher than art, both because conceptual thought
is the essence of man and because philosophy has
a wider range. Philosophy can speak about art, but
art cannot speak in any detail about philosophy,
unless it is tending to become philosophy, and this,
in Hegel's view, entails its degeneration as art.[18]

In *Critique of Judgment*, one of Immanuel Kant's
central question is how can we objectively evaluate art?
His question marks a shift. In the post-Kantian era, art's
existence is taken for granted. Art's ontological question,
"what is art and what is its relationship to truth, etc.?" has
been transformed into the critical question: how should
we assign value to art? This question is posed from the
point of view of the philosopher as the disinterested
viewer.[19] The contemporary artist has embedded Kant's
disinterested viewer into her unspoken understanding of
art's ontology. The contemporary artist attempts to judge
her own work from the point of view of the objective
observer. According to Friedrich Nietzsche,

> ...[Kant], like all philosophers, instead of envisag-
> ing the aesthetic problem from the point of view
> of the artist (the creator), considered art and the
> beautiful purely from that of the "spectator," and
> unconsciously introduced the "spectator" into the
> concept "beautiful." It would not have been so bad
> if this "spectator" had at least been sufficiently

familiar to the philosophers of beauty—namely, as a great *personal* fact and experience, as an abundance of vivid authentic experiences, desires, surprises, and delights in the realm of the beautiful! But I fear that the reverse has always been the case; and so they have offered us, from the beginning, definitions in which, as in Kant's famous definition of the beautiful, a lack of any refined first-hand experience reposes in the shape of a fat worm of error. "That is beautiful," said Kant, "which gives us pleasure without interest.[20]

Quantum art addresses the ontological question, What is the being of art? approached from the perspective of the artist, as opposed to Kant's disinterested viewer. Quantum art attempts to create an ontological approach to art, which is responsive to art's fundamental uncertainty, desire and playfulness. Quantum art does not intend to prove anything about art's worth or create a system of making, viewing or evaluating art.

1.2 Art, Artifact, Art World and New Art Order

The term "art" is used in reference to any activity that results in an image-object. The resultant image-object is referred to as the artifact,[21] which is "something created by humans usually for a practical purpose; especially: an object remaining from a particular period."[22] The term "artifact" commonly references archaeology and as such denotes a separation from art. It refers to the art object before an aesthetic understanding of that object is

applied to it. Jean Baudrillard uses the term in order to stress his anthropological study of art. He writes,

> Art interests me as an object, from an anthropological point of view: the object, before any promotion of its aesthetic value, and what happens after. We are almost lucky to live at a time when aesthetic value, like others by the way, is foundering. It's a unique situation.[23]

Quantum art uses the term "artifact" to acknowledge the creation of the art object, which occurs prior to and regardless of any dominant understanding of the function, nature and/or assigned aesthetic value of an art object. This analysis attempts to separate the being of art from the creation and destruction of aesthetic values so that the being of art can be observed, imagined and created.

Quantum art is directed toward the plastic arts. The "art world" refers to the dominant community of artists, academics, critics, curators, gallery-owners, dealers, auctioneers and others involved with the making, selling, teaching and marketing of contemporary art. "New Art Order" is a phrase coined by Sylvère Lotringer, who writes:

> It was obvious that visibility and fame, not contents, were the real engine of the New Art Order. Its power and glamour managed to entice, subdue and integrate any potential threat. Criticizing art, in fact, has become the royal way to an art career *and this will be no exception.*[24]

Thus, the "New Art Order" refers to the art world in the postmodern era, in which the art-object has been replaced by the image of the "art-career," and the market, with its expert systems of public relations, auction houses, financial advisors, press releases, and price negotiations, has replaced the philosopher as its ultimate evaluator.

1.3 The Differend

Jean-François Lyotard borrows from Ludwig Wittgenstein's concept of "language games" in writing about justice and situations of conflict:

> Wittgenstein, taking up the study of language again from scratch, focuses his attention on the effects of different modes of discourse; he calls the various types of utterances he identifies along the way (a few of which I have listed) *language games*. What he means by this term is that each of the various categories of utterance can be defined in terms of rules specifying their properties and the uses to which they can be put—in exactly the same way as the game of chess is defined by a set of rules determining the properties of each of the pieces, in other words, the proper way to move them.
>
> It is useful to make the following three observations about language games. The first is that their rules do not carry with themselves their own legitimation, but are the object of a contract, explicit or not, between players (which is not to say that the players invent the rules). The second is that if there are no rules, there is no game, that even an infinitesimal modification of one rule alters the nature of the game, that a "move" or utterance that does not

satisfy the rules does not belong to the game they define. The third remark is suggested by what has just been said: every utterance should be thought of as a "move" in a game.[25]

Lyotard addresses the moment when one group's language games are applied to a second group, where the second group uses a different set of language games.[26] The second group is rendered powerless to express its needs within the system of the first group's language games. Lyotard calls this situation "the differend" and warns of the injustice that the differend incurs.

I would like to call a differend the case where the plaintiff is divested of the means to argue and becomes for that reason a victim. If the addressor, the addressee, and the sense of the testimony are neutralized, everything takes place as if there were no damages. A case of differend between two parties takes place when the regulation of the conflict that opposes them is done in the idiom of one of the parties while the wrong suffered by the other is not signified in that idiom"[27]

The dominant paradigms of contemporary society abide to a system of language games, which the being of art does not recognize. Because the being of art uses a different set of language games, a differend occurs. The differend renders art silent. Because the arts do not "talk back" (in the language of philosophy, for example), the arts become voiceless putty in the hands of their system-makers. The dominant language games that affect art in the twenty-first century belong to three systems:

market, academia and the scientific method. Aesthetic philosophy, which often resides within the realm of academic and the scientific method, is also subject to the market, which appropriates the language of aesthetic philosophy without regard to its content.

Paul Virilio considers silence to be a fundamental characteristic of art and laments art's loss of silence in the mid-twentieth century. He attributes art's loss of silence to two phenomena: the explosion of audio-visual technologies and the political implication of silence in the post-Auschwitz era.[28] Virilio writes, "Nowadays everything that remains silent is deemed to consent, to accept without a word of protest the background noise of audio-visual immoderation."[29]

While Lyotard claims that, "one's silence makes a phrase"[30] Virilio argues that, due to a shift in dominant language games toward the audiovisual, the arts no longer enjoy the privilege to be silent. That phrase, formerly represented by art's silence, was rendered null. In response, contemporary art either adopted the language games of its system-makers or was assumed to be without content.

In the mid-twentieth century, the art world responded to art's loss of its ethical and artistic right to remain silent by adopting Formalism.[31] In the art world, Formalism is also referred to as the "formal language of art." It alludes to the recognizable and nameable characteristics of an artifact (composition, line, form, space, picture plane, etc.). The increased awareness of and discussion of "art's language" indicates the art world's attempt to alleviate art's uncomfortable state of muteness. Clement Greenberg used Formalism to give voice to the last group of silent painters, the abstract expressionists.

Before art was forced to speak, the dominant aesthetic question was Kant's question, "how do we assign value to this art?" After art was forced to speak, the aesthetic question became, What is art trying to say? The question of art's content came bursting to the surface. In the late twentieth century, the art world adopted art theory, giving it not only speech, but content and authority.

The being of art is at the center of a differend. However, it is a differend without conflict. It incurs no injustice. The being of art does not recognize the demands and language games of the market, academia and the scientific method. The silence of art is only named and recognized as such by the dominant language games, at the point in which the dominant language games no longer allow for silence. Art's silence, or lack thereof, is a construct of the dominant language games. As such, its loss is only meaningful in terms of those dominant language games.

The differend is useful in that it recognizes the being of art's indifference towards the dominant language games. The market, academia and the scientific method ask: is it art? what does it mean? how do we assign it value? The being of art does not answer these questions because it does not recognize this mode of questioning. An honest artist will admit that the primary urge to create is not motivated by the desire to answer the above questions. Children and young artists follow an urge to create before they are aware of these questions. It is only upon becoming aware of these questions that children and young artists begin to ignore their desires to create.[32] It is not that the artist dislikes these questions. Simply, the being of art does not hear, see or recognize these questions.

Lyotard asks the reader to bear witness to the differend.[33] He attempts to illustrate the rules that govern actions, rather than claiming the ethics of one group's rules as opposed to another. According to Lyotard, "the mode of the book is philosophical, and not theoretical (or anything else) to the extent that its stakes are in discovering its rules rather than in supposing their knowledge as a principle."[34]

In this case of art's differend, the question becomes what are the language games that govern or affect the being of art, and does the being of art employ its own language games? The language games of the dominant paradigms - academia, the market and the scientific method - are so prevalent that the nature of the being of art has been systematically ignored. This lack of attention has resulted in a working definition of art's ontology which is not based in art's desires and needs, but in the desires and needs of the language games of the market, academia and the scientific method.

1.4 The Scientific Method, Newness and Validation

The language games of academia are dominated by the language games of the scientific method. The scientific method, actively espoused during the age of the Enlightenment, was designed to ensure that the sciences produce objective and universal Truth. The history of the scientific method's creation includes ancient Greek philosophers, Arabic philosophers and early Renaissance thinkers.[35] Francis Bacon's text, *Novum Organum,* laid a clear foundation for the scientific method, defined as the creation of general theories or laws deriving from evidence, gathered through experiment and observation.[36] Bacon's

scientific method and Sir Isaac Newton's deterministic understanding of the physical world are referred to as the classical view of physics. David Lindley describes the classical view as such:

> Nature was knowable—and if it was knowable, then one day, necessarily it would be known.
>
> The classical vision, springing from the physical sciences, became in the nineteenth century the dominant model for science of all kinds. Geologists, biologists, even the first generation of psychologists, pictured the natural world in its entirety as an intricate but inerrant machine. All sciences aspired to the ideal that physics offered. The trick was to define your science in terms of observation and phenomena that lent themselves to precise description—reducible to numbers, that is—-and then to find mathematical laws that tied those numbers into an inescapable system.[37]

Philosophy absorbed the scientific method to ensure that its activity continue to be regarded as a legitimate method of producing and illuminating Truth. Martin Heidegger traces philosophy's subservience to science to the ideas of Plato and Aristotle. He urges his reader to free the act of thinking from its service to doing, making and technology ("techné"):

> To learn how to experience the aforementioned essence of thinking purely, and that means at the same time to carry it through, we must free ourselves from the technical interpretation of thinking. The beginnings of that interpretation reach back to

Plato and Aristotle. They take thinking itself to be a techne, a process of reflection in service to doing and making. But here reflection is already seen from the perspective of praxis and poiesis. For this reason, thinking, when taken for itself, is not "practical." The characterization of thinking as *theoria* and the determination of knowing as "theoretical" behavior occur already within the "technical" interpretation of thinking.

Such characterization is a reactive attempt to rescue thinking and preserve its autonomy over acting and doing. Since then "philosophy" has been in the constant predicament of having to justify its existence before the "sciences." It believes it can do that most effectively by elevating itself to the rank of a science. But such an effort is the abandonment of the essence of thinking. Philosophy is hounded by the fear that it loses prestige and validity if it is not a science. Not to be a science is taken as a failing that is equivalent to being unscientific. Being, as the element of thinking, is abandoned by the technical interpretation of thinking.[38]

The art world, especially as expressed in academia, employed the scientific method for the same reasons that philosophy absorbed the scientific method: the desire for validation and authority. The internalization of the scientific method, in conjunction with Modernism's obsession with newness, progress and the liberation of mankind, produced the following ontological conclusion: art = emancipatory truth, where truth = new.

In order to reach emancipatory truth, the artist employs the four processes of the scientific method: set up an experiment, observe the experiment, document the experiment, create a hypothesis. This set of rules ensures that the artifact will belong to the realm of knowledge and that it will be both new and true. As Sylvère Lotringer writes, "art is a creation of knowledge, just like concepts."[39]

The postmodern era remained true to the modernist ontological paradigm of art, except that it replaced truth with criticism. Instead of relying on the language of formalism, artists turned to the language of critical theory. The postmodern ontological paradigm became: art = emancipatory criticism, where criticism = new.

Art's ontology remains in servitude to the act of producing new knowledge (in service to the scientific method) and aiding in the processes of emancipation or transcendence (in service to Modernism). Freeing art, ontologically, from its mercenary activities, is necessary to begin to question the being of art. Art's being, itself, does not need to be freed. Art's being is indifferent toward the language games of the dominant systems (market, academia and the scientific method), but in order for the artist to see, hear, listen, touch, feel and think about the needs and desires of the being of art, she needs to make a choice to do so.[40] In order to make this choice, she must become aware of the foundations of her own ontological beliefs so that she may choose to create them in reflection of her needs and desires. In doing so, she becomes her own philosopher. The problem becomes: how can the artist-philosopher question art's being?

1.5 Using Scientific Ideas to Inspire the Questioning of the Being of Art

The endeavor which is closest in nature to art's being is science and, in particular, quantum physics. Historically, the sciences have obeyed Newton's scientific method and Plato's paradigm of "techné." But before and beneath science's mercenary functions, the being of science is grounded in the realm of the unknown and the activity of play. The young scientist, like the young artist, is driven by curiosity about the unknown in nature.

Quantum physics, by its method and nature, breaks with the common sense understanding of a scientific truth. Shimon Malin writes:

> Erwin Schrödinger's discovery of "wave mechanics" led to insights concerning the nature of electrons and other subatomic entities. When left alone, electrons are not "things." They do not actually exist in space and time; their existence is merely potential. They emerge into momentary actual existence by acts of measurement. Hence, unlike classical measurements, quantum measurements are creative; they literally create the entities that are measured.[41]

Quantum mechanics does not prove or create certainty. It can only say something about the potentialities of nature as well as the problematic nature of measurement. The being of art and the practice of quantum physics have this characteristic in common: they simultaneously respond to and create uncertainty.

Scientists have carefully guarded the authorship and usage of scientific concepts. Alan Sokal and Jean Bric-

mont lament that philosophers take scientific ideas out of context and apply them to social issues.[42] Baudrillard challenges this assumption by suggesting that scientific concepts are not sequestered in the context of scientific experiments. They "play themselves out in the body and in the social order."[43] Baudrillard encourages the non-expert to strip scientific concepts of their identity as authoritative, scientific truth. The singular, sovereign and certain truth is questioned by the new physics (quantum physics). Baudrillard encourages the non-expert to use scientific concepts to directly question, in a non-metaphysical manner, events in the "non-scientific" realm:

> All these concepts coming from elsewhere—from the confines of uncertainty and the indetermination of the object, from calculus—concepts at once "scientific" and fictional, are not to be taken metaphorically, as the human sciences are eventually doing, and scientists themselves when they extrapolate their intuitions to fit the human dimension. These must be at once transferred literally and conceived in the two universes. Uncertainty, fractals, catastrophic form, the relationship of incertitude, the indetermination of subject/object are not the privilege of science; they are active throughout the social order, on the order of events, and we cannot assign a priority between the conjectural order of science or the subjective order of morality and history. It is part of uncertainty that we cannot tell whether scientific intuitions secretly belong to a society at a given moment in history. All of this makes a simultaneous irruption and one must deplore the impotence of our thought and incurably determinist discourse confronted with

their revolution of our material universe. It is up to
us to entertain a radically different philosophical
vision of this situation: the non metaphorical use of
scientific concepts doesn't carry with it an effect of
truth because there is no longer a definition of this
science just as there is no longer a definition of our
real world.[44]

Baudrillard challenges his reader to abandon the
method of critical thinking, which is based in the scientif-
ic method. The new physics creates, embraces and func-
tions within a realm of uncertainty. He suggests a mode of
thinking which creates potentiality instead of fixed truths.

The problem is how to give up on critical thought
that belongs to a history and a past life. Instead of
making determinist analysis of a deterministic soci-
ety, can one finally make an indeterminist analysis
of an indeterminate society, a fractal, stochastic,
exponential society of critical mass and extreme
phenomena—a society entirely dominated by the
relationship of uncertainty?

This has nothing to do with metaphor and the abuse
of "scientific" metaphors, that is to say, wondering
whether it is legitimate to extend to other domains
a principle of indetermination and incertitude
coming from elsewhere. Rather, we should ask: what
about quantum physics, fractal physics, and ca-
tastrophe theory? What about the radical principle
of uncertainty in our universe, in the human uni-
verse, in the moral, social, economic and political
universe? The problem is not to transfer concepts
borrowed from physical, biological, or cosmological

science into metaphors or science fictions, but to
transfuse them literally into the core of the real
world, making them suddenly appear in our real
world as non identifiable theoretical objects, as
original concepts, as strange attractors...[45]

Is it possible that the being of art is a human activity
which is not designed to create, illuminate or point towards
Truth? Is it possible that the being of art is a human activ-
ity which does not function within the language games of
language itself? If so, what alternatives present themselves
for the imagination of the potentiality of the being of art?
Baudrillard writes, "Thinking, therefore, is not as valuable
for its inevitable resemblances to truth as for the immeasur-
able divergences that separate it from truth."[46]

Quantum Art will use scientific ideas as inspira-
tion for the creation of philosophical concepts and
questions, which will be applied to the being of art.
For example, Does the act of observation disturb the
being of art? Questions are intended to open a path
towards uncertainty, so that the artist's ontological ap-
proach may allow her to be more responsive to her own
uncertainties, desires and play.

Concepts and questions inspired by scientific ideas will
not be used to prove something about art or philosophize
about science. It is of little importance, therefore, if scientific
concepts are eventually proven "true" or "false." In the case
of the question of art's being, the act of proving, itself, is
null. The concepts and questions, inspired by scientific
ideas, are intended to simultaneously expose art's being
(by allowing the artists to observe art as the thing-in-itself)
and create art's being (by allowing the artist to imagine the
potentiality of art).

Gilles Deleuze claims that his approach to philosophy is analogous to that of an artist. The philosopher, in Deleuze's understanding, does not reflect on the past, but creates concepts in order to imagine the future. The creation of concepts, however, must be in response to a necessity.

> The idea that mathematicians would need philosophy in order to think about mathematics is quite comic. If philosophy was made to think about something, it would have no reason to exist. If philosophy exists, it is because it has its own content. If we ask ourselves what the content of philosophy is, it is very simple. Philosophy is a discipline as creative, equally as inventive as all other disciplines. Philosophy is a discipline that consists of creating or inventing concepts. Concepts do not just exist. Concepts do not just exist in the sky where they are waiting for philosophy to come up and seize them. Concepts must be fabricated. Of course they are not made just like that. One does not just say to oneself, "Okay, I am going to make a concept, I am going to invent a concept." Not any more than a painter says to himself one day, "Okay, I am going to create a painting just like that." *There has to be a necessity*, in philosophy as in elsewhere, If there is not some necessity, there is nothing at all. This necessity, if it exists at all, is that which makes a philosopher.[47]

The question is: to what necessity does the artist and philosopher respond to today?

1.6 Necessity

Is art itself a necessity? It does not appear to be a nec-
essary component of the human's biological ability to
survive both at the level of the individual and the species.
Evolutionary art theorist Denis Dutton writes,

> Natural selection stresses survival in a hostile
> environment as fundamental to the prehistoric evo-
> lution of any adaption. But if art is an adaptation,
> mere survival is a completely inadequate explana-
> tion for its existence.
> The reason is clear: artistic objects and perfor-
> mances
> are typically among the most opulent, extravagant,
> glittering, and profligate creations of the human
> mind. The arts squander brain power, physical ef-
> fort, time and precious resources. Natural selection,
> on the other hand, is economical and abstemious: it
> weeds out inefficiency and waste.[48]

Is art an inherent and biological component of our
being? Yes. Dutton believes humans are born with an
instinct to create; "human beings are born image-makers
and image-enjoyers. Evidence for Aristotle can be seen
in children's imitative play: everywhere children play in
imitation of grown-ups, of each other, of animals, and
even of machines. Imitation is a natural component of
the enculturation of individuals."[49]

Dating to the Upper Paleolithic Era, there is evi-
dence of the human activity of art. Further, the activity of
creation appears to emerge prior to the activity of written
language (both in the baby and in the evolution of the
human).[50] But why does the human have an essential

component of its being which is not necessary to its survival? Is art a vestigial organ? Or does it continue to fulfil some other kind of necessity? Does humans have a need for symbols and images? Herein lies the necessity to which the philosopher of art must respond. The philosopher must create a concept that opens the ontological potentiality for art's being. In doing so, it is possible that art's potentiality will amount to only this: to be forgotten. Only in allowing for this possibility can the artists bear witness to art's differend and thereby create an approach to art that allows for art.

The differend occurs between the ontological treatment of art and the being of art. The ontological treatment of art is supported by the language games of the three dominant systems: the market, academia and the scientific method. The being of art does not desire or need the dominant language games. It does not recognize or respond to the dominant language games and therefore, no conflict occurs. However, in the absence of conflict, the being of art remains ignored by the philosopher. Through the dominant ontological paradigm, the being of art also remains ignored by the artist. This is not a situation of injustice to which we bear witness. It is a situation of previously disregarded potential, which we have the opportunity to explore and explode. The artist is called upon to create an ontological approach that directly responds to the needs and desires of the being of art and which opens the potentialities of the being of art.

1.7 Affirmation of Art, Technology and Body:
Homo generator
The art object is the artifact that gives evidence of the activ-

ity of the being of art. The question posed here is: what is the being of art? Humans experience the being of art in the body. The being of art is experienced consciously as a set of desires which originate and resonate within the body.

What is the body? The body is a being that becomes aware of itself as a whole. The body, from its earliest stages, uses itself as a tool to observe, mimic and create itself. The body is also the senses, the mind, the organs, the cells, the molecules, the muscles, the consciousness and all the other parts which we do not have names for and have not yet imagined. The body is also a tool. For example, the brain uses the hand as a tool to reach for an object. The hand uses the senses as a tool to decipher an object's temperature, and so forth.

The body is, therefore, a being as well as a tool. The body's most obvious tools are its brain, its eyes, its muscles, its hands, etc. However, it is also made up of external tools such as the pencil, the camera and the computer. Consciousness can be considered a tool, although we do not know where it resides in the physical body.

Quantum physics inspires the questions: Where is the separation between bodies? Do bodies share tools? Do bodies share being-ness? Perhaps just as the body creates tools and tools create the body, the singular body creates other bodies and other bodies create the singular body. This is simple to imagine in terms of the parent-child relationship. If one extends this potentiality to all humans, one can imagine that there is a shared and common techno-body-brain, where the term "techno" denotes tools.

Each component of the techno-body-brain, like a molecule of the body, uses the other components as tools. Simultaneously, each component regards itself as an indi-

vidual. In this manner, we can imagine that the being of
art (as manifested in the body) carries the potential to be
a shared tool, in a shared body. Potentially the being of
art functions simultaneously as a tool, the shared whole
and an individual being. Each component of the com-
mon techno-body-brain creates itself simultaneously to
being itself.

Quantum art proposes that the being of art is re-
lated to this behavior. The being of art is a tool which
continuously creates itself. It manifests itself in the body.
It desires to observe, imagine and create uncertainty.
The being of art, understood as the substance of desire,
creation and uncertainty, is the essence of our existence
as *homo generator*. For Schirmacher, "*Homo generator*
does not have to settle for what's given; he or she works
instead, without any restrictions, with the fundamental
building of life in all forms."[51] The being of art is related
to the fundamental substance and activity of creating
being itself.

Like thinking, the being of art is used for many mer-
cenary purposes. However, in and of itself, it appears to
be without direction and function. This uselessness exists
precisely because it is the substance of which beings are
made. The being is constructed of the substance-ability
to create itself by imagining and observing itself. Bodies,
like art-objects, are the artifacts or evidence of *homo gen-
erator*'s being. Schirmacher writes, "We are but artificial
beings among all other beings, our bodies are artifacts by
nature."[52] The human becomes *homo generator* when she
recognizes the essence of her own being. The being is not
foreign to her, for it is her own creation. Homo genera-
tor observes himself while creating himself and creates
himself while observing himself.

The *homo generator* uses his body, tools and senses like other beings. Unlike other beings, he is aware of his capacity to create. Because his capacity to create is manifested in his body, he is acutely aware of his senses, desires and tools. He does not regard his sensations as irrational or dangerous, nor does he privilege them. His senses are his being. He takes responsibility, but claims no power.

> *Homo generator*'s body politics is to see/hear/smell/ touch/taste/think before you act, it claims aesthetic perception as the basis of comprehending and interaction. *Homo generator* has no fear of his or her mistakes, for they are inseparable from his or her succeeding—as body politics teaches us. Responsibility also means being able to assume one's guilt and to reject blame for anything you have not caused yourself. *Homo generator* is a substantial beginning, unique but not original, self-care without egotism.[53]

Quantum art attempts to create an ontological approach to the being of art which recognizes the artist's desires. The artist's desires, which have previously been ignored or denied, are understood to be the essence of *homo generator*: the ability to exist simultaneously as being and creator, being and tool, being and uncertainty, individual and whole, sensation and awareness of sensation, and the being that observes, imagines and creates in a simultaneous manner.

1.8 Quantum Concepts

Quantum physics, also referred to as quantum mechanics, is a branch of physics which was developed in the early twentieth century. The theory of quantum mechanics originates in Max Planck's idea that energy exists as discrete quantities and that energy's emission and absorption can be measured in bunches or "quanta."[54] Niels Bohr writes, "A new epoch in physical science was inaugurated, however, by Planck's discovery of the elementary quantum of action, which revealed a future of wholeness inherent in atomic processes, going far beyond the ancient idea of the limited divisibility of matter."[55]

In 1905, with the aid of Planck's insights, Albert Einstein made assertions regarding the existence of atoms and photons, the special theory of relativity and the equivalence of matter and energy.[56] Einstein's theories of relativity describe the universe at the macro level. Quantum mechanics (developed by Niels Bohr, Max Born, Louis De Broglie, Paul Dirac, Werner Heisenberg, Wolfgang Pauli, Max Planck and Erwin Schrödinger) describes the universe at the micro level, at the level of subatomic events.[57] Heisenberg's "uncertainty principle" states that a person cannot simultaneously measure the position and momentum of subatomic particles, as the act of measuring one disturbs the other. David Lindley describes Heisenberg's uncertainty principle,

> You can measure the speed of a particle, or you can measure its position, but you can't measure both. OR: the more precisely you find out the position, the less well you can know its speed. Or, more indirectly and less obviously: the act of observing changes the thing observed.[58]

Bohr's "principle of complementarity" concludes that subatomic matter exists as both a wave and a particle (wave-particle duality), although they cannot be simultaneously measured as wave and particle. As Bruce Rosenblum and Fred Kuttner describe, "[Bohr] thus asserted his principle of complementarity: The two aspects of a microscopic object, its particle aspect and its wave aspect, are 'complementary.' And a complete description requires both contradictory aspects, *but we must consider only one aspect at a time.*"[59]

The form which matter takes (wave or particle) seems to depend upon the method of observation. Bohr and Heisenberg's principles, as understood together, are known as the "Copenhagen interpretation."[60]

> Within a year after Schrödinger's equation, the Copenhagen interpretation was developed at Bohr's institute in Copenhagen with Niels Bohr as its principal architect. Werner Heisenberg, his younger colleague, was the other major contributor. There is no "official" Copenhagen interpretation. But every version grabs the bull by the horns and asserts that an observation produces the property observed. The tricky word here is "observation." Does "observation" necessarily mean conscious observation? It depends on the context.[61]

The Copenhagen interpretation calls into question the philosophical and scientific assumptions about objective observation, knowledge and truth. Bohr writes, "the discovery of the quantum action show us, in fact, not only the natural limitation of classical physics, but by

throwing a new light upon the old philosophical problem of the objective existence of phenomena independently of our observation, confronts us with a situation hitherto unknown in natural science."[62]

Schrödinger attempted to create a way to understand waves of matter without relying upon *"Bohr's 'damn quantum jumps.'"[63] According to Bohr,* Schrödinger's wave equation was a success, but it did not relieve physics of "quantum jumps."[64] The wave-state describes the state in which matter exists in a *potential* of multiple positions and momentums.[65] Rosenblum and Kuttner write:

> Schrödinger speculated that an object's waviness was the smeared out object itself. Where, for example, the electron fog is densest, the material of the electron is most concentrated. The electron itself would thus be smeared over the extent of its waviness. The waviness of one of the states of the hydrogen electron pictured above might then morph smoothly to another state without the quantum jumping that Schrödinger detested.
>
> This reasonable-seeming interpretation of waviness is wrong. Here's why: Though an object's waviness may be spread over an extremely wide region, when one looks at a particular spot, one immediately finds either a whole object there, or no object in that spot.[66]

They continue:

> The waviness in a region is the probability of *finding* the object in that region. Be careful—the waviness is not the probability of the object *being*

there. There's a crucial difference! The object was not there before you found it there. Your happening to find it there caused it to be there.[67]

The wave-function, or the probability wave, can only predict the potentiality and probability of what will be observed, and upon observation, the wave-function collapses to a particle state.[68] Rosenblum and Kuttner describe the wave-state as such:

> The most accurate way of describing the state of the yet-to-be-observed atom is to put into English the mathematics describing the state of the atom: The atom was simultaneously in two states…. That is saying that the atom was in both situations at the same time. Putting it this way, however, boggles the mind. It's saying a physical thing was in two places at the same time. [69]

Does the wave-state, in which matter exists simultaneously in multiple positions, actually exist? Or is it a mathematical abstraction? In either case, the act of observation seems to create the collapse.[70] This revelation challenges the Newtonian system of classical physics, which relies on a local, linear and causal reality, made up of finite and definite bits of matter, which exist separately from the observer.[71] The implications of the Copenhagen interpretation are difficult to grasp. Schrödinger's famous cat-in-the-box thought experiment is an attempt to illustrate the seemingly absurd effects of the Copenhagen interpretation in our everyday worlds.

Schrödinger's cat sits alone in a box. An atom is

released, unobserved by the cat. Depending on the state that the atom takes (wave or particle), it either activates a mechanism that kills the cat or does nothing and allows the cat to live. According to the theory of the Copenhagen interpretation, the atom would not choose a state until it was observed. Schrödinger's cat is thus left in the awkward position of being both dead and alive at the same time. It would remain in that state until the experiment was observed.[72]

The Copenhagen interpretation supports the ideas of symmetry and entanglement. Entanglement is the notion that one quantum system cannot be measured without affecting another quantum system, regardless of distance in space-time or direction of space-time. According to Rosenblum and Kuttner, "in principle, however, any two objects that have ever interacted are forever entangled. The behavior of one instantaneously influences the other—and the behavior of everything entangled with either. In principle, our world has a mysterious universal connectedness that goes beyond what we usually consider physical forces."[73]

There are many interpretations of the relationship between symmetry and quantum mechanics. One suggestion is that each quantum system has an underlying (symmetrical) form, which is the form that encompasses all potential forms and which cannot necessarily be directly observed.[74]

Chapter Two:
Ontology

2.1 Monism

Monism is the philosophical belief that everything is one: indivisible and unified. Monism opposes Cartesian dualism, which states that mind and body are separate phenomena.[75] René Descartes writes, "To commence this examination accordingly, I here remark, in the first place, that there is a vast difference between mind and body, in respect that body, from its nature, is always divisible, and that mind is entirely indivisible." Although versions of monism are manifested in philosophies and religions dating to Ancient Greece, Portuguese-Dutch philosopher Baruch Spinoza, a contemporary of Descartes, is one of modern philosophy's most influential monists. He claims that God and Nature are two names for the same substance. Deleuze writes of Spinoza, "(…) the *Short Treatise* is based on the equation God = Nature, and the *Ethics* on God = substance."[76]

Descartes and Spinoza each attend to the differences between the divisible (and finite) and the indivisible (and infinite). Whereas Descartes regards the mind as indivisible and the body as divisible, Spinoza regards the body and mind as inextricably connected to each other, to Nature and therefore to God. In *Ethics* Spinoza writes, "We have shown that the mind is united to the body from the fact that the body is the object of the mind."[77] Further, he states, "[i]t is impossible that a man should not be a part of Nature."[78] Connecting the body to God, he writes, "By body, I understand a mode that in a certain and determi-

nate way expresses God's essence insofar as he is considered as an extended thing. "[79] Because God is infinite,[80] it follows that Nature, substance and self are also infinite. According to Spinoza, to know or understand the self is to understand Nature and God. Spinoza writes, "He who understands himself and his affects clearly and distinctly loves God, and does so the more, the more he understand himself and his affects. "[81] Therefore, the human is capable of accessing the infinite, indivisible, oneness of life.

2.1.1 Spinoza and Neutral Monism

Spinoza's theory is an example of neutral monism. Neither God, nature, nor the particular are privileged in Spinoza's theory. Spinoza writes, "The more we understand singular things, the more we understand God."[82] Spinoza further claims that all phenomena occur due to necessity. Thus the mind and body do not make a series of free choices. Instead they respond to nature, which is both necessary and perfect. Spinoza writes, "In nature there is nothing contingent, but all things have been determined from the necessity of the divine nature to exist and produce an effect in a certain way."[83] He continues, "the will cannot be called a free cause, but only a necessary one."[84]

Spinoza claims that the peaceful being does not fight or deny necessity. Instead, Spinoza urges the philosopher to try to understand. He calls this understanding the intellectual love of god (where God and Nature are one) or *Amor Dei Intellectualis.* Spinoza states, "Knowledge of God is the mind's greatest good; its greatest virtue is to know God."[85] and "This intellectual love follows necessarily from the nature of the mind insofar as it is considered as an eternal truth, through God's nature."[86] Spinoza be-

lieves that the human has the ability, through his reasoning mind, to understand himself, nature and God. Spinoza asserts, "the human mind has an adequate knowledge of God's eternal and infinite essence."[87] In his words:

> The mind's intellectual love of God is the very love of God by which God loves himself not insofar as he is infinite, but insofar as he can be explained by the human mind's essence, considered under a species of eternity; that is, the mind's intellectual love of God is part of the infinite love by which God loves himself.[88]

Spinoza gives the philosopher the hope that through intellectual inquiry, he may find respite from his misery and access to the oneness: the necessity and perfection that is Nature.

2.1.2 Schopenhauer and Monistic Idealism

Arthur Schopenhauer claims that the will, or the thing-in-itself, is the one indestructible substance. The will is the instinct to survive and it is present in all conscious beings. When the will is observed through individual consciousness, it appears in the form of representation. Schopenhauer gives primacy to the will or the thing-in-itself. In other words, representation is an expression of the original, the will. Through consciousness, the individual creates representations of the will. Schopenhauer's theory falls under the categories of "monistic

idealism" and "transcendental idealism." In W*orld as Will and Representation*, Schopenhauer writes:

> The fundamental mistake of all systems is the failure to recognize this truth, namely that the intellect and matter are correlatives, in other words, the one exists only for the other; both stand and fall together; the one is only the other's reflex. They are in fact really one and the same thing, considered from two opposite points of view; and this one thing is the phenomenon of the will or of the thing-in-itself. [89]

Schopenhauer claims that the oneness of all substances is found in each individual bit of matter and each bit of matter contains everything. The individual, Schopenhauer maintains, with its finite and separate nature, is an illusion. The individual is actually the whole, containing everything and connected to everything. Schopenhauer writes, "The Will reveals itself just as completely and just as much in one oak as in millions."[90]

Schopenhauer's will is indifferent to the individual. The individual comes directly in contact with the will through himself, and as such, it appears that the will *is* the individual. The individual's sense of himself as a separate and finite entity is the result of the individual's limitation of awareness, and not a reflection of reality.

> When you say I, I, I want to exist, it is not you alone that says this. Everything says this. Everything says it, absolutely everything that has the fainted trace of consciousness. It follows, then, that this desire of yours is just the part of you that is *not* individual—the part that is common to all

things without distinction. It is the cry, not of the
individual, but of existence itself; it is the intrinsic
element in everything that exists, nay, it is the cause
of anything existing at all. This desire craves for,
and so is satisfied with, nothing less than existence
in general—not any definite individual existence.
No! that is not its aim. It seems to be so only
because this desire—this Will—attains conscious-
ness only in the individual, and therefore looks
as though it were concerned with nothing but the
individual. There lies the illusion—an illusion, it
is true, in which the individual is held fast: but, if
he reflects, he can break the fetters and set himself
free. It is only indirectly, I say, that the individual
has this violent craving for existence. It is *the Will
to Live* which is the real and direct aspirant—alike
and identical in all things. Since, then, existence is
the free work, nay, the mere reflection of the will,
where existence is, there, too, must be will; and for
the moment the will finds its satisfaction in exis-
tence itself; so far, I mean, as that which never rests,
but presses forward eternally, can ever find any
satisfaction at all. The will is careless of the indi-
vidual: the individual is not its business; although,
as I have said, this seems to be the case, because
the individual has no direct consciousness of will
except in himself. The effect of this is to make the
individual careful to maintain his own existence;
and if this were not so, there would be no surety for
the preservation of the species. From all this it is
clear that individuality is not a form of perfection,
but rather of limitation; and so to be freed from it
is not loss but gain.[91]

Schopenhauer's understanding of the will denies the individual his traditional notions of mortality and autonomous separation. Instead, Schopenhauer's individual is the representation of the interconnected, indestructible will, present in all beings at all times.

2.1.3 Heisenberg and Quantum Symmetry

German physicist Werner Heisenberg, one of the early contributors to quantum physics, noticed that the idea of division, in regards to particles of matter, was no longer a useful or meaningful concept. The language of classical physics, when applied to quantum physics, lost its meaning. Heisenberg writes, "Just as in relativity theory the old concept of simultaneity had to be sacrificed, and in quantum mechanics the notion of electron pathways, so in particle physics the concept of division, or of 'consisting of', has to be given up."[92]

Heisenberg points out that physicists hope to find some type of elementary particle which will finally be indivisible and with which physicists could build an understanding of the larger picture. This desire is born out of the language games of classical physics, which, according to Heisenberg, ask the following questions: "Of what does this object consist, and what is the geometrical or dynamical configuration of the smaller particles in the bigger object?"[93] This line of questioning must be abandoned. Instead, he suggests that, "every particle consists of all other particles."[94] The physicist need not search for more and more elementary forms of matter, but rather the symmetry found in matter. Heisenberg writes,

There remains the question: "What then has to replace the concept of a fundamental particle?" I think we have to replace this concept by the concept of a fundamental symmetry. The fundamental symmetries define the underlying law which determines the spectrum of elementary particles.[95]

American physicist and Nobel laureate P.W Anderson warns against the desire to apply the laws of a small system to laws of a larger system in his 1972 article, "More is Different." He writes, "The ability to reduce everything to simple fundamental laws does not imply the ability to start from those laws and reconstruct the universe."[96] Anderson suggests that each system is complicated in its own right and demands its own language and inquiry. He writes, "But the hierarchy does not imply that the science of x is 'just applied Y.' At each stage, entirely new laws, concepts and generalizations are necessary, requiring inspiration and creativity to just as great a degree as in the previous one."[97]

How can systems be understood if one does not fit within the other? How do these systems relate to each other? F. W. Anderson, like Heisenberg, suggests that the over-reaching principle is symmetry. Anderson writes, "By symmetry, we mean the existence of different viewpoints from which the system appears the same. It is only slightly overstating the case to say that physics is the study of symmetry."[98] The quantum symmetrical state is the state that encompasses all potential states, and which appears the same from many different viewpoints. To this extent, the quantum symmetrical state is a form of an absolute.

2.1.4 Symmetrical Monism

Quantum symmetry inspires the philosopher to ask: Is the mind a part of the body? Or is the body a part of the mind? Does the mind create the body? Or does the body create the mind? Could the mind and the body be one thing, simply appearing as different things when viewed from different vantage points? Monistic idealism suggests that mind and body are united by a third element, which according to Schopenhauer is consciousness or will.

If the philosopher takes symmetry as inspiration, he arrives at something close to Plato's ideal form. Plato's ideal form is the original form, which does not exist in reality. The ideal form is the form that all perceived forms reference or replicate. Heisenberg writes,

> This situation reminds us at once of the symmetrical bodies introduced by Plato to represent the fundamental structures of matter. Plato's symmetries were not yet the correct ones, but he was right in believing that ultimately, at the heart of nature, among the smallest units of matter, we find mathematical symmetries.[99]

Symmetrical monism is the philosophy suggested by Quantum art. It differs from Plato's ideal form in that symmetrical form cannot be understood as existing or not existing in the human's perceivable reality. Symmetrical form should be understood as infinite and uncertain potentiality. Unlike some interpretations of quantum symmetry, symmetrical monism does not claim an absolute or universal symmetrical state. Symmetrical monism is the idea that the world is one substance; it is the

uncertainty that includes all potential forms. The uncertain and potential state is both symmetrical and infinite. Symmetrical potentiality is recognized, when observed, as an asymmetrical event. The symmetrical wave of potentiality and the asymmetrical event are ever-present in our daily lives.

Symmetrical potentiality includes all possible matter, locality, speed and interactions existing at once. Symmetrical monism claims that the particular and the many are one and the same. They simply appear differently to the observer, depending upon the observer's method of observation. Symmetrical monism does not claim that the one represents or reflects the other, but that the particular and the one are two names for the same substance, and exist simultaneously.

In the cubist paintings, the philosophy of symmetrical monism is partly visible. An object only looks a certain way when observed from a specific viewpoint. As the observation point changes, the object changes. John Berger writes, "For the cubists, the visible was no longer what confronted the single eye, but the totality of possible views taken from points all round the object (or person) being depicted."[100] It is difficult on a practical level, to represent every possible vantage point.

Each painting can be understood then, as the description of a function which approaches symmetry or potentiality. Monet's haystacks are of a similar sensibility, although the vantage point changes in time, rather than position. However, Cubist painting did not succeed in representing the potentialities of the object when it is not directly observed or measured. Is it possible to make an artifact, which is evidence of being, un-observed in the wave-state or in the state of symmetrical potential?

Symmetrical monism claims that the act of observation is always the play between reality existing in its potential form, and that reality which is created by the observer (the asymmetrical event).

Symmetrical monism is related to Gilles Deleuze and Félix Guattari's concept of the plane of immanence.[101] The plane of immanence is infinite and one, a field that cannot be transcended, much like Spinoza's substance. "Spinoza, the infinite becoming-philosopher: he showed, drew up, and thought the "best" plane of immanence-that is, the purest, the one that does not hand itself over to the transcendent or restore any transcendent,…"[102] In Deleuze and Guattari's oneness, neither the self, nor the subject, nor the concept comes before the plane of immanence. The self, the subject and the concept are embedded within the plane of immanence. In their words, "Immanence is immanent only to itself and consequently captures everything, absorbs All-One, and leaves nothing remaining to which it could be immanent."[103] The plane of immanence is a substance that contains no separations and defies transcendence, and "In any case, whenever immanence is interpreted as immanent to Something, we can be sure that this Something reintroduces the transcendent."[104] They continue, "It is only when immanence is no longer immanence to anything other than itself that we can speak of a plane of immanence."[105]

Symmetrical monism differs from the plane of immanence in that it does not recognize a whole, indivisible, without separations. Symmetrical monism, like the plane of immanence, refutes transcendence. But it gives no priority to the whole (symmetrical potentiality) or the parts (the asymmetrical event). The whole, understood

as symmetrical potentiality, is not unified. On the contrary, it is a collection of infinite, particular, uncertain potentials.

Symmetrical monism does not claim that the whole is composed of or related to its parts. Symmetrical monism claims that the whole *is* its parts. The whole and the part are two names for the same substance-activity. Their different names are not the result of a difference in substance, but of the difference in the method of observation. Symmetrical monism does not claim that there is a possibility for existence without separation, but that the whole, which is its parts, exists as uncertain potentiality (the potentiality of all of the possibilities that may be actualized as events). When uncertain potentiality is observed, and thereby takes the form of event, that event is the substance of the whole, which is entangled with all other events and possible events. Symmetrical monism therefore, does not move toward transcendence, unification or wholeness, but potentiality, uncertainty and entanglement.

Symmetrical monism claims that substance exists simultaneously as a wave of symmetrical potential and a point of asymmetrical form. If the potentiality of the wave were condensed to a drop of water, its substance would not be changed. The symmetrical potentiality should not be considered more perfect or real than an asymmetrical event. The asymmetrical event *is* the symmetrical potentiality, observed in a different manner. All matter is symmetry, inseparable, like an infinite ocean. Thus, symmetrical potentiality does not "contain" asymmetrical form. Symmetrical monism claims that the one, the many and the particular exist simultaneously.

2.1.5 Symmetry, Asymmetry, Singularity and Entanglement

Quantum symmetry can be interpreted as a form of a finite and singular absolute, similar to Plato's ideal form. Quantum symmetry suggests that a substance, in its entangled and unobserved or unperturbed state, maintains a shape, in which it encompasses each of its potential states. This potential state can be understood to have a function that describes a stable and defined shape. Anderson writes, "only by adding up all the possible unsymmetrical states in a symmetrical way can we get a stationary state."[106] When an object is observed, the object undergoes "spontaneous symmetry breaking,"[107] a phenomenon also referred to as the "collapse of the wave-state."[108] Quantum symmetry thus suggests that the unobserved state is a symmetrical collection of possibilities and that these possibilities form an absolute and definite state.

The philosophical suggestion, symmetrical monism, does not claim that the symmetrical state is absolute, defined or stable. Rather, the symmetrical state, as suggested by symmetrical monism is an uncertain, potential and infinite state. It can be described mathematically as a function that approaches the infinite. However, the mathematical description "N approaches the limit of infinity"[109] is useful only because contemporary language is insufficient with regards to the infinite and the unstable. Symmetrical monism suggests that the symmetrical state is the state that is not actively and consciously observed. This state does not approach, become or grow towards the infinite. It is already infinite. What does the infinite look like? No one is certain. The asymmetrical state,

or the state that is actively observed, is the very same substance of the infinite which has temporarily taken the form of a particular event due to the activity of observation.

The quantum artist differentiates between singularity and the asymmetrical event. Baudrillard equates the two, writing, "There is, admittedly, in this cloning and perfect symmetry and aesthetic quality, a kind of perfect crime against form, a tautology of form which can give rise, in a violent reaction, to the temptation to break that symmetry, to restore an asymmetry, and hence a singularity."[110] The quantum artist agrees that there is a constant play between the unobserved (infinite symmetry) and the observed (asymmetrical event). The desire to "break symmetry" is the desire of the play of mimesis, the play of observation and, thus, creation and imagination.

When symmetry is observed and thus broken, the infinite and potential temporarily take the form of a particular event. However, singularity implies a form which is unique and distinct from all other forms. The asymmetrical event is entangled with itself, with time and with all other potential events. In addition, the event is the same substance as the infinite, the uncertain and the potential. The event simply appears as a particular form from the point of view of the observer, upon observation (mimesis).

2.2 Consciousness

Consciousness refers to a state of awareness. Humans have the sensation that there is an "I" which observes and becomes aware of the world. Scientists have not been able to find where the observer, the center of awareness, or the "I" are located within the body.

Neuroscientists study different states of consciousness, such as blindsight, anaesthesia, dream states and meditation. Their results do not point toward a definite location or substance of consciousness. Franz Brentano argues that all conscious beings direct their attention toward an object and toward the self. He calls this directed attention "intentionality." Brentano writes, "We could, therefore, define mental phenomena by saying that they are those phenomena which contain an object intentionally within themselves."[111]

Heidegger's understanding of intentionality can be understood as direct perception. It is an awareness that must be activated by directing it toward the thing-in-itself. Heidegger's intentionality is an un-mediated and nonrepresentational connection to the world.[112] Heidegger thus contradicts Kant's idealism and Plato's idea of reality, which both claim that the self's perception is a derivative illustration of the world, thus separating the self from its experience of the world.

> The statement that the comportments of the Dasein are intentional means that the mode of being of our own self, the Dasein, is essentially such that this being, so far as it *is*, is always already dwelling with the extant. The idea of a subject which has intentional experiences merely inside its own sphere and is not yet outside it but encapsulated within itself is an absurdity which misconstrues the basic ontological structure of the being that we ourselves are.[113]

Heidegger's intentionality is a consciousness which the self, inextricably connected to the world, activates, thus uncovering or revealing the thing-in-itself. This

act of uncovering creates a direct relationship between the self and the world. Heidegger writes, "Uncovering… brings Dasein face to face with the *entities themselves*."[114]

Language, for Heidegger, is the force which allows beings to think about their perceptions/consciousness and, thus, to become human. In Heidegger's words, "Language is the clearing-concealing advent of Being itself."[115] Heidegger's concept of intentionality suggests that consciousness resides in the senses (through perception) and that thinking (via language) is the act of becoming aware of one's perception and thus becoming human. Lotringer suggests that the question of whether or not one can think without language, is still unanswered. He writes, "whether one can think without words is a major controversy among semioticians. Some artists, at any rate, could do that."[116]

The neoplatonist Plotinus, suggests that even inanimate nature has consciousness. Further, Plotinus believes that the fundamental activity of consciousness is creation. Plotinus states that "Nature, which they say is without imagination and without reason, has contemplation in itself, and produces what it produces by the contemplation which it "does not have."[117]

Is there a consciousness that exists in all beings, including nature? Is there a consciousness that exists when it is not directed or observed? How is the being of art related to consciousness, thinking and language? Can a being become aware of herself without the use of language? Is there an ultimate observer or director of consciousness?

2.2.1 The Copenhagen Interpretation

Materialism is the monistic approach, which claims that all is one, given that the one is the material or physical.[118] In this case, the mind is considered a phenomenon of the body. Schopenhauer, a proponent of monistic idealism, argues that materialism failed to acknowledge consciousness. He writes, "[M]aterialism is the philosophy of the subject who forgets to take account of himself.[119] Schrödinger further acknowledges the problem of the method of classical physics. He writes, "Without being aware of it and without being rigorously systematic about it, we exclude the Subject of Cognizance from the domain of nature that we endeavor to understand."[120]

Consciousness has yet to be found, proven or understood in terms of philosophy or science. Intuition would have the philosopher believe that consciousness resides within the brain. However, the sciences have searched the entire body for an observer with no success. The "I"cannot be found.

Quantum physics inspires a philosophical inquiry regarding the nature of consciousness. Is it possible that consciousness creates the self and the world? Does consciousness observe itself? Is it possible for any bit of matter to exist unobserved?

Heisenberg's uncertainty principle states that the position and momentum of subatomic particles cannot be measured at the same time. The act of observing one disturbs the other.

> The observation itself changes the probability function discontinuously; it selects of all possible events the actual one that has taken place. Since through the observation our knowledge of the system has

changed discontinuously, it mathematical representation also has undergone the discontinuous change and we speak of a "quantum jump."[121]

Bohr's principle of complimentary concludes that items can have the contradictory properties of existing both as a wave and a particle, though they cannot be measured as both wave and particle at the same time (wave-particle duality). The act of observation and the tools used in order to observe cause matter to take the form of either wave or particle. Bohr and Heisenberg's principles, as understood together, are known as the "Copenhagen Interpretation."[122]

The Copenhagen interpretation recognizes the affect of the subject (as measuring apparatus) which was previously ignored in Newtonian physics. Heisenberg writes:

> This again emphasizes a subjective element in the description of atomic events, since the measuring device has been constructed by the observer, and we have to remember that what we observe is not nature in itself but nature exposed or our method of questioning.[123]

Although the Copenhagen interpretation does not directly point toward consciousness or subjectivity within the scientific method, it opens a door towards the problem of the observer. Heisenberg writes,

> To what extent, then, have we finally come to an objective description of the world, especially of the atomic world? In classical physics, science started

from the belief—or should one say from the
illusion?—that we could describe the world or
at least parts of the world without any reference
to ourselves.[124]

Philosophically, the Copenhagen interpretation re-
lates to Kant's Copernican Revolution, which posits that
we can never objectively know true reality or the thing-
in-itself. The mind, Kant argues, is a limited measuring
device, which can only see the world as a reflection of
itself. Kant concludes that due to the subjectivity of the
perceiving mind, the philosopher cannot reasonably state
that matter *exists* outside of the mind. Kant writes, "[I]f
I remove the thinking subject, the whole material world
must at once vanish because it is nothing but a phenome-
nal appearance in the sensibility of ourselves as a subject,
and a manner or species of representation."[125]

Schopenhauer points out one important hole in
Kant's theory. He claims that when the mind perceives
itself, it is both the thing-in-itself *and* the measuring de-
vice. The one thing-in-itself that we *can* know is our own
bodies. Further, Schopenhauer suggests that that which
is perceived (matter) and the perceiving mind (intellect)
are not separate at all, but in fact one thing.

But I say that between the act of will and the bodily
action there is no causal connection whatever; on
the contrary, the two are directly one and the same
thing perceived in a double way, namely in self–
consciousness or the inner sense as an act of will,
and simultaneously in external spatial brain–per-
ception, as bodily action.[126]

Schopenhauer's ideas share an affinity with the philosophical questions inspired by quantum physics. Schopenhauer's theory is however, still that of idealistic monism. In Schopenhauer philosophy, the one substance is the will. The self appears as an individual when consciousness directs its attention towards the will (the thing-in-itself) and observes the will in the form of its own body. To the perceiving mind, the will takes the form of individual, thus giving the individual the allusion of his own certain, definite and separate nature.

2.2.2 Consciousness and the Being of Art
Quantum art claims that the being of art is manifested in the body and recognizes itself through the act of consciousness. When consciousness recognizes the being of art, it names the being of art according to three activities: observation, imagination and creation. Observation, imagination and creation are the substance of play and desire. When consciousness does not recognize the being of art, the being of art exists in the state of symmetrical potentiality. The being of art, in its symmetrical state, exists as a wave of simultaneous possibilities. When an individual's consciousness recognizes the being of art, she names it as such and thus creates it (art). The moment of naming and creating is an asymmetrical event. It is transient and cannot be thought to exist separately from symmetrical potential. Upon observation, the being of art takes the form of an event.

The being of art is the essential characteristic of the *homo generator*, who creates herself through the act of continuously becoming aware of herself. *Homo generator* becomes herself through awareness of her being, her

being is the being of art. The being of art is entangled, uncertain and playful. It is in a constant state of desire.

Consciousness observation is the act of play and desire, in which the being moves back and forth between symmetrical potentiality and asymmetrical event. During the act of observational drawing, the artist observes all potentialities of the object. She chooses one potential and makes a mark, accordingly, on the paper. She is only fully aware of the moments in which she makes a choice (a mark, in this case). For the rest of the time, as she observes, she experiences a semi-unaware state, in which she "forgets herself" and finds herself surprised that so much time has passed.

The event, the act of putting a mark on the paper, changes her perception of the object. Curious, she again observes the object's potentialities, chooses one and makes another mark. As she dances between observing potentiality and creating asymmetrical events, each mark changes the object. As the object changes, the drawing changes. As the drawing changes, the idea or perception of the object changes. There is no point in which the object, the drawing and the idea of the object become static. This is why artists who are highly involved with the process of observation often feel that a drawing is never finished. They simply get tired, destroy the paper or make a decision that they like the event, as is. But this "liking" has nothing to do with "getting it right" or coming to a conclusion about the object's absolute form.

Beginning drawing students are often astonished by the fact that their perception of reality changes when they begin to observe reality. For instance, students begin to draw a chair, which they believe to be white and fairly square. They are astonished to find that the color of the

chair is not white. The chair will not stop changing its color. Its square nature becomes round and warped and they inevitably say, "This chair looks nothing at all like what I thought it looked like before I started drawing it. This is strange! What has changed?" Or else they will say, "I can't draw this chair! It keeps changing!" Forms change when they are observed. The process of observing does not create form, for this would imply that prior to observation it did not exist. Rather, observation, through choice, creates a particular and transient event, whereas the unobserved chair takes the form of a multiple of possible events.

During the act of observation and imagination, the artist observes many potentialities at once. Imagine that she watches a rainstorm. At some point, she picks one potentiality. She focuses on a droplet of rain, thus focusing her attention and causing an asymmetrical event. At the same time that she focuses on the droplet, she is observing the entire rainstorm. She is capable of doing both at once. When she returns to staring at the rainstorm, her attention is no longer focused. She holds no particular droplet in mind.

The artist who stares out into a rainstorm may say that she is "not paying attention to anything at all." However, during the moments in which she is not paying attention to "anything," she is actually observing "everything." She observes the symmetrical potentiality without observing herself observing it. At the moment in which she observes herself observing the storm, she creates an asymmetrical event. It is only at that moment that she claims to be watching the rainstorm.

Although it seems that the artist is either in the act of imagination or observation, these two activities are the same thing, simply observed from different vantage points. Observation, as we commonly understand it, is the moment in which we make a choice about what we are observing. But the entire act of observation involves imagination. Prior to a choice, the artist observes all possibilities simultaneously. She suspends belief, thus allowing herself to observe what is there (the certain) and what may be there (the uncertain). The play between observation and imagination is the essence of the symmetrical potentiality of the being of art. The awareness of this play is that which allows the artist to become *homo generator*. John Gribbin writes:

> What happens when we make a measurement at the quantum level is that we are forced by the processes of observation to select one of these alternatives, which becomes part of what we see as the "real" world; the act of observation cuts the ties that bind alternative realities together, and allows them to go on their own separate ways.[127]

Daydreaming is an activity associated with the activity of imagination. The daydreaming artist often cannot recall all of her daydreams or what she was doing while she was daydreaming. She recalls only the set of events which she chooses to focus upon. In doing so, she becomes aware of the fact that she was daydreaming. At the moment when she recognizes herself observing her daydreams, she temporarily stops daydreaming. She becomes aware of a particular event in her mind and she "wakes up from her daydream."

Daydreaming is the act of allowing the self to observe many potentialities without choosing one. The self "returns" from a daydream at the moment when the self has chosen a particular potentiality upon which to focus. The daydreaming artist is at once observing all potentiality and creating asymmetrical events. It is an illusion that the self is either daydreaming or not. The self is continuously and simultaneously in the state of daydreaming and not daydreaming.

When the self observes herself in the act of choosing a particular potential, she holds this event in mind. She calls this process "thinking." When the self observes potentiality without observing herself and without chooses a particular potential, she calls this "daydreaming." The daydreaming self and the thinking self are one activity-substance. They occur simultaneously and only appear different when they are observed from different vantage points.

Finally, creation is observed and named as the activity of making an asymmetrical event. However, just like the act of observation and daydreaming, creation involves both symmetrical potentiality and the asymmetrical event. As the artist creates, she chooses a singular potential from infinite potentiality. The act of choosing changes the idea of the form and the potentiality of the form. The changing form changes the artist's idea of the form and so on and so on. Thus, form and the activities that create form are one thing. Form cannot be separated from the activities that create form, and form and creation cannot be separated from their symmetrical nature of possibilities.

The being of art is the essential substance and activity of *homo generator*. The being of art is at once the act of creating form and the form itself. The act of creation in-

volves observation and imagination, play and desire. The being of art is both the substance of *homo generator* and the way in which *homo generator* exists. She creates herself and the world by becoming aware of herself and the world, and by becoming aware of herself as that which plays with uncertain potential.

Homo generator is artist by nature. The artifact and the body-artifact are both evidence of the artist's substance as creation (including observation and imagination) and desire (including play). *Homo generator* becomes herself through awareness of the being of art and thus allows herself the ability to play with possibility and make choices. An asymmetrical event, created with awareness of potentiality and uncertainty, is the quantum artifact.

2.3 Entanglement

2.3.1 Quantum Entanglement

Entanglement is a concept used in quantum physics, which states that two quantum systems cannot be measured independently from each other.[128] John Gribbin writes:

> It seemed as if, in the quantum world, the measurements we make on a particle here affect its partner there, in violation of causality, an instantaneous "communication" traveling across space, something called "action at a distance."[129]

The act of measuring one quantum system affects the second quantum system, even when great distances separate the quantum systems in question.[130]

Albert Einstein initiated research on quantum entanglement with the EPR paradox. The EPR paradox is a thought experiment which states that under the Copenhagen interpretation of quantum mechanics, either the measurement of one quantum system must effect another quantum system, regardless of distance and time, *or* the description of the wave-function must be inaccurate. In Gribbin's words,

> The point of the argument was that, according to Einstein and his collaborators, the Copenhagen interpretation had to be incomplete—that there really is some underlying clockwork that keeps the universe running, and that only gives the appearance of uncertainty and unpredictability as at the quantum level, through statistical variations.[131]

Einstein was hoping to prove that matter exists in a definite state, even when unobserved. Einstein writes, "I like to think the moon is there even if I am not looking at it."[132]

The principles of causality and locality are violated if measurement of one quantum system affects another quantum system, instantaneously and without direct contact in space-time. Einstein was unwilling to accept entanglement, which he called, "spooky action at a distance."[133] He concluded that either the quantum wave function is incomplete or quantum physics is missing information about a hidden variable.

Following Einstein's lead, Schrödinger conducted experimental research on quantum entanglement. He reluctantly concluded that his results pointed towards the existence of quantum entanglement. Schrödinger writes, "I would not call [entanglement] *one* but rather *the* characteristic trait of quantum mechanics, the one that enforces its entire departure from classical lines of thought."[134] The Copenhagen interpretation supports the theory of entanglement, thus violating the principles of locality and

causality. Entanglement suggests the possibility that a quantum system can be instantaneously affected by another quantum system, regardless of its position in space and time.[135]

2.3.2 Philosophical Entanglement

Entanglement inspires the following philosophical questions: Can beings exist separately from each other? Does the observation of one being affect another being? Does the consciousness of one being affect the consciousness of another being, regardless of distances in space-time? Can the consciousness of a future community of beings affect a community of beings in the present?

Heidegger's notion of being-in-the-world suggests that the self does not exist separately from the world. The self exists in the world as a self that is inextricably connected to a world. The connection between the self and the world is not a secondary consequence of being's place in the world, but an essential characteristic of being. Heidegger wrote, "Being-in is thus the formal existential expression for the Being of *Dasein*, which has its Being-in-the-world as its essential state.[136]

Jean Luc Nancy's concept "being-with" claims that self does not exist separately from many selves. It suggests that not only is the being wedded to all other beings but that the individual is not prior to many or the whole. As such, the singular self coexists with the plural self. Nancy writes, "Being cannot *be* anything but being-with-one-another, circulating in the *with* and as the *with* of this singularly plural coexistence."[137]

An entangled-being suggests the singular self and plural self are one self, which simply appear as singular or plural when viewed from different vantage points or different methods of observance. Entangled-being suggests that the "I" is neither independent from "we," conjoined with "we" or simply a part of "we." Entangled-being is an existence, in which "I" and "we" exist simultaneously. When the "I" is conscious of itself, it recognizes itself as "I" and creates itself as "I." When the "we" is conscious of itself, it recognizes itself as "we" and creates itself as "we." "I" and "we" as well as "self" and "world" are one and the same.

2.3.3 Non-Locality, Non-Causality and The Entangled-Being

Non-locality inspires the philosophical question: Can a being be with another being if they are not together in time-space? Non-causality inspires the philosophical question: Can a being affect another being if they are not together in time-space? Both inspire the question: What separates the self from the other self, the future self and the past self? Baudrillard explains:

> According to Dirac, 'We must revise our ideas on causality." Causality only applies to a system that remains undisturbed. Once disturbed, a measured system in no longer causal. The chain of causality is broken by measure because measure brings about an uncontrollable disturbance, as in all forms of interaction with the fragile, quantum landscape. Measure shatters determinism in order to introduce a fundamental, stochastic element. Before measure, the system had a variety of states at its disposal. Measure only realized one of those. Mea-

sure is the act by which the range of the possible to the real is being reduced. Every state of the system disappears except for the one, the state this is "realized."[138]

Imagine that an entangled-being is entangled not only with those beings in his or her community, but also with those beings that exist in the future or in the past. Imagine that a being is entangled with a being on the other side of the universe. Monistic symmetry suggests that entangled beings are interacting with and continuously affected by beings whom they do not know and have no way of knowing.

When one being affects another being in an instantaneous manner, causality loses its meaning. When one being is in fact several beings, identity loses its meaning. Schrödinger writes:

We are obliged to assert that the ultimate constituents of matter have no "sameness" at all. When you observe a particle of a certain type, say an electron, now and here, this is to be regarded in principle as an *isolated event*. Even if you do observe a similar particle a very short time later at a spot very near to the first, and even if you have every reason to assume a *casual connection* between the first and the second observation, there is no true unambiguous meaning in the assertion that it is the same particle you have observed in the two cases. The circumstances may be such that they render it highly desirable and convenient to express oneself so, but it is only an abbreviation of speech, for there are other cases where the sameness becomes

entirely meaningless; and there is no sharp bound-
ary, no clear-cut distinction between them, there is
a gradual transition over intermediate cases. And I
beg to emphasize this and I beg you to believe it. It
is not a question of our being able to ascertain the
identity in some instances and not being able to do
so in others. It is beyond doubt that the question
of "sameness," of identity, really and truly has no
meaning [italics in original].[139]

In the everyday sense, when a body affects itself in
each moment that it exists, this is not called causality,
but being. An entangled being does not cause affects, it
simply becomes, and it becomes at once with the past
and the future. The entangled being therefore does not
recognize causality. Physicist Shimon Malin claims
that, "Nature violates local realism."[140] In the absence of
causality and local realism, symmetric monism claims
uncertainty. In contrast, physicist David Lindley writes:

But the quantum universe is different. Ever since
Marie Curie wondered at the spontaneity of ra-
dioactive decay, ever since Rutherford asked Bohr
what made an electron jump from one place in an
atom to another, the recognition has grown that
quantum events happen, ultimately, for no reason
at all.[141]

The entangled being is the philosophical notion that
the singular being does not exist *with* other beings and
with the world. The entangled being is a being which
is one and the same as other beings and other worlds.
Entangled beings exist simultaneously as singular and

plural, subject and object. Their interactions, or becomings, do not occur due to logic, cause, or necessity. They occur as uncertainty.

Without causality, the accumulation of events in time loses its traditional meaning. The entangled being, like Schopenhauer's will, does not recognize linear time. Schopenhauer writes, "But your real being knows neither time, nor beginning, nor end…"[142] Schrödinger describes the collapse of causal time as such:

> [T]he Self is not so much linked with what happened to its ancestors, it is not so much the product, and merely the product, of all that, but rather, in the strictest sense of the world, the SAME THING as all that: the strict, direct continuation of it.[143]

Whether we can name, know, see or otherwise perceive our selves or our worlds makes no difference to the entangled being. The entangled being is both the particular and uncertain, the asymmetrical and symmetrical, actual and potential, existing as one substance-force which is simultaneously becoming.

2.4 Transcendence

2.4.1 Schopenhauer's Immortal Will

Schopenhauer's will is immortal and indestructible.[144] The individual, though his individuality is an illusion, suffers endlessly because of the will. Relief, however, is possible. Schopenhauer's individual can transcend himself through absolute denial of the will, which humans

recognize in the form of individuality. Schopenhauer writes, "From all this it is clear that individuality is not a form of perfection, but rather of limitation; and so to be freed from it is not loss but gain."[145]

Schopenhauer approaches individual death and the indestructible nature of the will in his essay *Immortality: (1) A Dialogue*. He argues that death is an illusion perpetuated by the individual. The will, or the "true and inmost being" never dies. The individual observes the will through himself. In doing so, he falsely claims that the will is his identity. The will, however, knows no time and is indifferent toward the individual.

> But your real being knows neither time, nor beginning, nor end, nor yet the limits of any given individual. It is everywhere present in every individual: and no individual can exist apart from it. So when death comes, on the one hand you are annihilated as an individual; on the other, you are and remain everything. That is what I meant when I said that after your death you would be all and nothing. It is difficult to find a more precise answer to your question and at the same time be brief. The answer is contradictory, I admit; but it is so simply because your life is in time, and the immortal part of you in eternity.[146]

The essay's original title uses the word *unzerstoerbarkeit*, which is translated by T. Bailey Saunders as "immortality." Its direct translation is "indestructability." Schopenhauer meant to illustrate that the will is indivisible, unending and indestructible. The will only appears as an individual and thus finite entity when the individual's

consciousness observes it. The individual thus regards himself as the sole proprietor and the finite container of the will. For Schopenhauer, a finite, definite, mortal, independent self is an illusion:

> It seems to be so only because this desire—this Will—attains consciousness only in the individual, and therefore looks as though it were concerned with nothing but the individual. There lies the illusion—an illusion, it is true, in which the individual is held fast: but if he reflects, he can break the fetters and set himself free…

> The will is careless of the individual: the individual is not its business; although as I have said, this seems to be the case, because the individual has no direct consciousness of will except in himself. The effects of this is to make the individual careful to maintain his own existence; and if this were not so, there would be no surety for the preservation of the species. From all this it is clear that individuality is not a form of perfection, but rather a limitation: and so to be freed from it is not loss but gain.[147]

Schopenhauer's being is an indivisible and indestructible being, but not an entangled being. He gives primacy and supremacy to the will and scorns the individual, which he regards as a kind of ill-fated hallucination: a tormented servant of the will. However, Schopenhauer provides a subtle hope. The will, or the thing-in-itself, is indifferent toward the individual. Through complete negation of the will, therefore, the self can transcend its miserable existence.

In Schopenhauer's essay *On Suicide*, he concludes that although suicide is not a crime, it is also not a successful way to escape the will. Because the will is immortal, suicide cannot touch the will, which is the ultimate source of the individual's misery. The most honorable and ethical act, according to Schopenhauer, is to live despite the misery and to negate the will. T. Bailey Saunders writes, "According to Schopenhauer, moral freedom—the highest ethical aim—is to be obtained only by a denial of the will to live. —When a man destroys his existence as an individual, he is not by any means destroying his will to live."[148] Schopenhauer's being is thus capable of transcendence if, and only if, he strives to deny his instincts and desires.

2.4.2 Against Transcendence

Transcendence is an essential characteristic of the Modern era. It is a seductive, pacifying and endless source of promise for something *else*. No matter who you are or where you are, you can escape to a better world. This theme is present in capitalism's rags-to-riches mythology, in Christianity's promise for the repentant sinner's salvation and in Modernism's belief in the forward progress of technology and mankind. Bruno Latour points out that technological advances have been misunderstood by social Darwinists to be evidence of Progress. He writes:

> As you all know, there is not the slightest connection between Darwinian account of evolution and the tale of Progress. It is only through a complete alteration and downright kidnapping of Darwin's theories that some social Darwinists, in the century

before an in our own, have equated evolution and
Progress, under the fallacious argument of the
survival of the fittest. In its own central argument,
there is no progress whatsoever in Darwin.[149]

The modern notion of progress suggests that each
new stage of human society replaces or overcomes its
past stage; moreover, each new stage moves humans
closer and closer to a state of freedom. Progress itself is a
transcendent idea. Latour suggests that the philosopher
understand history as a move toward ever-greater entan-
glement, as opposed to unity, clarity and emancipation.

It is more a tale, or if you prefer a myth, or to say it
in still other words, a counter-proposition, allowing
us to think differently about the same events which
are used to celebrate the march of Progress and the
stages in the grandiose ascension of Humanity to
Freedom. In the scheme of things I am proposing,
there is still a move forward but it goes toward ever
more *entanglement*, so that the path to freedom is
not the way to account for it; it goes forward in the
sense that our human evolution is taking into ac-
count and mixing always more and more elements
together, but it does not reach toward convergence
and unity, on the contrary, the more it moves for-
ward the more differences and *embranchements* of
all sorts appear.[150]

Lyotard suggests that in addition to the grand nar-
ratives of progress, technology, capitalism and religion,
language itself nurtures transcendence. It does so by

providing multiple names for the self. In this way, the self remains conscious of its future self and its goal: to become a free self.

> Drawn like this, the figure of experience is Christian, we see, like everything modern. It governs from afar the idea of salvation, and thus of progress, of revolution—it's enough to give different names to the "I." Its logic is the dialectic of opposites.[151]

The act of naming, in and of itself, is a tool of transcendence. Naming is the pre-requisite to language-oriented knowing. Without naming, that which is known cannot be communicated. Without naming and communication, a known thing is eliminated from the processes of documentation and evaluation. Documentation and evaluation are necessary in order to prove, scientifically, that things belong to the realm of knowledge. Knowing is understood to be a method of ascertaining the truth, thus a transcendent activity.

Heidegger points out that the activity of knowing has traditionally been equated to its mercenary activities. Knowing is understood to be the primary relationship between the subject and the world. But, in Heidegger's understanding, the self is inextricably connected to the world *prior* to the activity of knowing. The activity of knowing is the result of Dasein put toward mercenary activities. Heidegger writes:

> But no sooner was the "phenomenon of knowing the world" understood than it was interpreted in a "external," formal way. The evidence for this is the

> interpretation of knowledge, still prevalent today
> as a "relation between subject and Object" which
> contains about as much "truth" as it does vacuity.[152]

In its commonly accepted capacity (with which Heidegger disagrees), knowing is a transcendental activity because it not only connects the self to the world, it creates, out of this connection, knowledge, certainty and truth. The dominant language games of the scientific method, academia, market capitalism and Judeo-Christian religion have encouraged an understanding of truth (and therefore knowing) as the self's primary activity of transcendence. Through the understanding and thus possession of truth, the self encounters the possibility of emancipation. In John 8:32 of the Bible, it is written, "Then you will know the truth, and the truth will set you free."[153]

The belief in individual transcendence through understanding of truth is the essential characteristic of the modern era. For this reason, the modern understanding of art's ontology amounts to this: art= emancipatory truth (where truth is new).

Through the notion of transcendence and finally emancipation, the philosopher reconciles the existence of two opposing notions, such as being *and* death. Common sense dictates that a being cannot be simultaneously alive and dead. Therefore, transcendence allows for the possibility for the live self to be eventually replaced by the dead self. The idea of the linear progress of time is, by nature, a transcendent notion.

Transcendence necessitates linear time and, thus, causality. The live self must precede the dead self in order

for the first to turn into the other. But what happens, as Schopenhauer asked, before the live self?

> Notwithstanding all this, the question of our state after death has certainly been discussed verbally and in books ten thousand times more often than that of our state before birth. Theoretically, however, the one is a problem just as near at hand and just as legitimate as the other; moreover, he who answered the one would likewise be fully enlightened about the other.[154]

Schrödinger's cat inspires the philosopher to ask, can the self be both alive and dead, simultaneously? Can the self be alive *and* dead, before, during and after our conscious understanding of life?

The entangled being suggests that the self does not transcend but remains in a constant state of becoming. It remains in a state of symmetrical potential and asymmetrical event. Upon active, intentional observation, the self takes the form of asymmetrical event. The entangled being exists continuously in a state of observation, imagination and creation, wherein it exists both as potential and specific event. The entangled being is not alive or dead, but alive *and* dead, where both birth and death are a moment of becoming, observed by the self as an asymmetrical event.

The entangled being thus becomes more or less aware of entanglement, but never escapes or transcends itself. The entangled being exists in a constant state of becoming. Becoming is the activity, desire and substance of the being of art, which exists simultaneously as a multitude of potentiality and as particular asymmetrical

events. The difference between these states is not a reflective of matter, energy, placement or transcendence. The difference between states of potentiality and actuality is the difference in the self's method of observation and the extent of the self's awareness and belief.

2.4.3 The Being of Art, *Homo Generator* and the Quantum Artist

The entangled being is the being of art. It is the essential substance and activity of *homo generator*. The entangled being or the being of art is the being that is not simply connected to others and the world, but *is* others and the world. Through conscious observation of the being of art, awareness or belief in the being of art, the entangled-being takes the form of *homo generator*. *Homo generator* is the human who creates herself by observing the entangled being.

The quantum artist is the artist who regards herself as *homo generator*. She does not simply create herself, but plays with her substance, ability and desire to observe, imagine and create. Her body is simply one of many artifacts. The artifacts of her creation, made through the process of observation, imagination and creation, are evidence that she allows herself to observe the entangled being.

What are the entangled being's methods of observation? How does the quantum artist allow for the observation of the being of art? And how can the philosopher's ontology shift in order to respect the entangled being's substance and desires? When *homo generator* observes itself as the entangled being, she gives birth to herself. At the moment in which the being is conscious of her ob-

servation of herself as entangled, uncertain, playful and desiring, the self creates itself as *homo generator*. Through observation of *homo generator* by *homo generator*, the being of art is allowed to exist. Allowance is then simply the act of awareness of observation.

Homo generator does not need to search for the being of art. *Homo generator* does not need to struggle, fight or otherwise transcend itself. *Homo generator* is already the being of art.

Plato initiates a distrust of reflection, which launches a distrust of perception and the senses. Plato defines art as mimicry, which is an image of truth rather than the truth itself. Plato condemns the arts for their ability to trick people into believing false truths. He writes:

> Here is another point: The imitator or maker of the image knows nothing of true existence; he knows appearances only. Am I not right?
>
> Yes.[155]
>
> Thus far we are pretty well agreed that the imitator has no knowledge worth mentioning of what he imitates.[156]
>
> Then the imitator, I said, is a long way off the truth,[157]
>
> The imitative art is an inferior who marries an inferior, and has inferior offspring.[158]

Homo generator does not fear reflection, nor revere or glorify it. She accepts that reflection is one and the same with self and world. *Homo generator* regards reflection as self, as the being of art, as the constant act of

becoming. From the point of view of the entangled being, the separation of selves into discreet and separate identities (named as certainty and truth, representation of truth, future self, other, etc.) simply does not exist. When the *homo generator* observes himself as the entangled being, and creates himself as such (as the being of art, uncertain and infinite), she creates her own body. Her body then, is the artifact of her creation. Schirmacher writes, "If we penetrate all the dissemblance and tear away the last veil of analogy between human and animal, it then becomes irrefutable: we are but artificial beings among all other beings, our bodies are artifacts by nature."[159] Schirmacher claims that there is no separation between the artifact that is the body and the artifact that is a representation of the body. Representation is the act of creation.

"Virtual reality" simulates reality by creating a "double world" in which new possibilities may be explored. Such a term is especially useful in hammering out a sharp distinction to "artificial life" and discarding the misleading "fake" analogy. "Artificial life" is human-generated and shares this characteristic with "fake"—both are artifacts. But "artificial life" doesn't imitate life, has no original, doesn't work with the blueprint of nature, and is, as such, completely different from "fake." Instead, artificial life describes the only life we know anything about: humanity.[160]

Homo generator creates herself through observation of the being of art. She can observe herself through reflection (when she sees herself, the being of art, through the eyes of another), direct observation (when she recognizes herself in and as another), or through indirect observation (when she cannot see herself, but is aware of

her own existence through sensual awareness). All three forms of observation (reflective, direct and indirect) observe the entangled being, the being of art.

The idea that a reflection or an other is fundamentally different and inferior, with respect to the original, is the result of a paranoid and cautionary tale. This narrative is continuously perpetuated by the language games of market, academia, and the scientific method, which rely upon truth and transcendence. Transcendence necessitates a separation between the self and the future self or between the truth and the reflection. The separation allows for the leap which lands the self in the realm of truth and emancipation. Truth and transcendence are not reflective of the being of art. Truth and transcendence are indicative of the desires of the dominant language games. The entangled being, the being of art, is indifferent to truth and transcendence.

At times, the self becomes aware of the entangled being, yet cannot see it, recognize it, name it or speak of it. Historically, this unnamable self has been demonized (the artist as mentally ill), spiritualized (the artist as shaman) or glorified (the artist as genius). It is the same unnamable being that religions call God and philosophers call inspiration. Monists call it the one. Idealists call it the will or consciousness. Scientists point out that it cannot be measured.

When *homo generator* becomes aware of the entangled being and names it as such, she gives birth to herself. Her body is the artifact or evidence of the being of art. The quantum artist is a category of *homo generator*, in which *homo generator* plays with her ability to observe the being of art and creates artifacts *other than her own*

body. The quantum artist then, is the *homo generator* who plays with her ability to create through observation and does so for the sake of her own desire for uncertainty.

Although the quantum artist observes the being of art and names it art, the quantum artist denies art the transcendental phenomena of knowing, certainty, truth, creation or emancipation. In other words, the being of art, which is and has always been present, becomes an asymmetrical event when *homo generator* observes it directly and thus creates it. Her awareness of the being of art has no consequence in terms of the dominant language games. It provides no proof, truth or transcendence. It is only at this point, that the human becomes a quantum artist. Hegel announced the death of art:[161]

> In all these respects art is, and remains for us, on the side of its highest destiny, a thing of the past. Herein it has further lost for us its genuine truth and life, and rather is transferred into our *ideas* than asserts its former necessity, or assumes its former place, in reality. What is now aroused in us by works of art is over and above our immediate enjoyment, and together with it, our judgement; inasmuch as we subject the content and the means of representation of the work of art and the suitability of unsuitability of the two to our intellectual consideration. Therefore, the science of art is a much more pressing need in our day than in times which art, simply as art, was enough to furnish a full satisfaction. Art invites us to consideration of it by means of thought, not to the end of stimulating art production, but in order to ascertain scientifically what art is.[162]

But the death Hegel prophesized was the death of the artifact as understood through an ontology (art = emancipatory truth), which has nothing to do with the being of art. *Homo generator* gives birth to art, where art is the artifact of the being of art: desire, uncertainty, play and potential. It does so in a constant fashion such that giving birth is not an event, but a way of being. The being of art never died, it simply had not yet been observed, recognized, imagined, desired and created. It has not yet been born.

In order to observe the being of art, *homo generator* must accept that the being of art is self and world, self and other, being and tool, creator and observer. The being of art exists as symmetrical potentiality and asymmetrical event, simultaneously. The being of art is not separate from the self or outside of the self. It cannot cause transcendence or lead towards emancipation. It is not magical or mystical in the sense that there is nothing particularly different or special about the being of art. It is in fact the most common part of each of us.

Every child is born with the being of art. Every child exists as the being of art and uses the being of art to create himself, prior to language or education. Aristotle writes, "For it is an instinct of human beings form childhood to engage in mimesis (indeed, this distinguishes them from other animals: man is the most mimetic of all, and it is through mimesis that he develops his earliest understanding)."[163]

As children become adults, they are taught to deny the desires of the being of art. As the being of art manifests itself in the body, the denial of the entangled being is the denial of the body's desires. The *homo generator*, who observes the being of art and creates not simply his own

body but artifacts of uncertainty, is the quantum artist. She creates, not out of necessity but out of the desire to allow her being to enact her desire to play—to play with uncertainty to the fullest extent of her desire.

2.5 Technology

"Technology" is usually defined as the practical application of knowledge.[164] The practical application of knowledge involves tools. Tools are considered to be any object which is made, crafted or used toward a specific end.[165] Recent research has shown that animals use tools. For example, chimpanzees have been observed creating spears for hunting.[166] However, no animal has used tools to the same extent as humans.

The pre-Platonic understanding of the term technology refers to a body of knowledge, which is oriented around a goal. It should be reliable, teachable and publicly validated and recognized.[167] Plato used the term *techné* in order to denote art, skill, craft and technical knowledge.[168] Plato's understanding of the art as *techné* indicates a separation between the activity of art (including its techniques and tools) and the activity of philosophy (or thinking towards truth). Technology, Plato claimed, is an activity that mimics nature.[169] Thus technology, from its Platonic roots, denotes an activity that does not necessitate the ability to know truth.[170]

Contemporary society still relies upon Plato's fundamental understanding of technology as an empty vessel which must be activated and directed by a human who is alone capable of knowing the truth. Technologies created during the postmodern era are oriented around computers and generally referred to as "new technology,"

"communications technology" and/or "nanotechnology," which refers to the quantum realm. The art world refers to any art that uses new technologies, such as computer programs, the Internet or sophisticated recording devices, as "new media."[171]

2.5.1 *Homo Generator* as the Techno-Body-Mind

Philosophy has established a rigorous tradition of questioning the relationship between body and brain. However, technology has been treated as a bi-product of the self. Technology has been examined only *after* the question of self was resolved.

The separation between self and technology spawns intense excitement as well as fear. Heidegger writes, "The will to mastery becomes all the more urgent the more technology threatens to slip from human control."[172] As an independent self, technology can either control or be controlled. Technology becomes savior or demon. Schirmacher remarks, "The "radical technologists" may still believe that they use technology before they are used by it, but this stems from a philosophical ignorance that ill suits their technological smartness."[173]

Symmetrical monism suggests that tools are not simply a representation, reflection or attribute of the self. The tool is the self, called by another name. Fear or adulation of the tool is thus fear or adulation of the self. Traditionally, technology has been examined through its end goal or function and its relation to human activity. Heidegger writes, "The current conception of technology, according to which it is a means and a human activity, can therefore be called the instrumental and anthropological definition of technology. Who would ever deny that it is correct?"[174]

Symmetrical monism suggests that a tool is not an empty vessel which is activated by a self. A tool *is* the self. As such, the tool has a being which exists regardless of its usage. Heidegger writes:

> Likewise, the essence of technology is by no means anything technological. Thus we shall never experience our relationship to the essence of technology so long as we merely represent and pursue the technological, put up with it, or evade it. Everywhere we remain unfree and chained to technology, whether we passionately affirm or deny it. But we are delivered over to it in the worst possible way when we regard it as something neutral; for this conception of it, to which today we particularly like to pay homage, makes us utterly blind to the essence of technology.[175]

Heidegger urges his reader to consider the essence of technology, which exists, despite technology's mercenary activities. The essence of technology, he claims, is that of *revealing* or *bringing-forth*. As such, technology belongs to the same realm of truth, beauty and art.

> The word [technology] stems from the Greek. *Technikon* means that which belongs to techne. We must observe two things with respect to the meaning of this word. One is that techne is the name not only for the activities and skills of the craftsman, but also for the arts of the mind and the fine arts. *Tech* belongs to bringing-forth, to *poiesis*; it is something poetic.

The other point that we should observe with regard to techne is even more important. From earliest times until Plato the word techne is linked with the word episteme. Both words are names for knowing in the widest sense. They mean to be entirely at home in something, to understand and be expert in it. Such knowing provides an opening up. As an opening up it is a revealing....Thus what is decisive in *techné* does not lie at all in making and manipulating nor in the using of means, but rather in the aforementioned revealing. It is as revealing, and not as manufacturing, that *techné* is a bringing-forth.[176]

Heidegger observes the essence of technology as a creative force that reveals truth. Like his concept of being-in-the-world, he understands the self and technology as two inseparable, but nonetheless independent entities.

Donna Haraway's cyborg is a self which includes both natural and artificial parts, where artificial is considered anything man-made (except for the results of the act of sexual reproduction). The cyborg suggests that humans are evolving into humans that share their existence with artificial parts. Haraway writes:

By the late twentieth century, our time, a mythic time, we are all chimeras, theorized and fabricated hybrids of machine and organism; in short, we are cyborgs. The cyborg is our ontology; it gives us our politics. The cyborg is a condensed image of both imagination and material reality.[177]

Where is the boundary then, between tool and body part? Physicist Stephen Hawking is unable to speak or

write on his own. He communicates using a sophisticat-
ed computer system called Equalizer.[178] This computer
system is considered a tool which belongs to Stephen
Hawking. Runner Oscar Pistorius uses detachable pros-
thetic limbs in order to sprint. His limbs may be consid-
ered tools or body parts. They are tools in that they are
man-made, detachable and he chooses to use them for
a specific purpose. But they are body parts in that they
replace a naturally occurring body part — the leg.

The difference between the tool and the body part is
generally defined by the questions: Is it inside the body
or outside the body? Is it a part of the body or is it used
by the body?

Symmetrical monism suggests that the entangled be-
ing is both a body and a tool. For example, the body uses
its brain as a tool at the same time that the brain uses
the organs, limbs and senses as tools. Simultaneously,
the techno-body-brain regards itself as one self. Further,
symmetrical monism claims that the essence of technol-
ogy, which is one and the same as body and mind, does
not reveal or create truth. The techno-body-brain creates
itself as uncertainty. As such, the techno-body-brain is
the body of *homo generator*, the self that uses its being to
create itself. The shared techno-body-brain creates itself
so by playing in the space between symmetrical potential
and asymmetrical events.

Deleuze and Guattari's concept of "body without
organs" is an example of a techno-body-brain. Deleuze
and Guattari write, "Partial objects are the direct powers
of the body without organs, and the body without organs,
the raw material of the partial objects."[179] Deleuze and
Guattari's body without organs is not the sum of
its partial objects. The body without organs is the

symmetrical potential, where its parts are asymmetrical events. In Deleuze and Guattari's philosophy, it is desire that connects the body without organs to its parts.

> The body without organs is the immanent sub-stance, in the most Spinozist sense of the word; and the partial objects are like its ultimate attributes, which belong to it precisely insofar as they are the two material elements of the schizophrenic desir-ing-machines: the one as the immobile motor, the others as the working parts; the one as the giant molecule, the others as the micro molecules—the two together in a relationship of continuity from one end to the other of the molecular chain of desire.

> The chain is like the apparatus of transmission or of reproduction in the desiring-machine. Insofar as it brings together—without unifying or uniting them—the body without organs and the partial ob-jects, the desiring-machine is inseparable both from the distribution of the partial objects on the body without organs, and from the leveling effect exerted on the partial objects by the body without organs which, results in appropriation.[180]

Deleuze and Guattari's philosophy, despite its sim-ilarity to symmetrical monism, still claims separation between the body and its tools, the whole and its parts.

Symmetrical monism claims that the entangled-being is both self and tool. Technology is not simply a collection of tools used by humans. Technology is the very matter which forms the self. Neither tool nor being has priority or dominance. One does not come before the other or fit inside the other. The entangled being is thus the techno-

body-mind, where each aspect of the entangled being is simultaneously a tool, a body, and the ability (manifested as play and desire) to become aware. Just as the entangled being is the self and the world as well as the self and the many, the entangled being is also the self and the tool.

The entangled being shares its techno-body-mind. The techno-mind-body of self A becomes a tool of the entangled being of self B. The *techno*-body-mind of self B becomes a tool of the many entangled beings, etc. The entangled being is self and world. As such, tools exist both inside the self and outside the self. The mind, the organs and the senses are tools of the many selves. In addition, the pencil, the contact lenses, the pacemaker and the cell phone are tools. These tools are not simply used *by* the entangled being. They are the substance of the entangled being itself.

Symmetrical Monism claims that technology does not reveal truth, as Heidegger claims. Technology, or the techno-body-mind is a tool which creates itself. It is the essence of *homo generator*: a self who creates the self by becoming aware of itself as uncertainty, potentiality, play and desire. The being of technology is thus the being of art, the entangled being, the being of *homo generator*. The quantum artist is simply that being who chooses to observe the being of art and allows herself to play with her desire to observe, imagine and create.

2.6 Uncertainty

The dominant language games of modernism and post-modernism have placed selves, artifacts, and technology into a system which yields truth, transcendence, and emancipation. Truth is meant to be certain, definite and

able to be proven and justified. Heidegger points out that philosophy seeks truth, where "The metaphysics of the modern age begins with and has its essence in the fact that it seeks the unconditionally indubitable, the certain and assured, certainty.[181] Aristotle describes beauty, a characteristic of art, as certainty:"The chief forms of beauty are order, symmetry and definiteness"[182] Heidegger also claims that the self becomes aware of his consciousness and believes that he finds in his consciousness a kind of certainty where"The subjectness of the subject is determined out of the sureness, the certainty, of that consciousness.[183]

Nietzsche's will to power regards the creation and declaration of certainty as a necessary component of the will. Nietzsche's reliance on certainty as a kind of possession of the real is representative of the underlying attitude of contemporary society. For Heidegger, "Thus, according to Nietzsche's judgment, certainty as the principle of modern metaphysics is grounded, as regards its truth, solely in the will to power, provided of course that truth is a necessary value and certainty is the modern form of truth."[184]

Heidegger claims that an understanding of truth which is based in correctness or possession is erroneous. Heidegger's truth is an unveiling of uncovering of what is already there. The essence of technology, Heidegger claims, is also to unveil or uncover. Truth and technology, then, have a similar essence. Heidegger writes:

> The Greeks have the word *aletheia* for revealing. The Romans translate this with *veritas*. We say "truth" and usually understand it as correctness.
>
> But where have we strayed to? We are questioning concerning technology, and we have arrived now at *aletheia*, at revealing. What has the essence of

technology to do with revealing? The answer: everything— Technology is therefore no mere means. Technology is a way of revealing.[185]

Heidegger claims truth is the activity of uncovering or revealing:

> If we translate *aletheia* as "unconcealment" rather than "truth," this translation is not merely more literal; it contains the directive to rethink the ordinary concept of truth in the sense of the correctness of statement and to think it back to that still uncomprehended disclosedness and disclosure of being.[186]

Heidegger claims that *aletheia* is the activity of coming into a clearing or creating a clearing. Heidegger writes, "Truth signifies sheltering that clears as the basic characteristic of Being... Because sheltering that clears belongs to it, Being appears primordially in the light of concealing withdrawal. The name for this clearing is *aletheia*."[187]

Heidegger's truth is the activity of seeing clearly what is already there. It is the activity of allowing being to present itself in its. Art, Heidegger claims, is also a method of revealing the truth. Heidegger writes, "The artwork opens up in its own way the Being of beings. This opening up, i.e., this revealing, i.e., the truth of beings, happens in the work. In the artwork, the truth of beings has set itself to work. Art is truth setting itself to work."[188]

Today's common sense interpretation of art equates art with certainty and truth. Although the postmodern art world has shifted the meaning of Truth towards truths or criticism, the postmodern art world still uses truths

and criticism in order to refer to Truth. Moreover, the
art world has embraced technology, which has continu-
ously been regarded as a source of certainty and valid-
ity, even in the face of pluralism, poverty and violence.
As such, technology, more so than any other essential
characteristic of *homo generator*'s being, has been treated
as a method of transcendence. The marriage of art and
technology should be, under the language games of the
dominant paradigms, the perfect marriage of truth, cer-
tainty and transcendence. Postmodernism's end goal is
absolute emancipation: freedom from pain, suffering and
death! Schirmacher writes, "Our culture is fascinated by
the immaterial body which knows no ageing process and
may overcome even death. In virtual reality we could be
with Jesus Christ in Golgotha or with Marilyn Monroe,
any day, no stinking sweat, no salty tears, no inner-body
noise."[189] As the great emancipator, technology embod-
ies a future-oriented and transformational identity. The
Modern paradigm, which demands that technology pro-
duce certainty and transcendence, persists in Lotringer's
"New Art Order."

The entangled being's technology, however, sim-
ply creates. It creates without regard to any concept of
unveiling, truth, beauty, correctness, etc. The entangled
being remains in a constant state of becoming. As such,
the entangled being resides in a realm of uncertainty,
transition and potential. The entangled being does not
reach for certainty. On the contrary, it observes itself as
the uncertain. The entangled being exists as symmetrical
potentiality. Simultaneously, the entangled being exists
as a series of asymmetrical events, a series of moments of
becoming. These moments are not stacked vertically and
horizontally. Moments of becoming exist everywhere,

on all planes, at all times. Each moment of becoming *is* symmetrical potentiality, momentarily observed, and thus imagined and created as an asymmetrical moment of becoming.

Each moment of becoming has the look of certainty, according to its creator. The look of certainty derives from the human's ability to directly observe it. In doing so, the human has a sense of control over definite and finite matter. However, this control is not total. Each moment, which is observed as an asymmetrical event, simultaneously exists in the form of every possibility event, at every time in every place. The look of "certainty" of an asymmetrical event is a transient certainty which is entangled with all potential uncertainty.

Homo generator, when she observes herself as such, does not deny, embrace or fight uncertainty. The entangled being is uncertainty. When she observes herself *as* uncertainty, she imagines and creates herself as uncertainty. The artifact of the entangled being is *homo generator*'s techno-body-mind. Schirmacher writes, "*Homo generator* realizes the hope and the angst of the post-Hegelian philosophers, a *Dasein* beyond metaphysics, a human being that needs no Being, no certainty, no truth."[190]

Homo generator becomes herself when she recognizes that she no longer needs herself. When the entangled being observes herself as complete uncertainty, without distinction from tool, being or world, she will, at that moment, give birth to the artist, to quantum art and to *homo generator*.

How can the self observe itself without seeing a reflection of itself as a certain, asymmetrical event? Baudrillard writes:

> We are indistinguishable from ourselves in sleep, unconsciousness and death. This consciousness, which is something altogether different than belief, comes more spontaneously from challenging reality, from siding with objective illusion than from objective reality. This challenge is more vital for our survival and for the survival of the species than the belief in reality and existence, which are spiritual consolations for us in another world.[191]

The entangled being, the being of art, is the intentionality, the directed consciousness, which looks upon itself in its waking hours and recognizes that its reality is not solid and finite, but uncertain, infinite and potential. The being of art is the consciousness, which observes without criticism, judgment, naming or knowing. The being of art feels no panic in uncertainty. It recognizes itself in uncertainty and as uncertainty. It finds, in uncertainty, its home. And in the home of uncertainty, the being of art observes, imagines and creates. The name for the activity that moves between observing potentiality and creating asymmetrical events is play. Play is the activity of desire.

2.6.1 The Desire for Uncertainty
How does the entangled being observe the being of art? Is it hard to see, due to its uncertain nature? Has the being of art been squashed due to its conflict with

contemporary paradigms of thought and activity? Does the entangled being observe itself only indirectly, as through dreams and meditation?

The entangled being observes the being of art through desire. This desire is the ever-present activity of the body and its tools, including its organs, its brain, its senses, etc. This desire is not hidden, particular or special. In fact, this desire is common to every human and exists at all times. The desire reaches toward uncertainty and with uncertainty, it creates uncertainty. This desire is indifferent toward the demands of everyday life. It cannot be turned off and it cannot be destroyed.

Philosophers have understood desire as a behavior or activity of the self. Symmetrical monism suggests that the substance or form of self (the entangled being) and the activity or behavior of self (desire) are one. Schopenhauer writes, "force and substance are inseparable because at bottom they are one."[192]

The desire of the entangled being, as understood as both activity and substance, is not the instinct, which Schopenhauer calls the "will." Schopenhauer demands respite from the torture of the individual will. His thoughts concur with this Hindu scripture, "They are forever free who renounce all selfish desires and break away from the ego-cage of 'I,' 'me,' and 'mine' to be united with the Lord. Attain to this, and pass from death to immortality."[193] The desire of the entangled being is *not* Schopenhauer's instinct toward survival. Although the being of art creates, which generates more beings, the being of art does not create out of fear of death. It is indifferent towards death. It has no need to survive.

The desire of the entangled being is not the will to power of which Nietzsche writes. Nietzsche's will dominates Schopenhauer's will, and it desires to have and to have more, regardless of individual survival, as he writes:

> Even the body within which individuals treat each other as equals...will have to be an incarnate will to power, it will strive to grow, spread, seize, become predominant—not from any morality or immorality but because it is living and because life simply is will to power.[194]

Nietzsche's will is a special condition, found only in the being that is capable of abstract thought. Nietzsche writes, "[It is] in intellectual beings that pleasure, displeasure, and will are to be found."[195]

The desire of the entangled being, the being of art, is common to all beings and indifferent toward power. The desire of the being of art is essentially powerless. It regards each moment of creation as a transition in which it is acted upon at the same moment that it acts upon another. The being of art does not hold or collect these moments of becoming. Holding this desire would be like trying to hold the ocean.

Nietzsche's will to power depends upon Newtonian ideas of a definite matter which can be possessed in a definite space-time. The being of art does not recognize truth, certainty and definite matter. It does not resist or embrace possession, truth or power. Possession, truth and power are simply meaningless to the being of art.

In psychoanalysis, Jacques Lacan refers to desire as
the feeling which is left over after demands have been
met. It is the unending source of yearning which can
never be satisfied. It is related to an absence or lack.
Lacan writes, "The domain of the Freudian experience
is established within a very different register of relations.
Desire is a relation of being to lack. This lack is the lack
of being properly speaking. It isn't the lack of this or that,
but lack of being whereby the being exists. This lack is
beyond anything which can represent it."[196] Slavoj Zizek
points out that the accumulation of Lacanian desire sim-
ply creates more desire. He writes, "Desire's *raison d'être*
is not to realize its goal, to find full satisfaction, but to
reproduce itself as desire."[197]

The desire of the entangled being does create desire,
but this creation is not causal or cumulative and it is not
based on a lack, absence or need. Desire is the entangled
being's most basic activity, like the movements of the
autonomic nervous system. The entangled being's desire
is infinite and self-generative. It emerges from itself, from
the uncertainty and potential of the symmetrical realm.
It is the desire of the entangled being which observes the
uncertain and thus imagines and creates the uncertain.
Desire is thus the force that creates mimesis (observation,
imagination and creation). The word "creation" is, how-
ever, misleading. It denotes a cause, a goal and a product.
It is better to use the word "play."

Within the realm of the uncertain, desire plays. The
play of desire is the act of observing uncertainty, imagin-
ing uncertainty and creating uncertainty. The entangled
being desires, as it stands face-to-face with potentiality,
with every possibility in its infinite reach. It responds to
its desire by playing, by jumping back and forth between

observing symmetrical potentiality, imagining and creating asymmetrical events. The entangled being desires to play as clearly as the lungs desire oxygen or the brain desires glucose.

Why then, does it appear to be difficult to access the entangled being's desire, the being of art? It appears to be hidden, only because the contemporary techno-body-brain ignores it. Nearly every facet of contemporary adult life, with the possible exception of the sexual act, is dominated by the continual denial of desire. Even contemporary art has become regulated to such an extent that desire has become secondary to career. Lotringer observes:

> Art is being instrumentalized beyond recognition. It's becoming ancillary to capitalism. In the 80's, artists played with the post-modern idea of the "death of the author." It didn't occur to them that they were already post-mortem. It spite of everything, they believed they could still be some kind of cultural heroes. But there is not more artist life, only another regimented profession.[198]

Desire's play is not absent in contemporary life. It is simply refused. In order for *homo generator* to observe uncertainty and thus realize itself as *homo generator*, it simply needs to allow his desires to enter. The entangled being allows his desires by actively choosing to observe his senses, his desires, his tools and his essential uncertainty.

The entangled being's senses, like every other part of the entangled being, are created through observation. The continued ignorance of the senses results in the disappearance of the senses. The entangled being no longer hears the ticking of a clock, which he ignores. The disap-

pearance, however, is not a reflection of the presence or lack thereof, of the ticking or the clock. The disappearance is the reflection of the techno-body-brain's lack of observation. A conscious act of observation brings the sense as well as the noises and objects "back."

The entangled being thus becomes aware of her desires by becoming aware of her senses. The entangled being relies on her senses in order to observe her desires and in doing so, places great importance and trust in her senses. Schirmacher writes, "Homo generator's body politics is to see/hear/smell/touch/taste/think before you act, it claims aesthetic perception as the basis of comprehending and interaction."[199]

The desire of the being of art, as observed through the senses, is the desire to *play*. This desire is the substance of every self, including the self that is tool, the self that is brain, the self that is world, the self that is the many, the self that is *homo generator*, the self that is organ, the self that is veins and cells and bile. The desire of the being of art is the everyday desire, of every form of matter, to play and play and play.

2.6.2 The Fear of Desire

The entangled being, whose essence is that of *homo generator* and the being of art, continuously creates through the act of desire/play. This desire to create is not related to the substance or activity of creating truth or belief. The creation of truth and belief are the demands of the scientific method, the market and academia. These demands are fed by fear in which "the constant assertion of belief is an indication of fear," as Krishnaminurti writes.[200]

The desire to create is not born out of a lacking, a fear of death or a denial of pain. Nietzsche accuses artists of attempting to lighten or mitigate the pain of life. In doing so, they simply distract men from productive work. Nietzsche writes:

> There are, to be sure, several things to be said against their means of alleviating life: they soothe and heal only provisionally, only for a moment; they hinder men from working for a real improvement in their conditions by suspending and discharging in a palliative way the very passion which impels the discontented to action.[201]

Nietzsche also accuses the artist of glorifying the positive, perhaps as a way of avoiding the negative (death). He writes, "*The good and the beautiful*—Artists continually glorify—they do nothing else: they glorify all those conditions and things which have the reputation of making man feel for once good or great or intoxicated or merry or wise."[202]

Symmetrical monism claims that the being of art does not avoid, celebrate or ameliorate death and its associated pains. Nietzsche's ideas about art as deflection, distraction or glorification are a reflection of the needs of the dominant paradigms and their language games, and not a reflection of the being of art. Symmetrical monism claims that birth and death are asymmetrical moments of becoming, transition and creation. The being of art observes these moments, imagines them and creates them through play and desire. They are moments of uncertainty, just like each and every other moment of becoming.

The entangled being does not create in order to avoid death and pain. The entangled being creates despite pain and death. This is not to say that the entangled being feels no pain. Rather, the entangled being accepts death (and birth) as another (uncertain) moment of becoming and does not attempt to possess it, judge it or control it.

Acceptance toward death is the primary conflict between the contemporary human and the desires of the being of art. The contemporary human does not believe that his desires continue despite the arrival of death. He is embarrassed and sometimes horrified by his desires. Instances of the activity of creation resulting in destruction, pain and horror are abundant. In cases of cancer, the body continues to create, even when creation manifests as a tumor. Science fiction predicts the human creation of monster-clones who have no empathy and destroy mankind.[203] Germs, diseases and bacteria create faster than humans are able to observe (and thus control). Populations create even when there is no food, land or reason to live.

The fear of the entangled being's desire is thus based in the implicit acknowledgment that desire is not related to survival, power, truth or any other measurable or predictable phenomena. The desire of the entangled being must either be unclear or untrue and thus dangerous. Plato claims that the artist is incapable of truth. He writes, "Then the imitator, I said, is a long way off the truth"[204] Nietzsche argues, "*The artist's sense of truth*—. In regard to knowledge of truths, the artist possesses a weaker morality than the thinker."[205] Further he writes, "[The artist] thus considers the perpetuation of his mode of creation more important than scientific devotion to the true in any form, however plainly this may appear."[206]

The entangled being's desire is uncertain and indifferent toward its own death. As such, it is misconstrued as "unclear thinking" and thus feared. However, this fear is a reflection of the needs of the dominant language games, which call for certainty, power and truth and not a reflection upon the desires of the being of art.

The fear of the desires of the entangled being is manifested in every dominant paradigm of contemporary life. The fear is so prevalent that it is accepted as common sense. It is precisely this common sense which assumes an understanding of truth and judges art based upon its certainty which must be deconstructed in order to acknowledge the being of art. Heidegger writes,

> We want the actual "truth." Well then—truth! But in calling for the actual "truth" we must already know what truth as such means. Or do we know this only by "feeling" and "in a general way"? But is not such a vague "knowing" and our indifference regarding it more desolate than sheer ignorance of the essence of truth?[207]

Ignorance toward the being of art, then, is a more positive attitude than a common sense certainty which fears the being of art. This fear is reinforced on a daily basis and creates itself at the level of the body.

The teacher tells the young student to be still and quiet. The teenage girl tells her boyfriend that she wants to wait. The cubicle worker tells his boss that he loves his job. Our life is regimented by an endless series of denials of desire. These activities of denial are not simply theoretical. They are denials that present themselves in the body. Our bodies become the artifacts of fear.

2.6.3 Choosing Uncertainty

Why should the contemporary human affirm her desire to play, when her desires will not ensure her survival, protect her interests, fulfil a lack or generate power? And what is the philosophy of the individual who affirms her desires which stem from uncertainty and generate uncertainty? Reason calls for certainty and truth and as such, the being of art appears unreasonable. Kant claims that the pursuit of reason is the highest human endeavor. He writes, "All our knowledge begins with the senses, proceeds then to the understanding, and ends with reason. There is nothing higher than reason."[208] Is art in opposition to reason? Or is art a lower endeavor, an activity based in the senses, necessarily less moral and less powerful than the activity of the mind?

Symmetrical monism claims that the contemporary human will affirm his desires when he chooses to observe himself as an uncertain (entangled) being, and from the perspective of the uncertain being, reason loses its meaning. Homo generator's acceptance of himself as an uncertain being represents a paradigm shift between a Newtonian world-view and a quantum world-view. In the quantum world-view, definite matter and certainty retain only the history of their meaning. In a quantum world-view, the being of art is not measured by reason or truth.

The quantum artist recognizes and accepts the being of art through the activity of choice. He chooses to allow the activity and substance of desire which plays with potentiality and creates moments of becoming in the form of asymmetrical events. The senses are not a low or high activity. The senses are one of many tools. These tools can be activated in order to allow the self to observe the being of art. The self cultivates these tools by choosing them.

In order to allow for uncertainty, *homo generator* must make an intentional choice to allow the observation, imagination and creation of the desires and play of the being of art. When the being of art observes itself and finds itself in the form of uncertainty, it will no longer fear the loss of certainty. Without the fear of the loss of certainty, the desire for truth as well as the fear of death becomes meaningless. The affirmation of the being of art is thus the affirmation of choice, uncertainty and acceptance towards death, which is understood to be simply another moment of becoming (like birth).

What is the philosophy of *homo generator*? Homo generator shares an affinity with Spinoza's idea of *amor dei intellectualis* (intellectual love of god). However, Spinoza's oneness is certain and knowable. As such, Spinoza's oneness still resides within a Newtonian world-view. Spinoza's *amor dei intellectualis* contains a hope for transcendence. Through self-knowledge, the self can know God and therefore be freed from the pains that stem from misunderstanding. In addition, Spinoza regards free will as a delusion of the mind. Spinoza writes, "[M]en think themselves free, because they are conscious of their volitions and their appetite, and do not think, even in their dreams, of [those causes]."[209]

Homo generator's philosophy must allow for desire, play and the ability to choose uncertainty. *Homo generator*'s philosophy must also allow for indifference toward transcendence. Nietzsche's *amor fati* (love of fate or necessity) denies the transcendental nature of understanding. *Amor fati* challenges the philosopher to regard life as necessary and positive, despite the fact that the self is incapable of understanding. Nietzsche writes,

My formula for greatness in a human being is *amor fati*: that one wants nothing to be different, not forward, not backward, not in all eternity. Not merely bear what is necessary, still less conceal it—all idealism is mendaciousness in the face of what is necessary—but love it.[210]

Amor fati partly describes the activity of *homo generator*'s desire. Homo generator creates without escape plans. His desire plays without regard to intellectual, spiritual or scientific truth or understanding. Homo generator does not judge, evaluate, criticize or otherwise possess certainty. Nietzsche writes,

> I want to learn more and more to see as beautiful what is necessary in things; then I shall be one of those who make things beautiful. *Amor fati*: let that be my love henceforth! I do not want to wage war against what is ugly. I do not want to accuse; I do not even want to accuse those who accuse. [211]

Homo generator's philosophy differs slightly from Nietzsche's *amor fati*, in that *homo generator* does not regard the world as necessary or definite. Heidegger argues that Nietzsche's idea of the self's will is based in the activity of possessing power, an activity of creating a semblance of certainty. Heidegger writes,

The will is not a desiring, and not a mere striving after something, but rather, willing is in itself a commanding [cf. *Thus Spoke Zarathustra*, parts I and II; see also *Will to Power*, Aph. 688. 1888]. –Commanding, which is to be sharply distinguished from the mere ordering about of others, is self-conquest and is more difficult than obeying.[212]

Homo generator regards events not as necessary but uncertain. It is not a temporal uncertainty which will be remedied through understanding and, thus, one day rendered certain, knowable or capable of being commanded or possessed.

Homo generator's philosophy is thus *the choice of uncertainty. Homo generator* observes herself, his senses and

desires, with all of his uncertainty, pain and confusion. She responds to his uncertainty by playing and creating uncertainty. The act of play is the act of choice. In the place of judgment, criticism and reflection, *homo generator* chooses to observe, imagine and create. Schirmacher writes, "What can a self, which by definition doesn't care about having a fixed outlook and a secure place in society do? It has to become a creative self."[213]

Homo generator becomes *homo generator* when she makes the choice to observe the being of art, affirm her desires and allow herself to play. She says "Yes, not only do I stop denying my desire, my desire that ceaselessly continues even in the face of horror, not only do I accept my desire, my desire that persists even in the moment of death, I will *choose* my desire, my desire for play and uncertainty!"

Homo generator's desire springs from her essential uncertainty, which was previously occupied by the activity of fear. Homo generator's desire is the being of art, the desire to observe, imagine and create: the desire to enact mimesis. It is her desire that plays with the symmetrical potentiality of life, with all of its uncertainty, danger and misery.

Chapter Three:
Ethics

3.1 What is quantum art?

Quantum art is the artifact created when *homo generator* becomes conscious of herself as the being of art, as the entangled being, as pure uncertainty. Homo generator is itself an artifact, an object of quantum art. The quantum artist refers to the being which creates artifacts through observation of the being of art as entangled uncertainty. When she is conscious of the being of art as such, she is involved in the symmetrical potential of observation, imagination and creation. She creates an asymmetrical event by choosing a particular event and by applying intentionality toward the event. The asymmetrical event is called quantum art.

Is there a difference between art and quantum art? All humans contain the being of art. All art results from the choices of the entangled being. However, the contemporary artist does not believe in the uncertain, entangled being. Thus, when she creates an asymmetrical event, she does not observe the being of art which is the entangled and uncertain symmetrical potential. She does not create in response to her curious, playful and uncertain nature. She creates art despite her curious, playful and uncertain nature.

The contemporary artist observes the being of art in its partial, definite and seemingly certain states. She searches for this type of art and evaluates art as such. Further, this certain state is defined not by her but by the dominant language games of the twenty first century's "New Art Order." When she observes art as such, she

creates an artifact which is designed to satisfy the desires of the dominant language games. In doing so, she ignores the being of art and transforms herself into the spectator and the evaluator. This is how the contemporary artist becomes a non-artist without ever noticing. Giorgio Agamben writes, "The non-artist, however, can only *spectare*, that is, transform himself into a less and less necessary and more and more passive partner, for whom the work of art is merely an occasion to practice his good taste."[214] As such, the "New Art Order" is primed for its economically and intellectually productive activity of criticism and evaluation.

Contemporary artists serve three major systems of thought which dominate the twenty first century art world: the scientific method, academia and the market. Contemporary artists justify their creations by providing proof of their validity, which is an effect of the scientific method and the market. Proof comes in the form of exhibitions, theory, language, criticism and truth, which are each consequences of academia. Proof also comes in the form of monetary value, which is an answer to the demands of the market. Any moments of potential uncertainty are used by the system in order to create certainty. The artist, along the way, plays a passive role. Lotringer writes:

> Obstacles and oppositions, in reality, are used by the system everywhere in order to bounce ahead. Art in the process has lost most of its singularity and unpredictability. There is no place anymore for accidents or unforeseen surprises, writes Chris Kraus in *Video Green*. "The life of the artist matters very little. What life?" Art now offers career

benefits, rewarding investments, glorified consum-
er products, just like any other corporation. *And
everything else is becoming art.* Roland Barthes used
to say that in America sex was everywhere, except
in sex. Now art is everywhere, *even* in art.[215]

Quantum art is the artifact of the experience in
which *homo generator* observes her desires for uncertain-
ty, allows her desires and plays with her desires. Quan-
tum art is the artifact created in the midst of the differ-
end, where the artist is aware of the differend. A quantum
artist is aware of the language games of the dominant
paradigms, but directs her attention (intentionality) to-
ward the being of art. For example, the language games of
the "New Art Order" (as well as academia in general) de-
mand criticism (an indirect demand for truth). Lotringer
suggests that there is "no glorious alternative to the plea-
sure of criticizing, just a long patience: keep on a separate
course, deliberately choosing to differ from something
else rather than oppose it."[216] The quantum artist does not
actively oppose the demands of the dominant language
games. She simply chooses to direct her attention toward
her own desires. To do so, she must be able to differen-
tiate between her own desires and the "New Art Order."
She must become aware of the differend.

The being of art does not recognize the demands
of the dominant language games. The quantum artist's
silence toward the dominant language games is not a
matter of resistance or disbelief. To the being of art, the
dominant language games are null. The quantum artist is
indifferent because she is aware that uncertainty can-
not be defined, contained, divided, proven or otherwise

made into truth. The quantum artist makes a decision to become aware of the being of art and in doing so, becomes indifferent toward the dominant language games of the twenty first century.

The contemporary artist is not a victim. She is not beleaguered and oppressed by outside rules and rituals. The hipster's claim to struggle in the face of consumerism, pluralism and a host of other imaginary enemies, is a farce. In conversation with Baudrillard, Aude Lancelin says, "It is rather astounding that all contemporary American marketing block-busters, from The Matrix to Madonna's new album, explicitly claim to be a critique of the very system which massively promotes them." Baudrillard responds:

> That is exactly what makes our era so oppressive. The system produces a *trompe-l'oeil* negativity embedded in products of the spectacle just as obsolescence is built into industrial products. It is the most efficient way of locking out all genuine alternatives. There is no longer any eternal Omega point to anchor one's perception of the world, no antagonistic function; only a fascinated adhesion. One should know, however, that the more a system nears perfection, the more it approaches the total accident.[217]

Artists of the "New Art Order" are the engines of academia, the scientific method and the market. They build the system to which they claim to despise. In doing so, they generate art's accident: the nullity of contemporary art. Worst of all, the same contemporary artists who blindly adhere to the system, who ignore the being of art

and who fail to address their own questions, claim glory. They consider their work as heroic and demand applause. Lotringer writes:

> Who can doubt that contemporary art today is besieged by hostile audiences and badly in need of reinforcement? Aren't artists and dealers, curators, critics, collectors, sponsors, speculators, not to mention socialites, snobs, spongers, crooks, Parasites of all kinds, all feeding off art crumbs, heroically sacrificing themselves to redeem art from shoddy consumerism, just like Russian "liquidators" putting down the sarcophagus on the Chernobyl reactor at the cost of their lives? It wasn't enough that art would have become a huge business, a mammoth multinational corporation with its professional shows, channels and conventions, it still had to be treated with utter reverence, even awe.[218]

The contemporary artist has adopted the rules and rituals of the dominant languages games to such an extent that she applies these rules to herself and evaluates herself as such, without any provocation from the system. She rewards and punishes herself, regardless of her choices or limitations. The contemporary artist is the tool of the "New Art Order," a system destined for no other goal than to make profit and to create the illusion of certainty.

The quantum artist must choose to stop applying the rules of the dominant language games to herself, the being of art and her artifacts. She starts by recognizing the differend. The differend between the dominant language games and the being of art is particular in that it does not

create any conflict for the being of art. The non-conflict differend generates a flurry of activities and beliefs which continuously encompass the space reserved for art, causing the being of art to be ignored. The first step to becoming a quantum artist is to recognize the non-conflict differend and the systematic method in which the being of art is ignored.

3.2 The Differend that Incurs No Conflict

The non-conflict differend is a differend that invokes no conflict, involves no victim and does not necessitate action, judgment or decision. A differend is a situation in which the rules of judgment (language games) of party A are applied to party B, though party B does not recognize the language games of party A.[219] The non-conflict differend goes unnoticed because party B is unperturbed by the consequences of the language games of party A.

The being of art has long been defined, and thus understood and created, according to the language games of the dominant paradigms. Lyotard writes, "A phrase, even the most ordinary one, is constituted according to a set of rules (its regimen)".[220] In order to observe the desires of the entangled being, the artist must recognize herself and her own desires. To do so, she must first decipher the difference between her own desires and the will and consequences of the dominant language games. Lyotard writes, "The free examination of phrases leads to the (critical) dissociation of their regimens (the separation of the faculties and their conflict in Kant; the disentanglement of language games in Wittgenstein)."[221] The quantum artist must discover the rules of the dominant language games for the sole purpose of distinguishing them from her own being.

3.2.1 The Scientific Method, Truth and Newness

There is a non-conflict differend between the entangled being and the dominant language games of the scientific method. The scientific method calls for experiment, observation or measurement, documentation and reflection and finally, hypothesis.[222] Aristotle's method of scientific reasoning functions today as a set of guidelines that are so thoroughly imbedded that they are now regarded as common sense. Heidegger writes,

To be sure, it was Aristotle who first understood what empeiria (experiential) means: the observation of things themselves, their qualities and modifications under changing conditions, and consequently the knowledge of the way in which things as a rule behave.[223]

The end-goal, the hypothesis, has an explanatory function and creates a set of rules. It is this activity which the entangled being does not recognize.

In the scientific method, hypothesis cannot be reached without experimental observation or measurement. Heidegger calls science's method of creating truth/reality the activity of "entrapping-securing." He attests to its authority as well as its limitations.

Because modern science is theory in the sense described, therefore in all its observing [Be-trachten] the manner of its striving-after [Trachtens], i.e., the manner of its entrapping-securing procedure, i.e., its method, has decisive authority. An oft-cited statement of Max Planck reads: "That is real which can be measured." This means that the decision about what may pass in science, in this case in physics, for assured knowledge rests with the measurability supplied in the objectness of nature and, in keeping with that measurability, in the possibilities inherent in the measuring procedure.[224]

An experimental hypothesis, rule or truth which is verified by observation and measurement is regarded as new knowledge, where the discovery of knowledge is not valid unless it is both true and new. If an experiment uses the same method and arrives at the same result as past experiments, this experiment belongs to the category of validation of past truths. It is important, but it does not achieve the status of new truth.

The value placed in truth, and therefore newness, is reflective of the value placed in certainty. Spinoza demonstrates the desire for certainty and truth in his essay, *Fragments of a Theory of Scientific Theory. Section B. Achieving Clear and Distinct Ideas,* Spinoza writes:

> — I shall set forth first our aim in it, and then the means to attain it. The aim, then, is to have clear and distinct ideas, that is, such as have been made from the pure mind, and not from fortuitous motions of the body. — But the best conclusion will have to be drawn from some particular affirmative essence, *or* from a true and legitimate definition. — So the right way of discovery is to form thoughts from some given definition. — To be called perfect, a definition will have to explain the inmost essence of the thing, [225]

The plastic artists have embedded the scientific method (including the value of new truth and certainty) into their understanding of art. They have ingested the scientific method to such an extent that an artist may regard this understanding as instinctual and intuitive. The scientific method has become the artist's methodology, ontology, proof of validity and function. The contempo-

rary artist believes that he creates new knowledge (new truths, new reflections or new criticisms). Lotringer and Virilio agree, "art is a creation of knowledge, just like concepts."[226]

Gilles Deleuze likens the production of philosophical concepts to the creation of artworks, "A scholar invents and creates as much as an artist."[227] By this statement, Deleuze also infers that an artist invents and create as much as a scholar. Their inventions are similar in that they both fall into the realm of new knowledge.

Deleuze defends himself against the unflattering picture of the philosopher as a disinterested observer who critiques the already created creations of art and science. Dirac, a quantum physicist, illustrates the disdain for philosophy to which Deleuze reacted. Dirac calls philosophy "just a way of talking about discoveries that have already been made."[228]

Inherent in Deleuze's claim are the rules of science, philosophy and art. All endeavors (science, philosophy and art) must strive for the creation of new knowledge. New knowledge is proven via the scientific method. Artists and philosophers must incorporate the scientific method in order to remain valid.

The artist (generally speaking) does not produce books or lab results which incorporate the scientific method into her creation via statistics or citations. The artist produces artifacts. She must then prove that artistic artifacts are a certain form of new knowledge. She proves herself through the standard vehicles of evaluation: the market, academia and art theory.

In the search for new knowledge, newness has becomes a goal in and of itself. What better way to become new than to attach oneself to new technology? This is the

primary reason why the "New Art Order" shows excite-
ment toward new media. Contemporary artists do not
throw themselves into the uncertain realm of new tech-
nologies in order to experience the thrill of the unknown
(though clearly, many do). The dominant reason for the
inclusion of new media in the "New Art Order" is the
convenient assumption that technology is direct proof
of newness.

Other forms of newness include appropriation, crit-
icism and contemporary philosophy ("theory"). Attach-
ing oneself to contemporary philosophy serves several
purposes. Published contemporary theory is already
new. It is a product that oozes truth and validation and is
thus incredibly useful to the "New Art Order." Lotringer
describes the "New Art Order"'s consumption of theory
as such:

> That they would be just skimming through the
> theory and dropping names is another story alto-
> gether, although it definitely is part and parcel of
> the "theory effect" that swept over the American
> art world and academic circles, the mixture of envy
> and anxiety, of nervous excitement and ravenous
> desire, the exhilarating sense of intellectual power
> it provided, the genuine passions it elicited; also the
> impatience, spite, rage, resentment that accompa-
> nied it or followed it, all compacted in this phe-
> nomenon, French theory.[229]

Artists have set up various methods for the evalua-
tion and validation of new truths. French theory became
a source of validation in the late 1980s and remains a
force. Other sources of validation include exhibitions,

published criticism, academic position and market value. Artworks that fall outside of the paradigm of truth and evaluation of truth are not recognized as art. They are either ignored altogether, or named "outsider art," design, craft or hobby.

The sophisticated postmodern artist no longer admits to his belief in art's direct relation to truth and the evaluation of truth. Pablo Picasso predicts the postmodern artist's attitude in the following quotation: "We all know that art is not truth. Art is a lie that makes us realize the truth.[230] Despite the postmodern artist's distrust in art as a truth product, his activity betrays him. Instead of creating a truth, the postmodern artist intends to create an artifact (usually in the form of criticism) that refers to or points toward an external or historical truth. For this activity, theory has been extremely useful.

The non-conflict differend exists because the entangled being, the being of art, does not recognize truth, certainty or newness. Truth and certainty are disinterested ideas which are not felt, desired, encountered or sensed in everyday life. The entangled being has no need for the evaluation of truth or the establishment of certainty. Newness exists everywhere, at all times. All artifacts are asymmetrical events, which exist in a moment of becoming. The entangled being does not recognize newness, therefore, because there is nothing outside of newness.

The quantum artist is not hindered by methods of evaluation or proclamations of truth, certainty or newness. This is a non-conflict differend. The entangled being is simply indifferent towards certainty, newness, truth, and the evaluation of these ideas. The scientific method is dominant and the being of art produces no conflict. The desires and of the being of art are thereby ignored.

3.2.2 Language and Naming

There is a non-conflict differend between the entangled being and the dominant language games of word-oriented language. In *Remarks on Color,* Wittgenstein points out the difficulties of describing color with words. How can one know, for instance, if two people are seeing the same color, just because they both call it "red"? Each person may have a slightly different experience of the color, yet still, through common experience, they would both name the same object "red." Wittgenstein writes:

> One fact is obviously important here: namely that people reserve a special place for a given point on the colour wheel, and that they don't have to go to a lot of trouble to remember where the point is, but always find it easily.[231]

Further, once the name "red" is established, this same color-name is held in the subject's mind each time she thinks of "red." Wittgenstein writes, "Someone who speaks of the character of a colour is always thinking of just one particular way it is used."[232] The imperfect or general color names (red, blue, etc.) are used to describe objects in daily life. Does the observer's vision change, when he uses a necessarily flawed and limited word to describe nature? Wittgenstein asks, "Lichtenberg says that very few people have ever seen pure white. Do most people use the word wrong, then? And how did he learn the correct use?[233] Symmetrical monism claims that the observer's vision (and being) *is* changed by the words he uses, because each time he names an object as such, he imagines and creates the object as such.

Painters know that it is nearly impossible to describe a color in words. Words are finite and in comparison, colors seem endless. It is far easier to mix a color with paint than to attempt to explain it. If there are ten painters in a room and they are asked to paint the same reddish-brown cup, there will be ten finished paintings of differing colors. This is not due to inexperience or lack of skill. This occurs because light is a wave, which is not constant, definite or static. An object which is illuminated by light changes in color. Each painter stands in a particular asymmetrical point in space and thereby sees the light/color in a very particular and ever-changing form.[234]

Wittgenstein concludes that it is impossible to establish, through words, an objective account of the experience of color:

> Can I then only say: "These people call *this* (brown for example) reddish-green"? Wouldn't it then just be another word for something that I have a word for? If they really have a different concept than I do, this must be shown by the fact that I can't quite figure out their use of words.[235]

Monistic symmetry does not claim that it is impossible to describe the world objectively in words, although it seems obvious that this would be a futile attempt. Monistic symmetry claims that the being of art is indifferent toward the permanent, naming and defining activity of words.

Heisenberg laments that physicists must rely upon words that already exist. These words carry the prejudices, traditions and meaning of the past. Therefore, when attempting to create new concepts, the scientist or philosopher must always be aware of unwanted meanings or

words that have become meaningless. Heisenberg writes,

> When we speak about our investigations, about
> the phenomena we are going to study, we need a
> language, we need words, and the words are the
> verbal expression of concepts. In the beginning of
> our investigation, there can be no avoiding the fact,
> that the words are connected with the old concepts,
> since the new ones don't yet exist. Therefore these
> so-called prejudices are a necessary part of our lan-
> guage, and cannot simply be eliminated. We learn
> language by tradition, the traditional concepts
> form our way of thinking about the problems and
> determine our questions.[236]

There is a non-conflict differend which arises be-
tween the entangled being and the naming activity of
words. The word, in its general use, strives for clarity and
certainty through the activity of naming. The being of art
could desire, imagine, observe or create word artifacts.
But these asymmetrical moments of naming should not
be called "certain," for certainty implies permanence and
belief (which are needed for communication). The quan-
tum artist's asymmetrical moments are transient. They
are loved but not believed. They are created but not held.
They are birthed but they do not stay.

The being of art is not disturbed by the activity of
naming. When A and B name the object "red," they
do not inhibit the desires of the entangled being. The
entangled being observes the object's color, imagines the
objects color and creates the objects color simultaneously
to the self's continuous use of words and the activities of
naming. The entangled being becomes quantum artist

when she becomes aware of the non-conflict differend between language's dominant activity of naming and the observation of her own desires, senses, observations, creations and imagination.

3.2.3 Language and Truth

There is a non-conflict differend between language, truth and the entangled being. Language, due to its common naming capacity is often used to produce or point towards truth. Truth is variously understood as correctness, knowledge, beauty, love, god, objective or mathematical fact and/or understanding. In each case, truth is based in certainty. The inability to produce certainty and truth is marked as a failure. Wittgenstein remarks:

> Here I would like to make a general observation concerning the nature of philosophical problems. Lack of clarity in philosophy is tormenting. It is felt as shameful. We feel: we do not know our way about where we should know our way about. And nevertheless it *isn't* so. We can get along very well without these distinctions and without knowing our way about here.[237]

Heidegger believes that language has a separate existence than its mercenary activities of naming, proving, possessing truth and producing value. In Heidegger's understanding, language produces a truth which is not correctness but the revealing or uncovering of what is already there.

> Language still denies us its essence: that it is the house of the truth of Being. Instead, language

surrenders itself to our mere willing and trafficking as an instrument of domination over beings. Beings themselves appear as actualities in the interaction of cause and effect. We encounter being as actualities in a calculative *businesslike* way, but also scientifically and by way of philosophy, with explanations and proofs. Even something that is inexplicable belongs to these explanations and proofs. With such statements we believe that we confront the mystery, As if it were already decided that the truth of Being lets itself at all be established in causes and explanatory grounds or, what comes to the same, in the incomprehensibility.

But if man is to find his way once again into the nearness of Being he must first learn to exist in the nameless. In the same way he must recognize the destructions of the public realm as well as the impotence of the private. Before he speaks man must first let himself be claimed again by Being, taking the risk that under this claim he will seldom have much to say. Only thus will the pricelessness of its essence be once more bestowed upon the word, and upon man a home for dwelling in the truth of Being.[238]

Heidegger claims that "Language is the clearing-concealing advent of Being itself."[239] Further, he claims that language is not an attribute, activity or characteristic of the self. Language is the essence of self. Self becomes self through attention to language. Heidegger writes, "But man is not only a living creature who possesses language along with other capacities. Rather, language is the house of Being in which man ek-sists by dwelling, in that he belongs to the truth of Being, guarding it."[240]

Symmetrical monism claims that the entangled being becomes herself not through language but through symmetrical potentiality, through uncertainty. The entangled being becomes aware of her self as uncertainty and thus creates her self as uncertainty. Through the activity of becoming conscious (the activity of desire/intentionality) of symmetrical potentiality, the entangled being becomes her self. The name for this self is *homo generator*.

Baudrillard claims that language, in its dominant form, is used to create certainty, critical analysis and meaning. However, it can be used to create illusion, uncertainty and play. The latter is the form of language which Baudrillard refers to as "radical thought." It is a form of play and an expression of desire. Baudrillard writes:

> Meaning is always unhappy; analysis is by definition unhappy, since it comes from critical disillusion. But language is happy, even if it indicates a world without illusion or hope. This would be the definition of radical thought, even here: intelligence without hope but with a happy form. Critics, unhappy by nature, always choose the battlefield of ideas. They never see that, while discourse always tends to produce meaning, language and writing always make illusions-they are the vibrant illusion of meaning, the resolution of the misery of meaning by the happiness of language that is really the only political, or transpolitical act that someone who writes can accomplish.[241]

As a phenomenologist Maurice Merleau-Ponty claims that sensual and perceptual consciousness is primary. Thought, reflection and judgment, he argues, are

secondary to the act of experiencing the world. Thinking reconstructs or creates an image of the world, whereas sensual perception is a direct connection to the world. Perception is thus prior to language. He writes, "Yet, there is a world of silence, the perceived world. There is an order where there are non-linguistic significations"[242] John Berger argues that the act of seeing is the primary activity in which the self situates itself in the word. He writes, "Seeing comes before words. The child looks and recognizes before it can speak."[243] And, "The reciprocal nature of vision is more fundamental than that of spoken dialogue."[244]

Symmetrical monism does not claim that the sensual perceptions of the entangled being are primary or prior to thinking or language. Rather, symmetrical monism claims that the being of art is indifferent toward the naming properties of language. The entangled being plays with uncertainty, and this play does not exclude or precede other activities of the self, such as thinking, language and communication. In everyday use, language is oriented toward definition, truth, certainty, understanding and finally communication. The entangled being is thus indifferent toward the common manifestations of the activity of naming. The entangled being dwells in the house of desire and uncertainty: the substance and activity of the being of art.

3.2.4 Communication
There is a non-conflict differend between the being of art and communication. Word-oriented language, by nature of its finite and shared substance (a system of words), names and communicates. Words which cannot be

understood by others are noises. Noises are words that do not point toward and name a substance such that others can recognize that substance.

An asymmetrical event *could* take the form of a name-word. However, the entangled being does not posit this name-word as permanent, certain or true. The name-word is merely a moment of transition which will be followed by more moments of transition. The name-word, therefore, in the realm of the entangled being, loses its naming capacity. A word whose name is transient sometimes becomes a noise.

The differend between the being of art and the naming-operation of language renders the artifact (from the point of view of the dominant language games) into a series of noises. As such, the dominant language games regard the being of art as either silent, unable to speak or having nothing to say. In his introduction to *Art and Fear*, John Armitage writes:

> In our day, however, the question according to Virilio is whether the work of art is to be considered an object that must be looked at or listened to. Or alternatively, given the reduction of the position of the art lover to that of a component in the multimedia academy's cybernetic machine, whether the aesthetic and ethical silence of art can continue to be upheld.[245]

In Lyotard's discussion of the differend, he urges his reader to regard silence as a "phrase." He writes, "There is no non-phrase. Silence is a phrase."[246]

In the case of the silence of the being of art, art is not *silenced* by the dominant language games. Art is not

silent due to any conflict. The being of art, itself, does not recognize itself as silent. Art has only been named "silent" by the dominant language games because it does not sufficiently appear to be trying to communicate. Art is often considered silent because of its indifference toward naming, proving and communication. Art is not hurt by noise, words or the demand for communication. The being of art does not recognize itself by names, language or communication. It recognizes itself in uncertainty.

The "New Art Order" consistently commands art to speak, and in speaking, communicate and evaluate truth. However, the "New Art Order" also associates direct communication with realism, which is no longer acceptable (unless it is ironic, critical, appropriated or hyper-real). Art that directly communicates its content is regarded as illustration and not recognized as art. Contemporary art has thereby become elusive, although the unaware contemporary artist will contend that this elusiveness is organic. The result is that contemporary art is now surrounded by an onslaught of explanatory interpretations. Lotringer writes (sarcastically), "People generally assume that visual arts don't talk, hence the need for interpretations, commentaries, theory to supplement them. Making art must be a dumb activity."[247]

The dominant language games (including the games of contemporary artists) either do not recognize silent art (non-communicative or uncertain art) or they regard art as the activity of the idiot savant: someone who creates beautiful things but has no idea why or what it means. These artists necessitate translators. Artists who are displeased with this situation are forced to become their own translators. They generate a body of theoretical or explanatory texts.

In producing explanatory texts, the artist creates moments of asymmetrical symmetry which are designed to define and clarify their artwork. The artist then believes in his or her own creation of certainty and applies this certainty to her artwork. During this process, the being of art is ignored.

Agamben points out the uncomfortable postmodern condition, in which the artist finds himself attempting simultaneously to be the artist, the translator (a version of Kant's disinterested spectator-critic) and the public relations director. In the process, the artist's connection to his content is lost:

> The artist, faced with a spectator who becomes more similar to an evanescent ghost the more refined his taste becomes, moves in an increasingly free and rarefied atmosphere and begins the voyage that will take him from the live tissue of society to the hyperborean no-man's-land of aesthetics, in whose desert he will vainly seek nourishment and where he will eventually look like the Catoblepas in Flaubert's *Temptation of St. Anthony*, who devours his own extremities without realizing it.[248]

Because non-communicative art is not recognized by the dominant language games, it is always necessary for artists to have something to say. In addition, they must also find and keep an audience. If the artist admits that he has nothing to say or that he is indifferent toward his audience, his art is regarded as non-art. Worse he is labeled stupid, apathetic or crazy.

A differend exists between the entangled being and communication. This is not to say that he quantum artist

never communicates. Rather, the being of art, to which the quantum artist must become aware, does not need or desire communication. It is possible that the entangled being has nothing to communicate, which is to say that the entangled being does not desire to relate certainty to others.

Can the entangled being communicate without naming and pointing toward permanent moments of certainty? Can the entangled being communicate uncertainty? Can the entangled being observe without creating, imagine without observing or create without imagining? Can the entangled being communicate uncertainty without naming it, "uncertainty"? Herein lies the non-conflict differend. The entangled being creates asymmetrical moments which have the appearance of certainty and invoke the dominant language games to initiate their explanatory machines. Asymmetrical moments, however, are not certain. But the being of art does not correct the dominant language games by claiming, "No! Its name is uncertainty." The being of art does not recognize the dominant language games. It is the quantum artist who must become aware of the fallacy of the activity of naming uncertainty for the sake of communicating certainty.

3.2.5 Market

The most obvious non-conflict differend exists between the being of art and the market. This non-conflict differend is also the single most irritating and enticing force in the contemporary artist's practical existence. Lotringer writes, "Art has become some sort of black hole. The pull, the glamour, the giddiness of it all is too strong for anyone to resist. And at the same time it's just crude business

deals and shady calculations. It's become no different than anything else."[249]

The entangled being does not recognize the market. The status of an artifact, in terms of recognition or monetary compensation, in no way affects the entangled being's desires, sensations or awareness of uncertainty. However, the contemporary artist spends a great deal of energy nurturing his or her success in the New Art Order. He does not apologize for his interest in the market. Instead, he asserts that the market, empty in and of itself, is a vehicle that reflects the spiritual, political, ethical or otherwise truthful value of the art work. John Berger writes, "This value is affirmed and gauged by the price it fetches on the market. But because it is nevertheless 'a work of art'—and art is thought to be greater than commerce—its market value is said to be a reflection of its spiritual value."[250]

In order for the contemporary artist to achieve success in the "New Art Order," she must have her work evaluated and proved to be an original and new truth. To do this, she must exhibit his work and gather commentary. Through exhibition, the artist claims his work to be some kind of truth and invites evaluation of said truth, thereby participating in the "New Art Order." A work enters into the market place as soon as it is exhibited and/or recognized by the "New Art Order." Regardless of whether or not the artifact sells, a work that has entered the realm of the "New Art Order" instantly becomes a part of the market. Lotringer writes:

> However hard I try, I myself find it more and more difficult to separate art from the market, which has become its finality and destination.

> Many artists have creative ideas, even take real
> chances, but the ecstasy of value is now preempt-
> ing everything.[251]

The entangled being does not recognize the market.
The market represents evaluation, truth, certainty, tran-
scendence and emancipation. The entangled being is not
simply disinterested in the market. It does not observe
the market. Thus it does not imagine, desire or create
the market.

The non-conflict differend between the being of art
and the market becomes especially evident when the
artist becomes so involved in the activities of the market
that she entirely ignores the desires of the being of art.
She does not believe, however, that she ignores the being
of art. She replaces the being of art with the desires of the
market. She believes that her attention toward artworks
presented in the art market is an attention toward the
mystery of art. The mystery, however, to which artists
attend, is not the mysterious nature of being, but the
awe-inspiring accumulation of wealth and status. John
Berger writes, "The majority take it as axiomatic that the
museums are full of holy relics which refer to a mystery
which excludes them: the mystery of unaccountable
wealth." Virilio writes 'They have masked the failure or
the accident [of art] with commercial success.'"[252]

For Virilio, the accident of art is not negative. It is an
event that opens the artist's awareness:

> Failure is not a condemnation! It's not the same
> thing. Failure is failure. Failure is an accident. Art
> has tripped on the rug. In any case, you should not
> forget my logic of failure, my logic of the accident.

In my view, the accident is positive. Why? Because it reveals something important that we would not otherwise be able to perceive. In this respect, it is a profane miracle.[253]

Each non-conflict differend has the potential to expose the difference between the desires of the dominant language games and the desire of the being of art. No other non-conflict differend affects the contemporary artists in such a constant, obvious and insidious way. As such, it is the differend that presents the most potential.

3.2.6 Transcendence and Emancipation

The language games of the scientific method, language, naming, knowledge, truth, certainty, communication and the market each exist within the paradigm of transcendence. Transcendence is the act of leaving one's self or situation and arriving at a higher, better, separate and new self or situation. The new destination is emancipation, which is the ultimate freedom. The self arrives at a state of emancipation by knowing, possessing or controlling truth, language, technology and/or the market. Each form of transcendence fits the familiar Christian notion that, "The truth will set you free." [254]

A non-conflict differend exists between the entangled being, transcendence and emancipation. The entangled being is indifferent toward transcendence because the entangled being does not recognize causality, locality, certainty or truth. The entangled being is at once here and everywhere. It is constantly in the process of becoming and playing with uncertainty.

The concept of transcendence implies arriving at a fixed point (emancipation) at which one can look backwards. Emancipation therefore requires linear time and a separation from the now. The entangled being does not recognize a static, constant, stable past or future. This is not to say that a definite past, for example, does not exist. But the entangled being does not desire, imagine, observe or create a definite past, present or future. It only observes, imagines, creates and desires the uncertain becoming now.

3.3 Making Quantum Artifacts

How does the quantum artist create artifacts in the face of the non-conflict differend?

3.3.1 Methods of Observation, Imagination and Creation

The entangled being exists as symmetrical potential as well as a series of asymmetrical events. Is it possible to observe symmetrical potential, or is symmetry collapsed immediately upon observation?

Monistic symmetry claims that consciousness occurs at all times, in all beings. However, intentionality, which creates asymmetrical events, only occurs when the self chooses to observe herself. Thus, the self observes symmetrical potential at all times. Upon directing her consciousness, she creates an asymmetrical event. To remain in a state of non-intentionality is a skill that some call meditation or profound rest. This state is often reached through the artistic process. Ironically, it is often reached through intense observation (of breath, of being, of an

object, etc.) or intentionality. At a certain point, the being becomes immersed in that which she observes, without the active intention of observation.

Between intentionality and non-intentionality, there exists a wide spectrum. Artists may work for hours upon hours while only experiencing a few moments of awareness. Moments of intentionality occur when the artist chooses to become aware. These moments are triggered by decisions ("I should create this form instead of that"), words ("This form is a circle"), communication ("How can I tell my viewer that this circle is a circle?") and judgment ("This circle is perfect").

Symmetrical monism claims that the self simultaneously exists in the realm of symmetrical potentiality and asymmetrical event. The artist in a state of non-intentionality observes each and every possibility. As she observes, she imagines, desires and creates. An actuality occurs when she chooses one event by directing her attention towards it. Thus she creates her event. She may, at this moment, have the sensation that the event created her. This happens because she does not remember her non-intentional moments, thus making the intentional moment seem to appear, like magic, out of nowhere. This phenomenon, which is actually the sensation of the moment of actualization, is often called inspiration. As such, it has been confused with notions of divinity or other outside forces, which mysteriously swoop in, and fill the empty vessel (the artist) with creation. Although the contemporary artist no longer associates inspiration with the divine, the idea that the moment of creation arrives from outside of the self remains. Plotinus writes, "This, then, is how the material thing becomes beautiful—by communicating in the thought that flows from the Divine."[255]

The self desires, observes and imagines countless potentialities *while* she is in the act of creating one, asymmetrical event. At the moment of an asymmetrical event, she observes her consciousness. She has *chosen* this event by directing her consciousness toward it. Can she observe without intentionality? Heisenberg questions, "What does actually happen when we do not observe, and do we know what the word actually means in this context? These are hard questions, and we see that tradition can lead us into difficulties."[256]

Choosing intentionality or directing one's consciousness should not be confused with freedom, which implies control and emancipation. The entangled being chooses and creates while she is chosen and created. She is not free or un-free. She is uncertain. Choice is the activity of intentionality which is activated in the creation of transient, uncertain, asymmetrical events.

The quantum artist does not advocate for intentionality or non-intentionality. She questions the extent and abilities of her senses, her tools, her perceptions and her consciousness. Heisenberg writes, ".[W]e have to remember that what we observe is not nature in itself but nature exposed to our method of questioning."[257] The quantum artist plays with her method of questioning. She flirts with the uncertainty between observed and un-observed consciousness. She chooses her environment and methods of observation accordingly. From this uncertainty, she creates desire, empathy and sensual awareness. She does not regard her artifacts as truth or certainty. Rather, each "finished" artwork is a transient moment of intentionality, of choice.

3.3.2 Truth, Newness and Forgeries

The quantum artist is indifferent toward the activities of making truth, evaluating truth and judging truth. She does not intend to create objects for the purpose of creating new knowledge. She does not incorporate methods of evaluation into her work. She feels no need to translate or communicate the meaning of her work. She makes her work because she chooses to follow her desires. If she has no desires, she must make the choice to actively observe. The desires of the entangled being have nothing to do with knowing, truth or value. Heidegger writes:

> To think against "values" is not to maintain that everything interpreted as "a value"—"culture," "art," "science" "human dignity," "world," and "God"—is valueless. Rather, it is important finally to realize that precisely through the characterization of something as "a value" what is so valued is robbed of its worth.[258]

The quantum artist's indifference toward truth and value extends to include most of the activities of the market, academia, art criticism and art theory. This is not to say that these activities hurt her. Rather, she does not desire these activities, and these activities do not create desire.

Newness, as a component of truth and a method of ascertaining certainty and worth, is also of no interest to the quantum artist. Newness, like the "original" and "first-ness" is regarded as a constant, common and continuous event. As such, newness loses its traditional meaning. The quantum artist, even as a student, does not worry about re-inventing the wheel. "Doing something that's already been done" is a concept that relies upon separation, progress and linear time. To the quantum artist, the idea of re-inventing the wheel is meaningless. The creation of new concepts, new knowledge, new forms, etc. is not a goal of the quantum artist.

A philosopher-critic attempting to illustrate the beliefs of the quantum artist (in itself, an activity of no interest to the quantum artist) would paint a series of admitted forgeries. For example, he would make a replica of each of Monet's haystacks. His conceptual content would be the idea that progress and newness are no longer the interest of the quantum artist. The quantum artist would undoubtedly experience Monet's haystacks in a different way than Monet experienced them, and as such, the paintings would be slightly different. The "New Art Order" critic would rejoice in the activity of deciphering tiny differences and hypothesizing about their meaning. The market would reward this intellectual activity by assigning them greater value than the original haystacks, thus proving that originality is no longer of interest to the quantum artist. The quantum artist, however, does not reject, embrace, analyze or create kitsch in reaction to the (imagined) forgery project. The quantum artist simply does not recognize forgery. Forgery, to the quantum artist, is not a crime. It's not anything. Forgery, itself, does not exist.

The quantum artist does not make art about his beliefs about art, or about his beliefs concerning the "New Art Order." This is an activity designed to satisfy the language games of the dominant paradigms. It is an activity that points toward truths and elicits intellectual validation. The Quantum Artist frees herself of this demand.

3.3.3. The Original
The quantum artist is indifferent toward the original for the same reason that she is indifferent toward the new. The new exists at all times, everywhere. To call some-

thing new is to say nothing more than, "an asymmetrical event exists." The original has never existed and as such, the word "original" loses its meaning.

Walter Benjamin declared that art's aura, its quality of authenticity and uniqueness, became meaningless when it became mechanically reproducible. Reproduction illuminated the fact that art's aura was based in ritual and, later, in the secularized version of ritual: the market. Benjamin writes,

> One might subsume the eliminated element in the term "aura" and go on to say: that which withers in the age of mechanical reproduction is the aura of the work of art. This is a symptomatic process whose significance points beyond the realm of art. One might generalize by saying: the technique of reproduction detaches the reproduced object from the domain of tradition.[259]

Far from lamenting the loss of the aura, Benjamin celebrates the end of "outmoded concepts, such as creativity and genius, eternal value and mystery."[260] He predicts that in the absence of art's originality, art would become political.

> [F]or the first time in world history, mechanical reproduction emancipates the work of art from its parasitical dependence on ritual. To an ever greater degree the work of art reproduced becomes the work of art designed for reproducibility. From a photographic negative, for example, one can make any number of prints; to ask for the "authentic" print makes no sense. But the instant the criterion

of authenticity ceases to be applicable to artistic production, the total function of art is reversed. Instead of being based on ritual, it begins to be based on another practice—politics.[261]

In fact, in the absence of art's aura changed nothing. Art was commodity when it was unique and remained commodity when it became reproducible. Moreover, the "New Art Order" still believes wholeheartedly in the original, albeit in a derivative form. The idea of originality remains unquestioned, regardless of whether or not it can be reproduced or it has already become simulacra.

The "New Art Order" recognizes the original by its first-ness. No matter how many duplicates are made, a first can be named. The first can manifest as the idea of the artwork or the first artifact produced. Conceptual artist Sol Lewitt illustrated this idea when he created a set of directions for wall drawings, which he then sent to galleries and communities, to be completed by whomever.[262]

Baudrillard does not suggest that the original has become meaningless. He suggests that the original no longer exists. He claims that the postmodern artist's first idea is simply a representation, reflection or symbol of an object, which is a representation of an object before that, etc. Baudrillard calls this process "simulacra," and divides the process into four chronological parts.[263] In the first part, during the pre-modern era, representations directly represent objects which physically exist in reality. In the last part, the postmodern era or the era of the hyper-real, images and signs do not relate to reality. Instead, they relate indirectly to other images and signs. The original object is no longer.

Today abstraction is no longer that of the map, the double, the mirror, or the concept. Simulation is no longer that of a territory, a referential being, or a substance. It is the generation by models of a real without origin or reality: a hyperreal.[264]

Baudrillard laments the loss of the real and with it, the loss of the original. In doing so, he illustrates the rules of his own language games. Baudrillard recognizes the original. And in the absence of the original, Baudrillard's world becomes cluttered with representations without substance, content or value. Baudrillard writes, "It is no longer a question of imitation, nor duplication, nor even parody. It is a question of substituting the signs of the real for the real."[265]

The quantum artist does not recognize the original. As such, she does not lament its loss nor divide the world into moments of real or hyper-real. The concept of reality is replaced by uncertainty. Inside uncertainty, transient asymmetrical events occur.

The dominant language games that define and thus create art each have Plato at their core. His interests are so prevalent that they are no longer recognized as philosophy, but common sense. Plato's idea of the original is the ideal form. His original cannot be destroyed or devalued. However, it does not exist in the realm of human perception. It is the first idea, made by God, which is good and which all human ideas replicate. Plato writes:

Let us take any common instance; there are beds and tables in the world-plenty of them, are there not?

Yes.

But there are only two ideas or form so them—one
the idea of a bed, the other of a table.

True.

And the maker of either of them makes a bed or he
makes a table for our use, in accordance with the
idea-that is our way of speaking in this and similar
instances—but no artificer makes the ideas them-
selves: how could he?

Impossible.

And there is another artist,—I should like to know
what you would say of him.

Who is he?

One who is the maker of all the works of all other
workmen.

What an extraordinary man!

Wait a little, and there will be more reason for your
saying so. For this is he who is able to make not
only vessels of every kind, but plants and animals,
himself and all other things—the earth and heaven,
and the things which are in heaven or under the
earth; he makes the gods also.[266]

Plato's human artist, like Baudrillard's artist, is inca-
pable of creating an original. Baudrillard's artist lost his
ability to create an original, whereas Plato's artist never
had a chance. Plato's idea of the original lends itself to a
Judeo-Christian idea of a god, who is the ultimate, first
and original creator. All human creations, which neces-
sarily occur after God's creation, become representations
of God's original. Eventually they become representations

of symbols of representations of God's original (simula-cra). The quantum artist is simply the artist who regards herself as the constant and common original and the entangled creator.

The iconoclasts of the Reformation objected to the creation of representations of God. Like a forged painting, these representations inspired humiliation, resentment and disdain. The faithful appeared to worship representations of God with the same reverence that they directed toward God himself. Martin Luther, in opposition to the iconoclasts, did not condemn the worship of representations as long as worshippers remained aware that the ultimate creator of all arts, images and representations was God himself.[267]

> "I am not of the opinion," said Luther, "that through the Gospel all the arts should be banished and driven away, as some zealots want to make us believe; but I wish to see them all, especially music, in the service of Him Who gave and created them.[268]

The quantum artist does not laud, mourn or recognize the original. Symmetrical monism claims a differend between the idea of the original and the being of art. Originality implies a first, a characteristic that separates it from other forms. It is not that there is no first. Rather, there are many firsts. They happen constantly, such that there is nothing that distinguishes a first form from any other form. The world is in a constant state of creating itself, thus it is always in a state of first and now. Distinguishing an artifact by its first-ness would be like distinguishing a human by nature of the fact that he was born.

Yes, he was born. But this does not separate him. On the contrary, it makes him the same as all others.

3.3.4 The Market

The quantum artist recognizes the differend between his desires and the desires of the market. He does not resist the market. He does not deny the artifact's nature as an object, attempt to manipulate or criticize the market, make artifacts about the market or make kitsch in reaction to the market. On the other hand, he does not make artifacts *for* the market. The quantum artist recognizes the difference between his own ontological uncertainties and the ontological demands of the market.

The "New Art Order" (which includes the academic dissemination of art theory) admires its philosophical pretentions while it ponders the meaning of art. What has long been dismissed is that the "New Art Order" *only* asks about the meaning of art in terms of its direct or derivative relationship to monetary value. The "New Art Order" does not reflect on the ontology of art. John Berger writes:

> The extremism of most recent visual art is a consequence of the same situation. The artist welcomes the prestige and liberty accorded him; but insofar as he has an imaginative vision he profoundly resents his work being treated as a commodity. (The argument that there is nothing new in this situation, because works of art have been bought and sold for centuries, cannot be taken very seriously: the concept of private property has been stripped of its ideological disguise only very slowly.) Abstract Expressionism, L'art Brut, Pop Art, Auto-Destruc-

tive art, Neo-Dada—these and other movements, despite profound differences of spirit and style, have all tried to exceed the limits within which a work of art can remain a desirable and valuable possession. All have questioned what makes a work of art. But the significance of this questioning has been widely misunderstood—sometimes by the artists themselves. It does not refer to the process of creating art: it refers to the now blatantly revealed role of art as property.[269]

The quantum artist does not incorporate the demands and desires of the market into his artistic process. This is an especially difficult task because the needs of the market are incredibly persistent (and inclusive of the needs of academia, language and the scientific method).

The needs of the market have come to be understood, not only as common sense, but also as the strategy, methodology and ontology of the artist himself. The contemporary artist no longer needs the critic, the historian, the curator, the dealer, the teacher or the gallery. He has incorporated the needs of the market into his own studio. He functions as if he were the market, regardless of his proximity to the market. He identifies with the market. He is a dedicated lover of art. This love is the ultimate betrayal of the being of art. Still, the being of art, itself, is unperturbed. It goes about imagining, observing, desiring and creating. It simply does so without the recognition of the artist. The artist therefore, does not benefit from his creative and imaginative self. He drowns out his creative potential by declaring his love, his identity as artist.

The contemporary artist-as-market has incorporated the elite art viewer (which includes academia, theory and market) to such an extent that he has transformed himself into viewer. He is the artist whose sole focus it to satisfy the viewer. John Berger declares that the Western art viewer, the art lover, has nothing worthwhile to express or give:

A love of art has been a useful concept to the European ruling classes for over a century and a half. The love was said to be their own. With it they could claim kinship with the civilizations of the past and the possession of those moral virtues associated with "beauty." With it they could also dismiss as inartistic and primitive the cultures they were in the process of destroying at home and throughout the world. More recently they have been able to equate their love of art with their love of freedom and to oppose both loves to the alleged or real abuse of art in the socialist countries

The usefulness of the concept has to be paid for. There were demands that a love of art, which was so apparently a privilege and was so apparently and intimately connected with morality, should be encouraged in all deserving citizens. This demand led to many nineteenth-century movements of cultural philanthropy—of which Western Ministries of Culture are the last, absurd, doomed manifestations.

It would be an exaggeration to claim that the cultural facilities concerned with the arts and open to the public at large have yielded no benefits at all. They have contributed to the cultural development of many thousands of individuals. But all

these individuals remain exceptions because the fundamental division between the initiated and the uninitiated, the "loving" and the indifferent, the minority and the majority, has remained as rigid as ever. And it is inevitable that this should be so; for, quite apart from the related economic and educational factors, there is a hopeless contradiction within the philanthropic theory itself. The privileged are not in a position to teach or give to the underprivileged. Their own love of art is a fiction, a pretension. What they have to offer as lovers is not worth taking.

I believe that this is finally true concerning all the arts. But—for reasons which we shall examine in a minute—it is most obvious in the field of the visual arts. For twenty years I have searched like Diogenes for a true lover of art: if I had found one I would have been forced to abandon as superficial, as an act of bad faith, my own regard for art which is constantly and openly political. I never found one.

Not even among artists? Least of all.[270]

The quantum artist faces his most obvious decisions when confronting the Market. He decipher the difference between the market and its language games (academia, scientific method, language, truth and transcendence) as well as the difference between the desires of the viewer and the desires of the being of art.

The first step then, for the quantum artist, is to make a choice that responds not to the market but to the artist's desires. In doing so, the quantum artist, through his indifference and/or silence, inadvertently makes a political statement towards his viewer, his teachers, his

philosophers and his entire social world. The quantum
artist appears irreverent. He appears to turn his back
upon all of the hard work of his predecessors. For this,
he will suffer. But the quantum artist turns his back on
contemporary art and the "New Art Order" not out of
a desire for power or purity and not out of disgust or
ignorance. He turns his back out of empathy—empathy
for his own desires, for the desires of the being of art.
Lotringer writes,"I was very moved, when I heard Gilles
Deleuze say that there was nothing he wanted more than
to leave philosophy—but, he quickly added, *leaving it as
a philosopher*. This is also what John Cage did his best to
achieve: leaving music, but *as a musician*."[271]

The quantum artist will face the non-conflict differ-
end of the market, commodification, academia and the
language games of the New Art Order—and he will leave
art, but he will leave art *as an artist*.

3.3.5 Abstraction and Representation

The modern and postmodern paradigms maintain an
understanding of abstraction and representation that
fits into a linear, progressive understanding of human
endeavor. Art which takes the form of new knowledge
comes from representation and moves toward abstrac-
tion. This idea is false.

The linear understanding of representation and
abstraction is rooted in Plato's notion of art as mimicry
and therefore failure (a false semblance of truth). Plato
announced art's starting place: representation. Hegel
cements the notion of evolutionary progress in the visual
arts by announcing and analyzing the death of art. He
claims that the arts were once, in the classical era, a

satisfying method of discovering or producing truth. At this stage (ancient Greece), arts were representative. Later, humans replaced representative art with religion (symbolic art). In a third phase, philosophy became the human's primary method for deciphering truth. At this point, the arts became nothing other than material for philosophical investigation. The arts were replaced by philosophical thought. According to Hegel:

> Thought and reflection have taken their flight above fine art. In all these respects, art is, and remains for us, on the side of its highest destiny, a thing of the past. Herein it has further lost for us its genuine truth and life, and rather is transferred into our ideas than asserts its former necessity, or assumes its former place, in reality. What is now aroused in us by works of art is over and above our immediate enjoyment, and together with it, our judgment; inasmuch as we subject the content and the means of representation of the work of art and the suitability or unsuitability of the two to our intellectual consideration. Therefore, the science of art is a much more pressing need in our day than in times in which art, simply as art, was enough to furnish a full satisfaction. Art invites us to consideration of it by means of thought, not to the end of stimulating art production, but in order to ascertain scientifically what art is.[272]

The conceptual art movement, beginning at the turn of the 20th century with Duchamp's urinal, attempted to defy Hegel by claiming that art had not been replaced by philosophy because art had become philosophy. They

cried out that the endeavor of thought does not exclude art. Art is also a method of thinking. Conceptual art came into vogue during the 1960's and 1970's. Virilio writes,

> Behind conceptual art, there is a confusion between painting and philosophy. It's not a bad confusion, it's abstract art. It is the same with Gilles Deleuze, and with conceptual philosophy. All our philosophers are conceptual Philosophers. [Lotringer responds] Yes, but these artists were conceptual philosophers of the visual.[273]

Art history further confuses the matter by assuming that primitive or aboriginal cultures did not have the tools and techniques to paint or sculpt realistic figures. The Renaissance is celebrated as the age of realism, in which painters "learned" how to paint perspective and realistic human forms. This notion feeds the allusion that prior to the Renaissance, humans were not able paint or sculpt space and figures in a realistic fashion.

Realistic forms are found far earlier than the Renaissance. The cave paintings of Lascaux, for example, boast realistic depictions of animals. The allusion of progress in realism during the Renaissance is in part, due to the advent of oil paint, which tends to make textures (such as skin, fabric and jewels) more touchable. The discovery of oil paint, however, should not be confused with the discovery of sight, hand-eye coordination or technique.

Renaissance perspective is a mathematical formulation that provides a strategy for creating space. Prior to the so-called discovery of perspective, artists were capable of creating realistic space simply by drawing space from observation. Young students, for example, are

able to draw train tracks without knowing that two lines, which recede toward a vanishing point, are the basis for linear perspective.

In aboriginal and primitive cultures, non-realistic forms are certainly found. These forms, however, should not be considered pre-realistic. They should simply be considered abstract. There is no such thing as abstract form which arises from nothing or nowhere. Abstract form has its base in observed form. In other words, a painter capable of abstract form is capable of realistic form, and vice-versa.

Impressionism, which is often understood as a bridge between European realism and American abstract expressionism, was an intensely sensitive and realistic study of light. Abstract expressionism was based in the observation of how forms and colors move in space. Hans Hoffman's push-and-pull, in which one form-color appears to push another form-color forward in space while pulling another backwards in space, works precisely because this is the way that forms behave in our observed reality. Minimalism isolates shapes and colors in such a way that they appear foreign to us. This effect works because these shapes and colors exist in our daily lives. They are simply integrated with so many other shapes and colors that we do not consider them. Conceptualism was an attempt to privilege ideas, and to communicate ideas by using a visual language. Thought, of course, was always present in artworks. It simply had not yet been an isolated element. Appropriation was permission for forgery (realism), as long as past images and ideas were collaged and re-arranged such that a new idea was formed.

What can be said about abstraction is that it isolates a form, color, thought, sensation, etc. by taking it out of its most accepted context. John Berger points out that the educated are trained to accept abstraction.

> Pollock, then, was unusually talented and his paintings can delight the sophisticated eye. If they were turned into textile design or wall-papers they might also delight the unsophisticated eye. (It is only the sophisticated who can enjoy an isolated, single quality removed from any normal context and pursued for its own sake—in this case the quality of abstract decoration.)[274]

The abstract artwork is no different from realistic artwork in terms of its substance or methodology. It is only different in terms of the way in which it is appreciated. In other words, abstraction and realism are named as such (by the viewer) depending on his method of observation.

Abstraction and realism, including each of their sub-movements and isms, arise out of observation. One is not superior to another. The progressive movement from abstraction to realism is an illusion perpetrated by philosophers, art historians and the language games of progress and transcendence.

The quantum artist does not strive to be realistic or abstract. The quantum artist strives to allow, listen, feel, touch, smell, see and follow each of her desires. The quantum artist allows for her desire to lead her toward uncertainty and with uncertainty. She plays, creates and desires uncertainty.

A so-called realistic artwork, which strives for precision, and a so-called abstract work, which strives to flex its intellectual muscles, are of no interest to the quantum artist because both endeavors strive for certainty. To the quantum artist, realism and abstraction, which are both based in observation, occur at every level of every artwork. Observation includes imagination, creation and desire. Observation also includes various states of intentionality, which may have the semblance of intense focus. The creation of a particular event takes form out of its context (the wave of potentiality) and this creation, as such, may appear abstract. But this abstraction (just like realism) arises out of intense observation.

3.3.6 Technology and the Senses

The plastic arts have been fighting with technological reproduction since the advent of the camera. As such, technology and the artist have maintained a tense and tenuous relationship. Will technology take over the role of sensations? Will some form of camera eventually see for the eye? Will some other technology perform taste or touch? Will even our organism become mediated by technology? Virilio writes:

> Every sensation is going to be digitized or digitalized. We are faced with the reconstruction of the phenomenology of perception according to the machine. The vision machine is not simply the camera that replaced Monet's eye—"An eye, but what an eye!" said Clemenceau—no, now it's a machine that's reconstructing sensations pixel by pixel and bits by bits. Not just visual or auditory sensations, the audio-visible, but also olfactory sensations, tac-

tile sensations. We are faced with a reconstruction of the *senses*.—"Sensas" are the basic sensations, the way we say psyche, etc. And here lies the failure of art. Because art was the interpreter between an "eye," or some analogous sense, and whatever else.[275]

The quantum artist does not fear or worship technology, nor does she regard art as interpretation or the righteous protectors of the senses. Technology is part of the essence of his body (his techno-mind-body). As such, tools are not an alien force, stripping the self of his beloved senses. The self chooses tools by focusing his intentionality upon these tools. At any time he can change his focus. The quantum artist chooses his tools with great care because his tools are the substance of his sensual being. Schirmacher writes, "*Homo generator*'s body politics is to see/hear/smell/touch/taste/think before you act, it claims aesthetic perception as the basis of comprehending and interaction."[276]

The quantum artist does not blindly accept tools which the dominant language games have deemed new, useful or progressive. Progress, newness and linear time are of no interest to the quantum artist. She embraces those tools that she desires. Desire is a sensation felt in the techno-mind-body. The quantum artist must observe the differend between the technologies that the dominant language games deem necessary, and the technologies, which the quantum artist desires.

3.3.7 Content

The problem of content, though it has always existed, is now contemporary art's most obvious problem. The Western history of the plastic arts is the history of the

mercenary activities to which the arts have been ap-
plied (magic, religion, politics, market, therapy, science,
status, etc.). The needs of society in conjunction with the
dominant understanding of art's function have dictated
art's content. The Impressionists were the first (in West-
ern history) to clearly and publicly take responsibility for
their own content. They explored vision and light and
were duly punished during their own time. (The term
"impressionist" was originally an insult.)[277]

In the post-Impressionist era, artists tried desperately
to find their own content, method of communication and
audience. The twentieth century witnessed a panicked
series of ism's, movements and declarations of artistic
intent. John Berger writes that artist Jackson Pollock
made his drip-paintings because in the absence of an
artistic theme (such as religion, which was art's theme for
most of Western history) and in the absence of a vehicle for
communication (such as the church), he found nothing to
do but retreat into the confines of his mind.[278] Berger writes:

> The constant problem for the Western artist is to
> find themes for his art which can connect him with
> his public. (And by theme I do not mean a subject
> as such but the developing significance found in
> a subject.) At first Pollock was influenced by the
> Mexicans and by Picasso. He borrowed stylistically
> from them and was sustained by their fervor, but
> try as he might he could not take over their themes
> because they were simply not applicable to his own
> view of his own social and cultural situation. Final-
> ly in desperation he made his theme the impossi-
> bility to find a theme. Having the ability to speak,
> he acted dumb. (Here a little like James Dean.)

Given freedom and contacts, he condemned
himself to solitary confinement in the white cell.
Possessing memories and countless references
to the outside world, he tried to lose them. And
having jettisoned everything he could, he tried to
preserve only his consciousness of what happened
at the moment of the act of painting.[279]

The twentieth century's artists' sincere efforts were
quickly diverted from the question of content to the
question of value. As such, the century's accomplishment
has been to turn art's ontology, methodology and con-
tent into a function of the market. The twentieth century
replaced art with the art career. In doing so, the "New Art
Order" created the following equation: art= emancipato-
ry product (where product is a symbolic entity existing
within the language games of the market). Content was
thereby replaced with market value. Today the question
of content is not, "What does it mean?" The question has
become (though indirectly, of course), "How can you sell
that *to the market*?" Lotringer writes:

Art is being instrumentalized beyond recognition. It's
becoming ancillary to capitalism. In the 80s, artists
played with the post-modern idea of "the death of the
author." It didn't really dawn on them that it had ar-
rived, that they were all already post-mortem. In spite
of everything, they believed they could still be some
kind of cultural heroes. But there is no more artist life,
only another regimented profession.[280]

In the "New Art Order," the market has become ar-
biter of value and dictator of content, just as religion was
during the Middle Ages or the academy in the pre-Im-
pressionist era in France. The exchange of content for
market value has occurred simultaneously to the "New
Art Order"'s complete acceptance of advertisement into
the realm of so-called Fine Art. While academia makes
a show of fighting off commodification, it quietly adopts
advertisement in the name of theory, kitsch, formalism,
newness and technology or new media. Virilio writes:

> All this interaction between SOUND, LIGHT and
> IMAGE, far from creating a "new art" or a *new
> reality*—to borrow the name of the 1950's Paris
> salon dedicated to French painter Herbin's geomet-
> ric abstraction—only destroys the nature of art,
> promoting instead its communication.

> Moreover, someone like Andy Warhol makes no
> sense as an artist in the Duchamp mould unless
> we understand the dynamic role played not only
> by sign painting, but more especially by advertis-
> ing, the last ACADEMICISM that has gradually
> invaded the temples of *official art* without anyone's
> batting an eyelid.[281]

The conversion of art to art career, advertisement
and market product does not mean that the conversation
amongst artists of the "New Art Order" has become,
"How can I turn my art into market product?" The insid-
iousness of art's contemporary ontology (art= emancipa-
tory product) is that artists have been taught to adopt the
demands of the market and to replace their own desires

with said demands, as if they were their own. Thereby, artists police themselves.

Why, for example, do artists strive to place their artworks on white walls in rooms and buildings to which they have no connection? Why do artists strive to exhibit their artwork for people that they do not know, and often do not care for? Why do artists spend their time applying for grants, residencies, academic jobs and exhibitions? If they did these things purely for the sake of making money in order to support their passion, one would have to conclude that artists are stupid, because there are far less time-consuming ways to make the time and space for art. If artists did these things for the sake of the art-star dream, so that someday he or she would become rich and famous, one would have to conclude that artists are not only stupid but also superficial, egotistical attention-starved diva-wannabes. But this is also not the case. Artists partake in the endlessly time-consuming processes of fulfilling their art career duties because the 20th century has defined art as such: the art career. If a contemporary artist does not fulfil his art career duties, he is no longer a part of art's ontological equation—he is no longer recognized as an artist.

Art's secondary diversion from the question of content is the constant philosophical battle for the right to exist. Since art left the embrace of religion, the state and the academy (though it has since re-entered), art has been fighting off the pervasive Hegelian threat that art is dead. As such, the contemporary artist has thrown herself into the following campaign: Art is alive! The endless array of exhibitions designed to elicit the question, Is that art? is designed as such, in order to claim, Yes, it is art. That is the extent of this type of art's content.

In all of the contemporary artist's attempts to claim her rightful position, she has forgotten about *her own* question of content—a content that must arise out of desire and necessity. In the midst of her forgetting, the market provides her with answers.

The battle over existence and the battle over market recognition are the two most energy-sucking activities of the contemporary artist. It is the quantum artist's role to stop feeding these panic-driven and panic-inducing activities. It is the place of the quantum artist to recognize the difference between her own desires and the demands of the "New Art Order" (including academia, market, language, communication, the scientific method and transcendence). These demands come in the form of value judgment, truth and evaluation. They necessitate proof, rationality and criticism. To deny the needs of the New Art Order is to resist not only the temptation to join but also the temptation to fight. The act of *not fighting* is difficult.

The quantum artist begins to allow her desires and sensations, her abilities to use her tools and to listen, feel, think, touch, smell and see when she chooses to do so. In order to choose to allow her intentionality to focus upon her own sensual desires, she must first end her servitude toward the demands that occupy her. In doing so, she will certainly offend and dismay. She will be seen as ungrateful and difficult. Worse, she may not be seen at all.

But this is precisely the position from which the quantum artist must start. She must allow herself space. She must allow herself to act upon her desires, to act upon her empathy and to act upon her uncertainty. In doing so, she will recognize herself as desire, empathy and uncertainty and she will become *homo generator*. As such, the entangled being, the being of the artist, will

finally be allowed to become. She will no longer fear her loss of certainty, for she will see that it never existed and never fed her desires. And what will she do? Play and play and play.

3.4 Ethics

3.4.1 Empathy and Anti-Ethics
Ethical behavior falls into the paradigm of transcendence and emancipation. If one acts in an ethical manner, one becomes an ethical being. An ethical being exists in a separate, higher realm and benefits from his knowledge or righteousness. Does art desire to be ethical? Is art an ethical behavior and/or substance? Can an ethical activity arise out of the substance and activity of uncertainty and desire?

Michael Anker claims that ethical decisions always arise out a position of uncertainty. Anker writes:

> Ethical possibility, or as Derrida would say, a decision worthy of being called a decision (and thus a "responsible" decision), exists only in this uncertain terrain of contextual becoming- (a becoming which be-comes not through the determined path of absolute knowledge of truth, but through the opening (Nancy) in the aporia of being itself.) Aporias open us to freedom, the possibility of possibility, the place where, as Derrida has taught us, an ethical decision may occur.[282]

Monistic Symmetry claims that there is a non-conflict differend between the being of art and ethical behavior. The being of art is not ethical, nor is it in opposition to ethics. The being of art does not recognize ethical decision or actions because ethical action requires certainty, separation and judgment. In order for ethical behavior to occur, the self must be confronted with a conflict and must make a critical decision. The being of art, however recognizes no conflict and makes no permanent decision. Every moment is a moment of becoming, however painful or joyful. And in each moment, the being of art does not escape or judge, nor does it desire to escape or judge. It desires to continuously observe potentiality, imagine potentiality and create an asymmetrical event. Although the quantum artist may be forced to make a decision that would fall under the category of ethical behavior, the quantum artist never believes or claims to make an ethical decision. The being of art does not recognize any decision of permanence, which delineates the self from others or otherwise names others as enemies.

Virilio discusses the ethical implications of art's silence and worries that silence has become a form of assent. He wishes for art to become "pitiful" again, so that it may find its voice: a voice which *cares*. John Armitage writes, "Virilio thus looks to reclaim a poignant or pitiful art and the politics of silence from an art world enchanted by its own extinction because to refuse pity is to accept the continuation of war."[283]

Assent and rebellion, however, belong to the language games of certainty and transcendence. The entangled being has nothing to fight against or agree upon. The entangled being observes, imagines and creates without naming, knowing or entertaining certainty, self, enemy or other.

Are the activities of the being of art unethical or amoral? It is certainly possible that the entangled being could desire and therefore create an event which common sense would declare unethical. The entangled being is at once itself and everything, one being and many beings, the being of now, yesterday and tomorrow. As such, the entangled being is wired for the capacity for empathy. In observing herself, he senses others. In sensing others, she observes herself. As *homo generator* chooses to observe her desires and sensations, her empathy grows deeper.

Science offers an experiment that further inspires the question, Is reflection and representation intrinsically related to empathy? Rizzolatti and his colleagues discovered a special class of neurons in monkeys, which they called "mirror neurons." Rizzolatti writes,

Mirror neurons are a particular class of visuomotor neurons, originally discovered in area F5 of the monkey premotor cortex, that discharge both when the monkey does a particular action and when it observes another individual (monkey or human) doing a similar action.[284]

Cognitive neuroscientist Vilayanur Ramachandran claims that mirror neurons can help explain the human's ability to learn through observation and to feel empathy:

With knowledge of these neurons, you have the basis for understanding a host of very enigmatic aspects of the human mind: "mind reading" empathy, imitation learning, and even the evolution of language. Anytime you watch someone else doing something (or even starting to do something), the corresponding mirror neuron might fire in your brain, thereby allowing you to "read" and understand another's intentions, and thus to develop a sophisticated "theory of other minds."[285]

John Berger values art based on its ability to allow
the viewer to compare his own activity of seeing or per-
ceiving to another's. The moment of comparison allows
the self to become aware of potentiality. It is possible that
this potentiality, the ability to observe another's vision,
also creates learning and empathy. Berger writes,

> Yet why should an artist's way of looking at the
> world have any meaning to us? Why does it give us
> pleasure? Because, I believe, it increases our aware-
> ness of our potentiality. —A work can, to a certain
> extent, increase an awareness of different potential-
> ities in different people.[286]

A system of entangled beings is a system of endless
potentiality, in which beings are not simply connected
to each other—they *are* each other and *become* each
other. The system of entangled beings is thus a situation
without enemies. When entangled beings claim each
other as enemies, they destroy themselves. This phe-
nomenon is played out in the body during an autoim-
mune attack. The body recognizes a part of itself
as an enemy and attacks, thus causing the body extreme
stress. The quantum artist is aware of her entangled
and uncertain nature and as such, the notion of enemy
is rendered meaningless. Schopenhauer writes,
"Tormentor and tormented are one. The former is
mistaken in thinking that he does not share the
torment, the latter is thinking he does not share
the guilt."[287]
 The quantum artist's lack of enemies in no way signi-
fies the end toward injustice. The quantum artist recog-
nizes and reacts toward injustice, not with certainty and

judgment, but with empathy and awareness of uncertainty. This awareness may lead to pain. It is not the claim of quantum symmetry that the quantum artist escapes misery or pain, nor that she becomes a more ethical human.

The quantum artist regards each element of her being and her world with empathy. She does not rely upon notions of necessity, causality, certainty or power (as do Spinoza and Nietzsche). She observers her world as an uncertain one, and tries to *allow* her empathy in order that she can love her world, without the support of knowing, naming or judging.

But like all substances and activities of the entangled being, empathy only occurs, when the being of art chooses to observe it. Just as the entangled being must choose to observe its own desire in order to become *homo generator*, the entangled being must also choose to observe its own empathy to become herself.

Finally, empathy should not be confused with therapy or ethics. Empathy does not lead toward, necessitate or create ethical behavior. Empathy does not create evolved humans who understand themselves better. Empathy is a desire of the senses. Empathy is the entangled being's activity of sensing the desires and sensations of herself and of others. Empathy may lead to avoidance of pain done towards others because this would mean pain toward himself. Empathy may lead toward protection of a so-called enemy, because the entangled being regards the enemy as the same substance of her own being. The being of art does *care,* as Virilio wishes, but it does so without making ethical decisions, statements or judgments. It simply cares and continues

to do so, without the result of a decision or an act of truth. As such, there is no relief for the being of art. In a few moments of joy and in many moments of pain, the being of art resists the temptation of ethics.

Chapter Four:
History

4.1 Aesthetic Ontology and Function

Ontology refers to the study of being or the study of existence. Heidegger points out that philosophy has yet to properly understand the question of being. Moreover, philosophy is not bothered by the unanswered question of being. The task then, is to illuminate the question of being. Heidegger writes:

> For you have evidently long been aware of this (what you properly mean when you use the expression "being"); but we who once believed we understood it have now become perplexed" (Plato, Sophist 244a). Do we today have an answer to the question of what we properly mean by the word "being"? By no means. And so it is fitting that we raise anew *the question of the meaning of Being*. But are we perplexed because we cannot understand 'Being"? By no means. And so we must first of all awaken an understanding of the meaning of this question.[288]

The question of art's being has historically been ignored, unanswered and untouched. The question of function takes it place. Art's being has been defined by its given function. But who has decided art's function and whose interests do they have in mind? The history of aesthetic philosophy, from Plato through Shaftesbury, is the history of the question of art's function. The history of

aesthetic philosophy, from Shaftesbury through present, is the history of the question of evaluation. In both cases, art's function is understood from the point of view of the philosopher-viewer.

Plato's suspicion regarding art's mimesis is not based in a concern for the artist's wellbeing, but for the viewer, who may be misled by false mimicry. Kant made the philosopher's perspective clear with his articulation of the disinterested viewer. In the Critiques of Judgment, Kant claims that the judgment of art must be free from the prejudices of likes, dislikes, pleasure and interest.[289] He defines his concept of the disinterested viewer in the section titled, "The Satisfaction Which Determines the Judgment of Taste is Disinterested." Kant writes,

> The satisfaction which we combine with the representation of the existence of an object is called "interest." Such satisfaction always has reference to the faculty of desire, either as its determining ground or as necessarily connected with its determining ground. Now when the question is if a thing is beautiful, we do not want to know whether anything depends or can depend on the existence of the thing, either for myself or for anyone else, but how we judge it by mere observation (intuition or reflection).[290]

> We wish only to know if this mere representation of the object is accompanied in me with satisfaction, however indifferent I may be as regards the existence of the object of this representation.[291]

Kant describes three types of satisfaction: the pleasant, the beautiful and the good.[292] Of these, Kant favor's

the beautiful, for it is the only one that can be apprehended in a disinterested fashion. Kant writes, "We may say that, of all these three kinds of satisfaction, that of taste in the beautiful is alone a disinterested and free satisfaction; for no interest, either of sense or of reason, here forces our assent."[293]

Kant initiates the following understanding of art and its judgment. The making of art is a subjective experience. However, beauty is truth and as such, objective and universal. If an art object is beautiful and true, the disinterested viewer should be able to name said beauty or truth, thus establishing the possibility for a universal judgment. In this way, philosophy introduced the concept of the objective viewer into the minds and studios of artists. In order for art to ensure that it be judged as beautiful and true, thus worthwhile, marketable, etc., the artist finds it necessary to take the disinterested viewer's judgments into account.

Philosophy's ontology of art, truth and beauty is based in the experiences and concerns of the viewer-evaluator. This ontology has been passed down, unwittingly, as a component of education and common sense. Academia evaluates artwork by the process of critique; an activity in which artists transform themselves into viewers and critics. Artist-viewers then analyze and evaluate art works. Hegel regards the process of aesthetic contemplation as an activity, which infects the art process and ultimately replaces it. He writes, "Art invites us to consideration of it by means of thought, not to the end of stimulating art production, but in order to ascertain scientifically what art is."[294]

The process of contemporary academic critique is influenced by the often unspoken but inherent questions, Would it sell? or How would the market value this object? The market's ontology does not arise from the point of view of the philosopher-viewer. The market, which treats the art object as commodity, regards art's being and function from the point of view of those who stand to profit. The art market, like any other capitalist market, is an uneven system, in which the few that profit make enormous profits, and the many that do not profit are desperate to become part of the game. In conversation with Baudrillard, Lotringer writes (in conversation with Baudrillard),

> In *The Conspiracy of Art* you dismissed art's claim for exceptionalism. By now it is no different from everything else. It's all about values, careers, accumulation, consumerism on a huge scale-and everybody there is aware of it. So one can't have it both ways. The art world should drop the pretense and own up to it. Your outburst indeed was a wake-up call. Also a reminder that art was supposed to be something else.[295]

Most contemporary artists utilize a working, common-sense understanding of art's being and function, which is defined by the art market and aesthetic philosophy. Few artists, however, come into direct contact with the art market or aesthetic philosophy. The market affects artists indirectly, through job possibilities, time to work, access to materials and monetary evaluation. For the majority of Western history, philosophers and artists have had a one-sided relationship. Philosophers wrote

about art, of which they had little experience, and artists were not in the privileged position to hear their words. But during the postmodern era, philosophy and art entered into a direct and complex relationship, resulting in the cult of art theory. The contemporary artist however, has not acknowledged the irony of the fact that the very system they theoretically abhor is the system to which they strive to become. Baudrillard writes, "That is what I wanted to denounce: passivity and servility as a form of conspiracy. The idea of art's collusion. Its unabashed complicity with the state of things."[296]

Historically, the combination of philosophy's ontology and the market's ontology has created a common-sense understanding of what art is, what art does and how to evaluate art. It is the responsibility of the quantum artist to view his common sense with skepticism and to decipher the differences between his own desires and the ways in which he fulfils the needs of the dominant understanding of art. Baudrillard writes, "Radical predictions always predict the non-reality of facts, the illusion of the state of fact. A prediction only begins with the foreboding of this illusion and is never mixed up with the objective state of things."[297] In the case of the quantum artist, his radical prediction must simply be to call into question the commonly accepted ideas of the ontology and function of art, and to admit that this question has yet to be approached and yet to be resolved.

It is the responsibility of the quantum artist to become his own philosopher, and to do so as an artist; as a thoroughly interested party, with his own needs, desires, play and uncertainties in mind. It is the task of the

quantum artist to illuminate the question of art's being. Only once the question of art's being is addressed, can the quantum artist begin to ponder art's needs and functions.

4.2 Prehistoric Art

The function of prehistoric art is generally regarded as ritual, magic and communication. A standard art history text reads, "Clearly social beings, Cro-Magnons must have had social organization, rituals, and beliefs that led them to create art."[298] Walter Benjamin writes, "We know that the earliest art works originated in the service of a ritual- first the magical, then the religious kind."[299] The assumption that artistic behavior results from the activity and desire to communicate and to understand is a modern notion.

Prehistoric artifacts include cave paintings, figurines, stone formations and tools. These objects date to approximately 40,000 B.C. and some argue that art artifacts are found as early as 100,000 years ago.[300] Prehistoric artifacts predate written language (3500 B.C.), agriculture (8,000 B.C.) and the exchange of money (640 B.C).[301] Because prehistoric artifacts predate written language, there is no way to be certain of the intentions or desires of prehistoric artists.

Denis Dutton, an aesthetic theorist who bases his theories upon Darwin's work, argues that early stone objects, called Acheulean hand axes, were not tools but the earliest art objects, built for no function other than to be beautiful.[302] Acheulean hand axes date to the Lower Paleolithic Era, roughly 2.5 million years ago.[303] Dutton writes:

Now, the sheer numbers of these hand axes shows

that they can't have been made for butchering animals. And the plot really thickens when you realize that, unlike other Pleistocene tools, the hand axes often exhibit no evidence of wear on their delicate blade edges. And some, in any event, are too big to use for butchery. Their symmetry, their attractive materials and, above all, their meticulous workmanship are simply quite beautiful to our eyes, even today.

So what were these ancient–I mean, they're ancient, they're foreign, but they're at the same time somehow familiar. What were these artifacts for? The best available answer is that they were literally the earliest known works of art, practical tools transformed into captivating aesthetic objects, contemplated both for their elegant shape and their virtuoso craftsmanship.[304]

Dutton attempts to separate beauty from the traditional realm of prehistoric art: ritual, magic and communication. Dutton claims that the creation of beauty is in of itself, a function. In other words, Dutton applies the ontology of Modernism, "art for art's sake" to prehistoric art. Dutton begins to question the assumption that an object's obvious function (in this case, the axe) dictates its reason for being. The question remains however, what does "art's sake" imply? What does the being of art actually desire?

4.3 Plato and Aristotle

Written aesthetic philosophy emerged during the age of ancient Greece and the aesthetic ontology of contemporary art is still based upon the texts of Plato and Aristotle. Plato defines art by its function of representation or semblance, which he calls "mimesis." In Book X of *The Republic*, Plato writes, "And the painter too is, as I conceive, just such another—a creator of appearance, is he not?"[305] Plato discusses the three makers of a bed: God, the carpenter and the artist. The artist, he claims, is the one who imitates without knowledge of truth.

> And what shall we say of the carpenter—is not he also the maker of the bed?
>
> Yes.
>
> But would you call the painter a creator and maker?
>
> Certainly not.
>
> Yet if he is not the maker, what is he in relation to the bed?
>
> I think, he said, that we may fairly designate him as the imitator of that which the others make.
>
> Good, I said; then you call him who is third in the descent from nature an imitator?
>
> Certainly, he said
>
> And the tragic poet is an imitator, and therefore, like all other imitators, he is thrice removed from the kind and from the truth?
>
> That appears to be so.[306]

Further, Plato writes,

> Which is the art of painting designed to be—an
> imitation of things as they are, or as they appear—
> of appearance or reality?
>
> Of appearance.
>
> Then the imitator, I said, is a long way off
> the truth…[307]
>
> Imagination, as well, falls into Plato's category
> of mimesis.

In *The Sophist*, Plato writes:

> *Str.* And let us not forget that of the imitative class
> the one part was to have been likeness-making,
> and the other phantastic, if it could be shown that
> falsehood is a reality and belongs to the class of
> real being.
>
> *Theaet.* Yes
>
> *Str.* Then, now, let us again divide the phantastic
> art.
>
> *Theaet.* Where shall we make the division?
>
> *Str.* There is one kind which is produced by an
> instrument, and another in which the creator of the
> appearance is himself the instrument.
>
> *Theaet.* What do you mean?
>
> *Str.* When any one makes himself appear like
> another in his figure or his voice, imitation is the
> name for this part of the phantastic art.
>
> *Theaet.* Yes

Str. Let this, then, be named the art of mimicry, and this the province assigned to it;[308]

Plato initiates the understanding of art's function as mimesis and established a distrust of mimesis (and therefore art), by setting mimesis in opposition to truth.[309] Aristotle, in agreement with Plato, treats art as mimesis: an activity of representation, which is incapable of producing truth. However, in Aristotle's understanding, art serves another function: it educates with regard to ethics and truth. The artist must create with an understanding of truth in order to properly create a semblance of said truth. In Book VII of *Nicomachean Ethics*, Aristotle writes, "Art then, as has been said, is a state concerned with making, involving a true course of reasoning, and lack of art on the contrary is a state concerned with making, involving a false course of reasoning;"[310]

In Aristotle's view, art that is created without an understanding of the truth to which it represents is not to be treated with suspicion. It is to be treated as non-art. This is the distinction which led to the contemporary understanding of the difference between propaganda and art. Propaganda is art which seeks to convince for the sake of convincing, without regard for truth. Advertisement, as such, is understood as propaganda. Art, on the other hand, seeks to convince for the sake of truth.

Alain Badiou points out that Aristotle's ontology excuses art from the process of creating truth, by replacing the creation of truth with ethical reflection.

Was it not Aristotle himself who had already signed, between art and philosophy, a peace treaty of sorts? All the evidence points to the existence of a third schema, the classical schema, of which one will say from the start that *it dehystericizes* art.

The classical *dispositif,* as constructed by Aristotle, is contained in two theses:

a) Art-as didactic schema argues –art is incapable of truth. Its essence is mimetic, and its regime is that of semblance.

b) This incapacity does not pose a serious problem (contrary to what Plato believed). This is because the purpose [destination] of art is not in the least truth. Of course, art is not truth, but it also does not claim to be truth and is therefore innocent. Aristotle's prescription places art under the sign of something entirely other than knowledge and thereby frees it form the Platonic suspicion. This other thing, which he sometimes names "catharsis", involves the deposition of the passions in trans-ference onto the semblance. Art has a therapeutic function, and not at all a cognitive or revelatory one. Art does not pertain to the theoretical, but to the ethical (in the widest possible sense of the term). It follows that the norm of art is to be found in its utility for the treatment of the affections of the soul.[311]

Although the plastic arts are mentioned in Plato and Aristotle's texts, the overwhelming majority of their texts are written with poetry, literature and tragedy in mind. Further, the place of the plastic artist in Greek Society

was that of a craftsperson or laborer. The contemporary idea of an artist, as something more than a skilled laborer, did not exist in Ancient Greece. The aesthetic ontology of Ancient Greece set a precedent, in which visual artists accept a set of philosophical texts that were created without the specific needs, desires and experiences of visual artist in mind.

4.4 Plotinus and Neo-Platonism

Aesthetic philosophy remained relatively dormant during the Roman Empire, the Middle Ages and the Renaissance, with the exception of the Neo-Platonist Plotinus, Augustine, and Ficino. Following in Plato's foundations, they equate art with mimesis and judge it against man's highest call: the search for truth. However, Plotinus, Augustine and Ficino's artistic truth is established in direct relation to religion. They endow art with the function of allowing the human to commune with the divine. Plato's idea of mimicry is replaced by Plotinus's idea of symbolism.[312]

Plotinus claims that beauty is symmetry. He writes, "[I]n visible things, as indeed in all else, universally, the beautiful thing is essentially symmetrical, patterned."[313] Further, Plotinus claims that symmetry, like Plato's ideal form, is divine and infinite. The being recognizes itself when it becomes conscious of symmetry, and as such, the self is connected to the divine and the infinite. Plotinus writes:

> Let us, then, go back to the source, and indicate at once the Principle that bestows beauty on material things.

Undoubtedly this Principle exists; it is something that is perceived at the first glance. Something which the Soul names as from an ancient knowledge and, recognizing, welcomes it, enters into unison with it.

But let the Soul fall in with the Ugly and at once it shrinks within itself, denies the thing, turns away from it, not accordant, resenting it.

Our interpretation is that the Soul—by the very truth of its nature, by its affiliation to the noblest Existents in the hierarchy of Being—when it sees anything of that kin, or any trace of that kinship, thrills with an immediate delight, takes its own to itself, and thus stirs anew to the sense of its nature and of all its affinity.

But, is there any such likeness between the loveliness of this world and the splendours in the Supreme? Such a likeness in the particulars would make the two orders alike: but what is there in common between beauty here and beauty There?

We hold that all the loveliness of this world comes by communion in Ideal-Form.[314]

The human's connection with the Divine is the activity that allows the self access to the truth of reality; its oneness or wholeness. Thus, Plotinus's aesthetic ontology is inextricably linked with monism and transcendence. Artistic objects are beautiful because they resemble God, the ideal form, truth and symmetry. Plotinus writes, "This, then, is how the material thing becomes beautiful—by communicating in the thought that flows from the divine."[315]

Further, he writes, "And it is just to say that in the Soul's becoming a good and beautiful thing is its becoming like God, for from the Divine comes all the Beauty and all the Good in beings."[316]

Plotinus's aesthetic morality claims not only that what is beautiful is good and what is good is true, but also that ugliness is evil. Plotinus writes, "And the ugly is also the primary evil; therefore its contrary is at once good and beautiful, or is Good and Beauty."[317]

How does the self illuminate the true, the Good and the Symmetrical? It does so by semblance, which is to be understood as symbol or metaphor. The artist's product is not to be understood as truth itself, but as a means to point toward the truth. Regarding Plotinus's ideas, Hofstadter and Kuhns write, "Not only is the beautiful object a symbol of cosmic harmony, but the cosmic order is best alluded to by metaphors themselves of a poetic nature."[318] Further, they write, "Art is symbol in a double sense: of that lower reality which it perfects, and that ultimate reality which it mirrors."[319]

Plotinus, like Aristotle, excuses art from Plato's condemnation (art as false mimicry). Plotinus regards art's function as symbolism or metaphor, thus assigning art an abstract form and content. Plotinus's aesthetic ontology is the foundation of the contemporary understanding of abstract art (transcendent, related to the truth or the divine and elevated above realism).

The Neo-Platonist aesthetic ontology is the following: art=a symbolic communication with the divine or the truth. Plotinus's aesthetic ontology influenced the religious aesthetic ontology of the Roman Era (Augustine) and the Renaissance (Ficino), a time in which the Church heavily subsidized artists. In addition, artists

were beginning to be recognizes as something more than laborers and craftspeople. Artists began to fulfill art's religious function by taking on the identity of genius: a person with the special capacity to observe the divine and create its symbolic semblance.

4.5 Kant and Hegel

Aesthetic philosophy emerged as an independent field of philosophy during the era of German Idealism. For Michael Inwood,

> Philosophers have reflected on art form the time of Plato. But aesthetics were first given a name, and conceived as a distinct part of philosophy, in the mid-eighteenth century, by Alexander Gottlieb Baumgarten. However, the book that moved aesthetics to the centre of philosophy was not Baumgarten's *Aesthetica*, but Kant's *Critique of Judgment* (1790)[320]

The abundant aesthetic thought which emerged from this era was no longer strictly concerned with art's definition and function. Aesthetic thought became preoccupied with the question of value and judgment. As such, art's function was transformed into the activity, which presents itself for the purpose of evaluation.

Shaftesbury and Kant developed the theory of the disinterested viewer, in which the viewer is capable of apprehending art's universal truth (its beauty).[321] Kant's *Critique of Judgment* implies the following: art=a subjective activity that creates a universal truth. Further, this subjective universal truth necessitates a particular (disin-

terested) viewer, whose job it is to recognize and name the artistic truth. Regarding Kant's disinterested viewer, Nietzsche writes:

> Kant, like all philosophers, instead of envisaging the aesthetic problem from the point of view of the artist (creator), considered art and the beautiful purely from that of the "spectator," and unconsciously introduced the "spectator" into the concept of "beautiful."[322]

Kant initiates the contemporary aesthetic understanding of the artist as idiot savant, one who is capable of truth, yet does not himself understand how he creates truth or what truth means. Kant's aesthetic ontology sets the stage for the role of the critic and theorist, as well as language and explanation in the world of contemporary art.

Techné, the Greek term for art that encompasses art, craft, skill and technology, gradually lost its inclusive meaning. During the Renaissance, the plastic arts became the fine arts and were understood to be separate from the realm of craft, skill and technology. Kant illustrates the specialization of the fine arts in the First Book--*Analytic of the Beautiful* in the *Critique of Judgment*.[323]

Kant separates fine art from other creative and productive activities by its function. Fine art, according to Kant, must have purposiveness and necessity (like nature), though no concept or purpose need by known in order to recognize the beautiful.[324] In the *Third Moment*, Kant writes:

Therefore it can be nothing else than the subjective
purposiveness in the representation of an object
without any purpose (either objective or subjec-
tive); and thus it is the mere form of purposive-
ness in the representation by which an object is
given to us, so far as we are conscious of it, which
constitutes the satisfaction that we without a con-
cept judge to be universally communicable; and,
consequently, this is the determining ground of the
judgment of taste.[325]

Concept, along with purpose, must not be needed in
order for the disinterested viewer to judge art as beau-
tiful. Kant writes, "The beautiful is that which pleases
universally without [requiring] a concept."[326] In *The
Second Moment*, Kant claims that true beauty should be
universal.[327] Kant writes, "[T]he judgment of Taste carries
with it an *aesthetic quantity* of universality, *ie.* of validity
for everyone; which cannot be found in a judgment about
the Pleasant."[328] The *Fourth Moment* states that the beau-
tiful must be necessary. Kant writes, "The *beautiful* is that
which without any concept is cognised as the object of a
necessary satisfaction."[329]

Kant thus sets up the following paradigm for the fine
arts: art must be true, purposive and necessary. It must be
capable of being evaluated without regard to end pur-
pose, concept or prejudice of interest. Art's necessity must
be clear while its function or purpose remains believable
yet unapparent. Kant writes, "Beauty is the form of the
purposiveness of an object, so far as this is perceived in it
without any representation of a purpose."[330]

Kant's *Critique of Judgment* formally separates fine art from all activities and objects that have a clear utility or function. This separation, in conjunction with the insistence upon universal truth, creates the foundation for Greenberg's formalism.

Hegel moves past the difficulties of evaluating his era's art by declaring that art, itself, is no longer necessary, useful or valid. Hegel understands art as the activity that produces sensual truths. Sensual truths, though they once aided in man's early search for truth, no longer satisfy the needs of men.

> The beauty of art presents itself to sense, to feeling, to perception, to imagination; its sphere is not that of thought, and the apprehension of its activity and its productions demand another organ that that of the scientific intelligence.[331]

> Whereas immediate appearance does not give itself out to be deceptive, but rather to be real and true, though all the time its truth is contaminated and infected by the immediate sensuous element.[332]

> Only a certain circle and grade of truth is capable of being represented in the medium of art.[333]

Art, according to Hegel, does not belong to the realm of thought. And thought, in Hegel's understanding, is the highest pursuit of truth. Hegel writes,

> We are above the level at which works of art can be venerated as divine, and actually worshipped; the impression which they make is of a more considerate kind, and the feelings which they stir within

us require a higher test and a further confirmation. Thought and reflection have taken their flight above fine art.[334]

Art, then, was only useful to men who were incapable of reflective and reasoned philosophical thought. Hegel writes, "The peculiar mode to which artistic production and works of art belong no longer satisfies our supreme need."[335]

Hegel thus initiated contemporary art's struggle for existence and relevance. Hegel writes, "In all these respects art is, and remains for us, on the side of its highest destiny, a thing of the past. Herein it has further lost for us its genuine truth and life, and rather is transferred into our ideas."[336] Though unwillingly, Hegel initiated the conceptual art movement by setting art in opposition to thought and furthered Kant's efforts by emphasizing the role of criticism and reflection. Hegel writes, "Art invites us to consideration by means of thought, not to the end of stimulating art production, but in order to ascertain scientifically what art is."[337]

It was Hegel, who inaugurated the art world's series of little deaths (the death of painting, the death of the image, the death of drawing, etc). Hegel's aesthetic philosophy reinforced Plato's notion that art is incapable of truth. And though Hegel's aesthetic philosophy was essentially negative, he also reinforced the ideas of forward linear progress, newness and transcendence. Hegel understands conceptual, reflective thought as a necessary replacement for sensuous activity. In Inwood's *Introduction to Hegel's Introductory Lectures on Aesthetics*, he writes,

> Man cannot remain in this condition, if he is a man
> rather than an animal. For his essential nature is
> to think: to think about the world, about himself,
> about the relationship between himself and the
> world, and indeed about his own thinking....He
> thus distances himself from sensuous desires and
> becomes capable of disinterested contemplation of
> the world as well as of appetitive consumption.[338]

Together, Kant and Hegel's aesthetic texts create the
foundation for formalism, Modernism and "art for art's
sake." Kant injected the question of evaluation into the
process of creating and formally separated art from purpose,
utility and craft. Hegel provoked an incessant doubt regard-
ing art's existence, function and necessity. Both maintained
the importance of truth, progress and transcendence.

4.6 Heidegger and Greenberg
During the Modern Era, art struggled, for the first time,
to relieve itself of its mercenary functions. Art attempted
to be free of an existence defined by mimicry, politics,
ethics, religion or market. The art world calls this ontolo-
gy "art for art's sake." The function to which the art world
held tight is the function of creating, finding or illumi-
nating truth. The modern ontology of art is the following:
art = emancipatory truth (where truth = new). Art for
art's sake was thus understood as the activity of creating
truth for the sake of transcendence and emancipation.
Thus the question still remains, what would be the art
that the being of art, itself, desires? Art for art's sake, in
other words, has yet to occur.

Heidegger understands art as the object or place that reveals truth. He writes, "What is art? We seek its essence in the actual work. The actuality of the work has been defined by that which is at work in the work, by the happening of truth."[339] Further, he writes, "In the work, the happening of truth is at work."[340] The origin of the artwork, according to Heidegger is not the artist or the artwork but art itself. He claims,

> The artist is the origin of the work. The work is the
> origin of the artist. Neither is without the other.
> Nevertheless, neither is the sole support of the oth-
> er. In themselves and in their interrelations, artist
> and work are each of them by virtue of a third thing
> which is prior to both, namely, that which also
> gives artist and work of art their names—art.[341]

But what is the being of art itself? And what does the being of art desire? In the absence of the answer to this question, the origin of art is understood as the progressive and transcendent activity of the search for truth. Heidegger writes, "This opening up, i.e., this revealing, i.e., the truth of beings, happens in the work. In the artwork, the truth of beings has set itself to work. Art is truth setting itself to work."[342]

Heidegger's art-truth, in conjunction with Kant's "disinterested viewer" and Hegel's notion of the end of art, led directly into the creation of Greenberg's Formalism and the idea of "art for art's sake," the aesthetic ontology of the Modern era. Formalism combines Plato's emphasis on proportion and measure,[343] Hegel's notion of progress, Kant's method of evaluation and the separation of aesthetic experience (form) from content.

Although Greenberg was not the originator of formalism, nor did he mean to become an advocate for abstraction as opposed to realism, he became the spokesperson for abstract expressionism, the methodology of formalism as critique, and the idea of art for art's sake. Greenberg said:

> Formalism was originally the name of a Russian art and literary movement before the First World War. And then it became used by the Bolsheviks (Communists is a dirty word) for any kind of art that was for its own sake. It became a dirty word like "art for art's sake," which is a valid notion. Sometime in the '50's the word formalism came up again in the mouths and at the pens of people I dare to call middlebrow. And then, it's true, I was made responsible for it, though I wasn't the only one, and by one of these easy inferences that plague human thought, it was held that I advocated a certain way of painting.[344]

Formalism and art for art's sake became art's goal, its method of making and its method of evaluation. The consequences of this understanding of art are as follows: the artwork is made with its exhibition in mind, and in particular the critique of the spectator. The disinterested formalist spectator judges a painting to be good if it is universally true, necessary and purposeful, though no clear purpose presents itself. Content should be inherent but not namable, for if it were namable, its universal truth would be tainted with the subjective interest tied up in subject matter, etc.

Abstract form was understood to be the pure and progressive art, thus elevating itself above realism and allowing it a chance to prove Hegel wrong. Abstract art is separated from the subjective impurities of life (such as prejudice, taste, sensation, subject matter, politics, desire), which allows the spectator-critic to judge art universally.

The content of abstract art is assumed to be truth. Formalism assumed that truth is inextricably linked to form. In his article, "Avant-Garde and Kitsch," Greenberg writes:

> Retiring from public altogether, the avant-garde poet or artist sought to maintain the high level of his art by both narrowing and raising it to the expression of an absolute in which all relativities and contradictions would be either resolved or beside the point. "Art for art's sake" and "pure poetry" appear, and subject matter or content becomes something to be avoided like a plague.[345]

Several problems arise from the paradigm of formalism and "art for art's sake." While artists are separated from the prejudices and interests of the everyday world, they are expected to communicate the highest of all contents: the truth. Simultaneously, artists are completing excused, or even forbidden, from exploring content out loud. In self-imposed isolation, artists searched for content within themselves. Regarding Jackson Pollock, John Berger writes:

> His paintings are like pictures painted on the inside walls of his mind. And the appeal of his work, especially to other painters, is of the same character. His work amounts to an invitation: Forget all, sever all, inhabit your white cell and—most ironic paradox of all—discover the universal in yourself, for in a one-man world you are universal![346]

But how can an artist communicate with the world the content of his universal truth which he finds in isolation? John Berger writes, "The constant problem for the Western artist is to find themes for his art which can connect him with his public. (And by theme I do not mean a subject as such but the developing significance found in a subject)."[347]

The modern painter had arrived at an impossible situation. He must produce truth, clarity and universality. Yet he must not allow his content to be recognized. He must communicate with the world while simultaneously remaining separate from that world. In Pollock's words:

> The method of painting is the natural growth out of a need. I want to express my feelings rather than illustrate them. Technique is just a means of arriving at a statement. When I am painting I have a general notion as to what I am about. I can control the flow of paint; there is no accident, just as there is no beginning and no end.[348]

Pollock illustrates the extent to which the Modern artist (the artist whose common sense understanding is art for art's sake) was systematically guided to deny his desires, deny his uncertainty and deny his sense of play. The artist is an entangled being, connected at once to everyone and everything, being both singular and plural. His isolation is the incessant cover he inflicts upon himself in order to play the dominant language games. Despite his utter denial of self (completed by his suicide), he managed to fulfill the demands of the art world. His works was new and thus progressive. His works appeared to have purpose and Truth (though no obvious content

could be named) and thus his work was named transcendent. He satisfied the modern aesthetic ontology, art = emancipatory truth (where truth is new and un-namable). In doing so, Pollock sacrificed his being. As John Berger states:

> If a talented artist cannot see or think beyond the decadence of the culture to which he belongs, if the situation is as extreme as ours, his talent will only reveal negatively but unusually vividly the nature and extent of that decadence. His talent will reveal, on other words, how it itself has been wasted.[349]

In 1958, when Berger published this article on Jackson Pollock, the age of postmodernism and French Theory was fast approaching. In the age of Modernism, the disinterested viewer was the critic-spectator (as represented by Greenberg) and the dominant language games were those of the market, the scientific method and academia. During the postmodern age, the disinterested-viewer became the market itself.

4.7 Postmodernism and French Theory

The postmodern age did not stray far from the demands of Modernism, German Idealism, Neo-Platonism and Plato. The dominant language games of the market and academia (including philosophy and the scientific method) demand that art exist in relation to truth, that it be new, that it be created for the purpose of being viewed (communication) and that it be a transcendent activity, somehow leading the viewer toward enlightenment, freedom or truth. According to Lyotard, philosophically

speaking, postmodernism is simply the original state of modernism, finally coming forth. Lyotard writes,

> What then is the postmodern? What place, if any, does it occupy in that vertiginous work of questioning the rules that govern images and narratives? It is undoubtedly part of the modern. Everything that is received most be suspected, even if it is only a day old ("modo, modo," wrote Petronius). What spaced does Cézanne challenge? The impressionists'. What object do Picasso and Braque challenge? Cézanne's. What presupposition does Duchamp break with in 1912? The idea that one has to make a painting-even a cubist painting. And [Daniel] Buren examines another presupposition that he believes emerged intact from Duchamp's work: the place of the work's presentation. The "generations" flash by at an astonishing rate. A work can become modern only if it is first postmodern. Thus understood, postmodernism is not modernism at its end, but in a nascent state, and this state is recurrent.[350]

There are two clear differences between the modern era and the postmodern era: the end of the admitted belief in universal truth and the explosion of the art market. Lyotard refers to the shift from universal truth to pluralism as the end of the "meta-narratives." He writes,

> The "meta-narratives" I was concerned with in *The Postmodern Condition* are those that have marked modernity: the progressive emancipation of reason and freedom, the progressive or catastrophic emancipation of labor (source of alienated value in capi-

talism), the enrichment of all humanity through
the progress of capitalist technoscience, and even—
if we include Christianity itself in modernity (in
opposition to the classicism of antiquity)—the
salvation of creatures through the conversion
of souls to the Christian narrative of martyred love.
Hegel's philosophy totalizes all of these narratives
and, in this sense, is itself a distillation of
speculative modernity.

These narratives are not myths in the sense that
fable would be (not even the Christian narrative).
Of course, like myths, they have the goal of legiti-
mating social and political institutions and prac-
tices, laws, ethics, ways of thinking. Unlike myths,
however, they look for legitimacy, not in an original
founding act, but in a future to be accomplished,
that is , in and Idea to be realized. This Idea (of
freedom, "enlightenment," socialism, etc,) has legit-
imating value because it is universal. It guides every
human reality It gives modernity its characteristic
mode: the project, the project Habermas says is still
incomplete and must be resumed, renewed. I would
argue that he project of modernity (the realization
of universality) has not been forsaken or forgotten
but destroyed, "liquidated."[351]

In the postmodern era, universal truth was re-
placed by truths. Simultaneously the art market
became so powerful that it replaced the disinterested
viewer. Criticism, pluralism and appropriation took

the place of truth-production and the market became
the ultimate source of validation. Lotringer writes:

> Art got reborn "critical" at a time criticality was no
> longer possible in an art world thoroughly bound
> for the market. [352]

> It was obvious that visibility and fame, not con-
> tents, were the real engine of the "New Art Order."
> Its power and glamour managed to entice, subdue
> and integrate any potential threat. Criticizing art, in
> fact, has become the royal way to an art career *and
> this will be no exception.*[353]

Art world elites like Charles Saatchi created a mo-
nopoly in which they were able to act as patron, critic,
curator and dealer. They produced artists, exhibitions
and movements for the sole purpose of raising profit.
Virilio writes, "[T]he Saatchi affair of the autumn 1999,
when the exhibition "Sensation" at the Brooklyn Muse-
um, financed by Christie's International, had the un-
avowed aim of speculation on the value of the works on
show."[354] During the postmodern age, for the first time
in Western history, art became a lucrative career choice.
Lotringer writes:

> At about the same time galleries began to prolif-
> erate, museums to expand exponentially like the
> obese. Then hordes of young artists started rushing
> in…Art became a legitimate career, a smart invest-
> ment, only more fetishized than most.[355]

Academia obeyed the art market, but was not willing to admit to an open and unabashed servitude toward the market. As a sort of unwitting public relations strategy, academia adopted French Theory as its source of authority. French Theory became postmodern art's method of evaluation, which replaced its former method: Formalism. French theory, which, for all intents and purposes, was understood as the activity of criticism, was based in content and a reflection of history. Postmodern art thus became conceptual, critical and historically aware. French theory became, not only a method of evaluation and a source of authority, but also a source of content. The modern "art for art's sake" became the postmodern "art about art," which was an attempt to integrate critical theory into postmodern art.

The art world's relationship to French Theory is at best one-sided and at worst, manipulative and parasitical. Rather than serving as a source for inspiration, French Theory, which is referred to in the art world as art theory, became nothing more than a source of authority. Lotringer describes the relationship between the American postmodern art world and French Theory as such:

> That they would just be skimming the theory and dropping names is another story altogether, although it definitely is part and parcel of the "theory effect" that swept over the American art world and academic circles, the mixture of envy and anxiety, of nervous excitement and ravenous desire, the exhilarating sense of intellectual power it provided, the genuine passions it elicited; also the impatience, spite, rage, resentment that accompanied it or followed it, all compacted in the phenomenon, French

theory. The obsession with theory, the intimida-
tion by theory, the eagerness of appropriation and
self-promotion feeding on the desire for credibility,
prestige, authority—all these "surplus values" of the
new code were present in this curious episode that
suddenly moved hundreds of artists to behave the
way Camille Paglia described academics, a "revolt-
ing sight" of "pampered American academics down
on their knees kissing French bums." —The more
they approved uncritically of Baudrillard, the more
they confirmed his own distaste of contemporary
art and the more they turned art into an indifferent
activity. They were *looking for a quick pay-off...*'[356]

As a consequence of the art world's attempt to in-
tegrate French Theory into the evaluation and content
of the plastic arts, the plastic arts became increasingly
academic. In the New York Times article published in
1999, "How to Succeed in Art," Deborah Soloman argued
that postmodernism champions a return of art to the
pre-modern role of the Academy.

While modern art began as an assault on the acad-
emy, postmodern art might be described as a return to
the academy. Instead of the old academy of rules, now we
have the Academy of Cool, schools that treat avant-garde
rebellion as a learned occupation[357]

Virilio argues that Modernism itself laid the founda-
tion for an academic art, through its Kantian incorpora-
tion of the disinterested viewer and the incessant modern
desire for objective aesthetic judgment. Virilio writes,
"How can we fail to see that the mask of modernism has
been concealing the most classic academicism: that of
an endlessly reproduced standardization of opinion."[358]

Moreover, Virilio argues that the inclusion of technological media, so often championed by the "New Art Order" as a method of creating "newness," is in fact the replacement of art by the most academic form of art: communication in the form of advertisement. Virilio writes,

> All this interaction between SOUND, LIGHT and IMAGE, far from creating a "new art" or a new reality-to borrow the name of the 1950's Paris salon dedicated to French painter Herbin's geometric abstraction—only destroys the nature of art, promoting instead its communication.
>
> Moreover, someone like Andy Warhol makes no sense as an artist in the Duchamp mould unless we understand the dynamic role played not only by sign painting, but more especially by advertising, the last ACADEMICISM that has gradually invaded the temples of official art without anyone's batting an eyelid.[359]

The "New Art Order" is the postmodern system, which turns *all art objects* into profit. The "New Art Order"'s formula for profit includes the authority of academia, the authority of theory and the authority of the gallery system. The "New Art Order" is so powerful that it no longer needs art. It functions regardless of whether or not humans create. Virilio and Lotringer conclude that the market is so successful that it has completely masked the fact that art no longer has a working understanding of its own function.[360] Art has lost track of its being, its desires and its needs. Lotringer writes:

> The accident of art could be that art no longer has any reason to exist. This doesn't prevent it from

growing exponentially more than it ever did before.
On the contrary, the more it is defined by extrinsic
conditions—by its position in the market place, in
the art circuits, as part of the monstrous museu-
ographic inflation—the more it will have to look
inward for justifications. Its existence is guaranteed
to last ad infinitum in some kind of suspended an-
imation. No one would dare take off the plugs. It's
too good for everyone to keep going in that happy
comatose state of the arts. The end of art has been
so much discussed everywhere (most brilliantly
by my friend Arthure Danto) because its already
behind us. The end is becoming meaningless. We
may be at the past-recovery stage.[361]

The postmodern age is the age in which the art mar-
ket became the ultimate source of validity. Kant's objec-
tive viewer of universal truth became the market. French
Theory was used as a mask, to cover the crassness of
the purely profit-based system of the art market. Hegel's
condemnation, that art was no longer necessary or useful
to human's progress, became increasingly apparent, while
art's market success became increasingly rarified, mo-
nopolized and separate from ordinary living.

The greatest crisis of art occurred during the post-
modern age. It is the crisis of being, meaning and func-
tion. And although art, throughout its documented his-
tory, has never succeeded in articulating its meaning and
function *on its own terms*, the postmodern era represents
the first generation of artists who have become fully
aware of this crisis. As such, the postmodern era is an
incredibly rich and fertile moment. In moments of great

crisis, choices become apparent. And it is the awareness of choice, which allows *homo generator* to play, to desire, to observe itself, to imagine itself and ultimately to create itself.

4.8 Art Theory Does Not Exist

There is an idea in the contemporary art world that there is such a thing as art theory. When artists refer to art theory, they refer to certain catch phrases, ideas and authors. Lyotard writes, "Homage is paid indirectly, by using terms like symbolic, the Other, the text."[362] It is assumed that by using the language of "art theory," the artist refers to a theory or system of understanding art. However, there is no postmodern theory which constitutes a systematic, explanatory or theoretical body, specifically created with regards to the contemporary plastic arts.

The term "theory" is itself misleading because it invokes the scientific method: a hypothesis or conclusion arrived at through documented experimental evidence, which amounts to a rule that can be applied in general.[363] The texts, to which art theory refers, are philosophical texts (mostly derived from Europe) which do not claim nor attempt to create any type of theory for art. Lotringer writes:

> French theory in an American creation anyway. The French themselves never conceived it as such, although French philosophers obviously had something to do with it. In France, French theory was considered philosophy, or psychoanalysis, or semiotics or anthropology, in short any manner of "thinking" (*pensée*) but never referred to as *theory*.[364]

Most of the philosophical texts to which plastics art-
ists refer to are not written with the plastic arts in mind.
The aesthetic texts of Jacques Derrida, Roland Barthes,
Heidegger, Theodor Adorno, Benjamin and Michel
Foucault for example, refer mostly to film, literature and
poetry. Their commentary refers to relationships between
art and culture, language and history. They do not create
a system, hypothesis or strategy for viewing, understand-
ing or creating art. One of postmodern art's most lauded
authors, Lyotard, writes:

> I imagine you are asking for my system on the
> arts today, and how it compares with those of my
> colleagues. I quake, feeling that I've been caught,
> since I don't have anything worthy of being called a
> system, and I know only a little about two or three
> of them, just enough to know they hardly consti-
> tute a system: the Freudian reading of the arts, the
> Marxist reading, and the semiotic reading. Perhaps
> what we should do is change the idea that has been
> dressed up with the name "system."
>
> By wanting something systematic we believe we are
> real contemporaries of the "system theory" age and
> the age of the virtue of performativity. Do you have
> something to say about the arts? Let's look at how
> you say it, at the set of language-based operations
> you use to work on your material, the works of
> art. And let's look at your results. That's the sys-
> tem being asked for: the set of word tools that are
> applied to given aspects of music, painting, film,
> words, and other things, and that produce a work
> of words—commentary. The time is past when we
> can plant ourselves in front of a Vernet and sigh
> along with Diderot, 'How beautiful, grand, varied,

noble, wise, harmonious, rigourously coloured this is!' Don't think we don't regret it. We are philosophers though, and it's not for us to lay down how you should understand what artists do.[365]

Further, Lyotard claims that the request for a theoretical or systematic understanding of how to make, view or understand art does not come from the realm of philosophy. The demand for a theory or system comes instead, from the New Art Order and all of the components that make the art career profitable.

> If you look just a little closer you will see that when the philosophers you have in mind decided to talk about the arts, it was not in order to explain works or interpret them. They wanted even less to make them fit into a system or build a system based on them. What then was their purpose? I'm not quite sure, and this is what we must try to grasp. But in any case these philosophers have had almost no part in the request for a system, except inadvertently. More often than not, they have purposely thwarted it as best they could. The request emanates instead from a new stratum: the managerial staff of the art professions, the reading engineers, the maintenance crews for the big explanatory machines patented under the name of Ideology, Fantasy, Structure.[366]

Postmodern theorists remain, for the most part, unperturbed by contemporary artists' invention of art theory' and their use of theory for justification, validation and authority. Baudrillard is an exception. He made his

feelings regarding the art world's relationship to his texts clear. In doing so, he provided the postmodern artist with a simple and explicit picture of art's ontological crisis.

Baudrillard's 1983 text *Simulations* was instantly appropriated by the art world (though it is not written about the plastic arts) and Baudrillard was transformed into an art world hero. A school of "simulationists" emerged in New York City.[367] So when Baudrillard claimed that art is "null" in his text *The Conspiracy of Art*, the art world was shocked.[368] Baudrillard writes,

> Raising originality, banality and nullity to the level of values or even to perverse aesthetic pleasure. Of course, all of this mediocrity claims to transcend itself by moving art to a second ironic level. But it is just as empty and insignificant on the second as the first level. The passage to the aesthetic level salvages nothing; on the contrary, it is mediocrity squared. It claims to be null—"I am null! I am null!"—*and it truly is null.*[369]

Although his art-star followers (Jeff Koons, for example)[370] were shocked, the statement did not dampen contemporary art's value or the "New Art Order"'s appropriation of Baudrillard. Criticism had become art's function, and Baudrillard's criticism simply gave contemporary art more credibility. But the art world missed Baudrillard's point, and it's a point that must be ingested in order for artists to finally begin to ask the necessary ontological questions regarding art's being, function and desire. Baudrillard showed the art world two things: the New Art Order and the art career that it supports are

antithetical to art. And the ontological beliefs of the New Art Order no longer (if ever) respond to, correspond with or relate to the needs and desires of artists.

Baudrillard's rejection of the "New Art Order" is the most significant opening for choice since Hegel's proclamation of the end of art. The end, to which Baudrillard refers, and the accident, to which Virilio refers, are the crises of art's understanding of its self: it's being and its desire. The contemporary artist must first admit that all of her beliefs regarding art's being and function are not at all based upon the needs and desires of the being of art. Her beliefs are based upon the dominant ontological paradigm as designed by the market, the scientific method and academia, all of which do not have art's interests in mind. Artists resist this idea because it leaves them with no belief or understanding regarding their own reality: their career, their identity as artists, the being of art and art's function. This lack of understanding must be regarded as a positive event: an imitation of an uncertain world by an artist who does not fear uncertainty. Baudrillard writes:

> Belief in reality is one of the elementary forms of religious life. It is a weakness of the understanding, a weakness of common sense, and also the final stand of the moral zealots, the apostles of the legality of reality and rationality who say that the reality principle can never be cast in doubt. Fortunately, no one lives according to this principle, not even those who profess it, and for good reason. No one fundamentally believes in reality or in the evidence of his or her real life. That would be too sad.[371]

The quantum artist must accept that his beliefs in reality and his reliance upon art theory to provide explanation, justification and clarification are a farce. Only when he accepts this point, can the artist begin to allow himself to observe himself and his world. At each point in which he had previously created the illusion of certainty (and believed in its certitude), he can observe his entangled and uncertain world and create an event, in full awareness of that uncertainty. When the artist creates an event, in awareness of his uncertainty, his entangled state and his potential, he becomes the quantum artist. The quantum artist must then choose what to do with his art.

Chapter Five: Conclusion

5.1 Quantum Artist Claims the Ontological Question

The most essential act of any contemporary artist today, and the activity that must be initiated in order for the contemporary artist to begin to make art, is the move to claim, for the first time, the ontological question *What is art?* from the point of view of the artist. Wittgenstein writes, "From its seeming to me — or to everyone — to be so, it doesn't follow that it is so. What we can ask is whether it can make sense to doubt it."[372] The contemporary artist must ask: what are the things about art that seem to everyone to be so? They are: art is truth, art is new, art is emancipatory, art is communication, art is language, art is spiritual, art is good, art is therapeutic, good art is beautiful, good art is true and true art is beautiful and good. The quantum artist responds to these claims with doubt.

In order to approach the ontological question *What is art?* the quantum artist must ask: Who am I as an artist? What do I do? What are my desires? For the entirety of Western history, these questions have been answered - by artists, philosophers, academics, critics and art-world members - by echoing the beliefs, suspicions and demands of Plato. And for the entirety of Western history, the being of art has been systematically ignored.

The art world felt betrayed[373] when Baudrillard proclaimed that contemporary art is "null."[374] Baudrillard writes, "Therein lies all the duplicity of contemporary

art: asserting nullity, insignificance, meaninglessness, striving for nullity when already null and void."[375] But the art world misheard Baudrillard. He was not attempting to destroy the artist's ability to make art or make a life for himself as an artist. Artists have already done that for themselves. Artists, most of all, have inflicted the demands of the dominant system-makers upon themselves. Baudrillard, with love in his heart, was trying to tear down all that is not art, in order that the self can begin to discover, for the first time, the being of art. Lotringer writes, "For Baudrillard art has nothing to do with art as it is usually understood. It remains a yet unresolved issue for post-humans to deal with — First one has to nullify art in order to look at it for what it is."[376]

The quantum artist must nullify the questions, beliefs, systems and language games that surround contemporary art and which have been held dear since the time of Plato. Is this art true? Is it good? Is it original? Is it real? Is it valuable? Each question is based on Plato's original suspicion of mimicry and his challenge to art: Prove that you are not less moral, truthful, useful and valuable than philosophy. Without Plato's demands, the project of Western art is without identity or function. In the absence of the will to prove art's validity, the artist becomes vulnerable. This uncertainty leaves art nameless. However, it is only through this utter nakedness, confusion and state of uncertainty that the artist can begin, for the first time, to make art. From the artist's point of view, the ability to play within uncertainty is to experience joy.

In order to make art, to be able to play with uncertainty and desire, the artist must claim the ontological questions surrounding his activity. He must not be in the position of answering the questions, Is it real? It is

original? Is it valuable? Answering these questions is part of a language game that has nothing to do with art. Instead, he must be in the position of asking the following questions from his own point of view: What is art? What are my desires? Why am I making this? And what will I do with it? This is not to say that the artist must become a philosopher in the tradition of Western philosophy. No. The artist must become his own philosopher in whatever method suits his needs. The artist must simply ask his own questions, with his own curiosity and desires in mind and without the fear that accompanies the contemporary insistence upon certainty.

5.2 Responsibility

The contemporary artist is past the time in which she can innocently claim that philosophy is irrelevant or outside of her practice. The contemporary artist is involved in a system, which is based on a set of philosophical beliefs and economic practices. To deny that the artist takes place in the system is false. Tom Beham writes:

> One case of corruption is one case of corruption, ten cases of corruption are ten cases of corruption, but a hundred cases of corruption is a system of corruption.--- Italian capitalism was and is part of that system. The stubborn denial of this, the idea that only single capitalists were involved and not capitalism, is to deny that there was a system, and at this point, almost deny the light of day…. Yet the responsibility for a system cannot be individual, it must be collective.[377]

The system in which contemporary artists partici-
pate is a betrayal to the being of art. The system includes
academia, the market and the common-sense views of
art that are practiced in daily life. There is no other path
than to take responsibility for this system. Responsibility
entails claiming the ontological question from the artist's
point of view and thereby creating an environment for
art which responds to the desires and uncertainty of art.

5.3 Remembering Plato

Contemporary artists are influenced by academia's un-
derstanding of the ontological status of art. Even when
contemporary artists separate themselves from academia
and/or philosophy, their basic intuitions about art re-
main. These intuitions have been created by the constant
attempt to answer Plato's challenge to prove that art is not
less moral, less real, less good, less true or less valuable
than philosophy. The quantum artist, then, must first
remember Plato and each of history's responses toward
his challenge. Only by remembering Plato can she begin
to separate her projects from those of Plato.

Hegel, Kant, Nietzsche, Heidegger, Benjamin and
Baudrillard each respond to Plato's challenge. Hegel de-
clares the death of art. He reasons that philosophy is the
superior method of producing truth, thus rendering art
useless except in the case of providing subject matter for
historical and philosophical analysis.[378] Kant, in an effort
to keep art alive, declares the necessity for an objec-
tive, disinterested evaluation of art by a third party (the
philosopher-critic).[379] In this way, art, which is otherwise
subjective, maintains a relationship to truth. Nietzsche
and Heidegger attempt to create the artwork as a truth in

and of itself: a truth that exists separately from the artist and the world. In doing so, they glorify art and alienate the artist. They treat art as a being, which, in its purest state exists like nature, as a self-producing truth phenomenon. Heidegger claims that the origin of the work of art is not the work, nor the artist, but the art itself. He writes:

> The artist is the origin of the work. The work is the origin of the artist. Neither is without the other. Nevertheless, neither is the sole support of the other. In themselves and in their interrelations artist and work *are* each of them by virtue of a third thing which is prior to both, namely that which also gives artist and work of art their names-art." [380]

Nietzsche treats art as a self-generating force that creates power. Agamben writes about Nietzsche's understanding of art:

> Art is the eternal self-generation of the will to power. As such, it detaches itself both from the activity of the artist and from the sensibility of the spectator to posit itself as the fundamental trait of universal becoming. A fragment from the years 1885-1886 reads: The work of art where it appears without an artist, e.g., a body, as organism///To what extent the artist is only a preliminary stage. The world as a work of art that gives birth to itself."[381]

Benjamin and Baudrillard attempt to separate art from its dependence upon the ideas of the original[382] and the real.[383] These ideas, they argue, have more to do with the project of modernism and the demands

of consumerism than with the nature of the being of art. But Benjamin and Baudrillard do not free art from truth, which sits at the base of the original and the real. They transfer the truth from the original to the political (Benjamin) and from the order of the real to the order of simulacra (Baudrillard). Both Benjamin and Baudrillard's arguments remain connected to a classical, Newtonian paradigm in which the definitions of the truth, the real, the original and the simulacrum are still meaningful.

The contemporary artist must embrace the nullification of art's ontological status in order to make the space to begin to ask the personal ontological questions. She does not need answers. She simply must allow herself to bathe in the uncertainty. For this is her desire: to become the substance of uncertainty, without the fear that leads to holding, knowing, naming and claiming.

Agamben points out that contemporary art has become both acceptable and useless precisely because it has left the realm of the artist's care.

> After characterizing man, insofar as he is the one who has…(that is, in the broad meaning the Greeks gave this term, the ability to pro-duce, to bring a thing from non-being into being), as the most uncanny thing there is, the chorus continues by saying that this power can lead to happiness as easily as to ruin, and concludes with a wish that recalls the Platonic ban on poets: "Not by my fire, / never to share my thoughts, who does these things." Edgar Wind has observed that the reason why Plato's statement is so surprising to us is that art does not exert the same influence on us as it did on him. Only because art has left the sphere of interest to become merely interesting do we welcome it so warmly."[384]

The contemporary artist must bring the ontological question back into the realm of her care, her senses, her desires, her techno-mind-body and her work. And she must ask without criticizing or judging. She must ask her questions without relying upon Plato's seeds of certainty and truth, which steadily grow into the need for originality, evaluation, newness and communication, all of which are of no interest to the being of art. The task therefore, of the contemporary artist is first to know Plato, and then to forget him.

In order to ask the ontological questions, the contemporary artist must choose to observe herself. When she observes herself, while allowing for her uncertainty as well as her desires, she becomes the quantum artist. Schirmacher writes, "*Homo generator*'s body politics is to see/hear/smell/touch/taste/think before you act, it claims aesthetic perception as the basis of comprehending and interaction."[385] The quantum artist needs no truth, no information, no text and no belief. The quantum artist makes a choice to observe that which was previously ignored, the uncertain and entangled nature of our being. Instead of reacting to uncertainty by creating new systems of belief, she observes her desire to play. Her play results in artifacts of uncertainty (quantum art), of which her techno-mind-body (*homo generator*) is one of many.

5.4 Forgetting: A Quantum Paradigm Shift

Plato asks, "Being is the sphere or subject-matter of knowledge, and knowledge is to know the nature of being? Yes."[386] The quantum artist disagrees. Stripped of the demands of Plato, the whole of Western philosophy, the scientific method, academia and the market, what

does the artist find? Uncertainty. Being is entanglement, potentiality and uncertainty. It cannot be known or turned into knowledge. The quantum artist is the artist who plays with being without fulfilling the demand to know it.

If the dominant system-makers have done anything worth celebrating, it is that no matter how hard they have tried to press art into the shape of truth, communication or knowledge, their efforts have only produced more and more uncertainty. The quantum artist celebrates this uncertainty. It is only within uncertainty that the artist confronts the choice to play and to observe her desires.

Upon choosing to allow for observation without certainty, expectation, conclusion, judgment, explanation or truth-procedures, the contemporary artist invokes a paradigm shift. She leaves a Newtonian and Platonic world dominated by ideas of definite and finite matter, causality, evaluation, truth and transcendence and enters a quantum paradigm. In the quantum paradigm, the process of observation is the process of creation.

In allowing for mimesis without certainty, she encounters the entanglement. The quantum artist finds herself connected to every being and every thing. She finds that she is not related to others and to the world. She *is* others. And she *is* the world.

Physicist Aaron O'Connell conducted an experiment in which the naked eye can actually see an object (a piece of metal) in a quantum position. The object exists in two places at once.[387] This experiment begins to bridge the gap between the quantum world, which so far, we have not been able to see, and the classical world, which we believe that we experience. O'Connell says:

If a single atom can be in two different places at the same time, and that chunk of metal can be in two different places, then why not you?...So imagine if you were in multiple places at the same time. What would that be like? How would your consciousness handle your body being delocalized in space?...You hear a lot of talk about how in quantum mechanics it's all interconnected—well, that's not quite right. It's more than that. It's deeper. It's that those connections, your connections to all the things around you, literally define who you are. And that's the profound weirdness of quantum mechanics.[388]

The entangled state is not an abstraction. The quantum artist discovers her state as an entangled being through her senses, her body, her mind and her tools. When she encounters her entanglement and her potentiality, the quantum artist resists the demand to criticize, explain or hypothesize. Instead, she plays. The quantum artist plays by observing, imagining and creating uncertain and potential events, beings, artifacts and worlds. Baudrillard asks:

Why couldn't there be just as many real worlds as imaginary ones? Why would there only be one real world? Why such an exception? In truth, the real world, among all other possible worlds, is unimaginable. Unthinkable, except as a dangerous superstition. We have to separate ourselves from it like critical thought once detached itself (in the name of reality) from religious superstition. Thinkers, try again![389]

Baudrillard suggests, "The absolute rule of thought is to return the world as it was given to us—unintelligible—and if possible a little more unintelligible. A little more enigmatic."[390] In order to respond to uncertainty with the play of the creation of uncertainty, the quantum artist must forget. She must forget Plato. She must forget her knowledge. She must forget her beliefs. She must forget her judgments. She must forget her certainty. And forgetting must be a choice. She must know what she is forgetting and make the choice to forget.

5.5 Choice, Play and Consciousness

The being of art creates through observation of all potential realities: imagined realities, lived realities and remembered realities. The body desires to create herself: to become herself. She does so continuously through the process of mimesis. She observes infinite potential realities and then makes a choice. The quantum artist is the artist who not only observes the being of art, but allows herself to play with the being of art. Play necessitates both the awareness of potentials and the ability to choose.

The quantum artist must choose to become quantum artist. The choice to observe and to play must be re-made continuously. Observation, imagination, creation, desire, play and uncertainty are natural to the techno-mind-body. On the contrary, the dominant language games demand that we ignore the uncertainties of our selves, our bodies, our desires, our observations and our artworks.

The discipline to continuously choose one's desires, to choose play and to choose uncertainty, brings the quantum artist joy. For Rainer Maria Rilke…

...one is still so far away from being able to work at all times. Van Gogh could perhaps lose his composure, but behind it there was always his work, he could no longer lose that. And Rodin, when he's not feeling well, is very close to his work, writes beautiful things on countless pieces of paper, reads Plato and follows him in his thought. But I have a feeling that this is not just the result of discipline or compulsion (otherwise it would be tiring, the way I've been tired from working in recent weeks); it is all joy; it is natural well-being in the one thing that surpasses everything else. Perhaps one has to have a clearer insight into the nature of one's "task," get a more tangible hold on it, recognize it in a hundred details. I believe I do feel what van Gogh must have felt at a certain juncture, and it is a strong and great feeling: that everything is yet to be done: everything.[391]

The joy of the quantum artist's choice renders the world infinite. There is endless space to play and endless matter with which to play. The popular notion of the end (of play, of art, of mimesis, of imagination) is a function of the dominant paradigm of Newtonian certainty. The quantum artist fears no end.

The quantum artist is able to play because she suspends her beliefs in certainty. She must suspend her beliefs in order to see more of the potential realities that surround her. She tries to stop ignoring the being of art. Baudrillard writes:

A certain form of thinking supports reality. It starts with hypothesis that there is a real reference for ideas and a possible ideation of reality. The

perspective of meaning and deciphering is a comforting point of view. Its polarity is found in ready-made dialectical and philosophical solutions. The other thought is on the contrary, exterior to reality, ex-centered from the real world- and therefore outside dialectics, which plays on opposing poles, and even outside critical thinking, which always refers to an ideal reality. In fact, it is not even a degeneration of the concept of reality. It is illusion, in other words a play with reality...[392]

The quantum artist plays by facing the infinite potential, choosing one possibility amongst the many and creating a transient asymmetrical event. She plays without belief, certainty, desire for transcendence or the hope of emancipation. Her choice to play (her discipline), in full awareness of her lack of belief, signals a paradigm shift from a Newtonian world to a quantum world. This shift does not change the being of art. It simply allows the quantum artist to observe herself as she already is. According to Baudrillard:

Belief in reality is one of the elementary forms of religious life. It is a weakness of the understanding, a weakness of common sense, and also the final stand of the moral zealots, the apostles of the legality of reality and rationality who say that the reality principle can never be cast in doubt. Fortunately, no one lives according to this principle, not even those who profess it, and for good reason. No one fundamentally believes in reality or in the evidence of his or her real life.[393]

Her choice (to observe herself as uncertainty) and her activity (to play with uncertainty) do not relieve her of pain, suffering or death. Her activity simply allows her to be as she is, an entangled being, endlessly creating herself and her world through the play of observation, imagination and creation.

In each moment of choice, the quantum artist becomes aware of her consciousness. She watches herself choose. In moments in which the quantum artist does not choose, she is not unconscious. She is in a state in which she observes infinite potential. It is the moment of choice that makes *homo generator* who she is: a being capable of creating her own reality. Amit Goswami writes, "Apparently, choice is a concomitant of conscious experience but not of unconscious perception. Our subject-consciousness arises when there is a choice made: *We choose, therefore we are.*"[394]

5.6 Function

What is the function of quantum art? It is easy to see what the function of quantum art is not. Quantum art does not produce understanding, truth, belief, certainty, newness, communication, originality or value. The play of mimesis does not alleviate pain, communicate the incommunicable or bring the self closer to transcendence. The being of art is indifferent to these functions. Historically, we have assigned functions to art that do not relate to art itself.

John Berger writes, "Mystification is the process of explaining away what might otherwise be evident."[395] What is evident to the quantum artist is the need for uncertainty in order to play, the joy of playing and the disci-

pline involved in making the choice to play. Further, the quantum artist finds that play is not rare or exceptional, but constant and common. The quantum artist must only choose to observe it.

Stripped of false functions and glorified ideas about the meaning of art, what can the quantum artist say about the function of the being of art? She can say only that the process of mimetic play is integral to all humans and occurs as incessantly as breathing. It occurs with or without the acceptance of the self, the academy or the world. Yet without acknowledging or observing mimetic play, the self survives. Becoming the quantum artist does not seem to be a matter of survival. The desire of the being of art persists in danger and pain as well as in health and joy. Yet it does not protect us from death or suffering.

The function of quantum art may have something to do with becoming uncertainty, of becoming entangled, of becoming potentiality, of becoming itself. The function of quantum art may have something in common with love, a process we cannot deny, yet one whose function remains mysterious. So what can the artist really say about the function of quantum art? She simply wishes to proclaim, out loud, that its function is a mystery. Denying that art has a function is like denying that we exist as part of a system or denying that our cells and organs have jobs. The quantum artist wishes only to face the mystery, sort out those functions that do not belong to her, and allow herself the joy of forgetting. She wishes to forget the certainty of being, function and reality. The quantum artist strives for the forgetting that allows her to play— the kind of play that an adult enacts, when she faces the world around her and allows it to be as potential and uncertain and entangled as she observes it to be.

5.7. Language

The quantum artist questions whether the being of art operates with a language of its own or exists in a language-less state. Sylvère Lotringer suggests that some artists are able to "think without words."[396] Contemporary artists comfortably refer to "the language of art" and generally assume that art has "its own language." The "language" to which they refer is compiled of the formal and nameable characteristics of art (shape, composition, space, color, texture, scale, size, symmetry, etc.) and their relationship to art history. However, we should not assume that naming characteristics can translate objects into communication, or that art history can tell us anything about the being of art. Regardless, contemporary artists continue to assume that the content of an artifact must be transmitted to the viewer through language. Who creates this need?

Heidegger points out that philosophy has long felt a pressure to prove that it is of equal merit to the science. He writes:

> Since then "philosophy" has been in the constant predicament of having to justify its existence before the "sciences." It believes it can do that most effectively by elevating itself to the rank of a science. But such an effort is the abandonment of the essence of thinking.[397]

Similarly, the contemporary artist has attempted to elevate his artifact to the level of language. Particularly, the contemporary artist aims to translate his artifact into a language of value, explanation, justification, hypothe-

sis and communication. This project is a betrayal of the being of art. The need for a language of certainty emerges from academia, the market and the scientific method.

The quantum artist observes that if art has a language of its own, that language, along with its rules and games, is unknown.[398] Further, contemporary artists have not yet invented a way to speak about the being of art in a way that allows for art's essential uncertainty. Leland del la Durantaye writes, "[W]e lack simple and straightforward terms for discussing potentiality in what Agamben refers to as its pure state—potentiality independent of its actualization."[399] When the dominant language of certainty is applied to the being of art or the quantum artifact, a non-conflict differend occurs.[400]

When one group's language games are applied to a second group, wherein the second group uses a different set of language games, the second group is rendered powerless to express its needs within the system of the first group's language games.[401] Lyotard calls this situation the differend and warns of the injustice that occurs. The quantum artist claims that this differend incurs no injustice for the being of art or the quantum artist. The being of art is indifferent to the dominant language of certainty. However, the non-conflict differend directs the attentions of the artist away from the desires of the being of art. The constant challenge of the quantum artist is to separate the desires of the dominant paradigm from her own.

5.8 Empathy and Anti-Ethics

Schirmacher writes, "The self is in no way satisfied by being apart and single."[402] The quantum artist inevitably becomes more and more entangled. This entanglement,

much like the sexual act, is a manifestation of the ulti-
mate desire of the self. The self desires to observe her
connection to every other being and every other world,
such that she does not find herself communicating with
another. Instead, she feels herself becoming another, feels
another becoming herself, and feels the world and herself
becoming, together.

What does the being of art do? It allows the self to
become herself; to become entangled and uncertain. In
becoming aware of herself as an entangled being, she be-
comes more empathetic. Empathy is not a choice, but an
inevitable fact of her entangled existence. Her empathy
leads her toward an anti-ethic: an inability to recognize,
judge or believe in an enemy or any distinct and separate
other. An ethical decision, according to the quantum
artist, is always a failure.

This entangled being, to which the being of art
strives to become, is not better than any other being. Her
empathy does not make her more intelligent, more crit-
ical, more philosophical, or more truthful. Her empathy
simply allows her to fulfil her desire: to become herself:
entangled and uncertain. Is the generation of empathy
and uncertainty the true function of art?

It is tempting to conclude that the function of the
being of art is to produce the post-human, the evolved
human, the x-man[403]. It is tempting to imagine that this
future human, the *homo generator*, is a more empathet-
ic being, whose philosophy is an anti-ethics; a disbelief
in enemies or separation between humans and world.
However, this conclusion would merely be a result of
the application of the dominant language games, which
call for a transcendental art, one that yields emancipated
humans. The only conclusion that the quantum artist can

draw, in full acceptance of entanglement and uncertainty, is that the being of art desires to play and that this play is the observation, imagination and creation of uncertainty. The function of this play remains unknown.

5.9 The Entanglement

The quantum artist does not reveal the world through her work. Karen Barad writes, "Science is not a method for pulling back the curtains on Nature and exposing her essence. "[404] Instead, the quantum artist allows the world to become less clear and more uncertain. In place of revelation, the quantum artist encounters the entanglement. There is no need, therefore, for a struggle or journey. The quantum artist must simply stand still, pay attention, and allow the entanglement to appear around her. At first, it may seem that she is being tethered to the world. But she slowly finds that the vines that bind her are nothing other than potentiality, uncertainty and the substance of self. She is not tethered to anyone or anything. She is becoming uncertainty. As she allows herself to see, feel, touch, smell, hear[405] and approach her own entanglement with every tool of her creation and being, she becomes more and more aware that she is the world, she is the other, she is desire and she is pure uncertainty.

The quantum artist trusts her desires, her playfulness, her senses and her entanglement. She does not fear the difference between her imagination, her creation, her observation, her reality and her desire. This fear is based on a distrust of play. Bohm writes:

This notion of falseness that can creep into the
play of thought is shown in the etymology of the
words illusion, delusion, and collusion, all of which
have as their Latin root *ludere*, "to play." So illusion
implies playing false with perception: delusion,
playing false with thought; collusion, playing false
together in order to support each other's illusions
and delusions.[406]

The fear of play, imagination and imitation is relat-
ed to a distrust of secrets. But nature does not harbor
secrets, which artists observe, uncover, measure and
share. Karen Barad points out that, "The word 'secret'
comes from Latin *secretus*, the past participle of *secerne-
re* (to separate or set apart)."[407] The quantum artist does
not separate herself from the uncertain entanglement
of nature. She claims no difference between the real, the
representation and the illusion. All is the substance of
symmetrical potential and uncertainty. She needs only
her senses and the tools of her techno-mind-body. She
becomes, not more trustworthy, truthful or ethical, but
more uncertain, more empathetic and more entangled.

Her empathy is her substance and her tool, a procla-
mation of her anti-ethics. She does not fear her decisions.
She does not recognize her enemies. Her empathy is not
therapeutic, ethical, truthful or capable of accessing the
un-namable. Her empathy simply allows her to become
herself and to care for her self. In caring for herself, she
cares for others and for the world. She cares for herself
not as a prize but as the ever-changing whole, which is
uncertain, potential and infinite. Schirmacher writes,

> *Homo generator* has no fear of his or her mistakes,
> for they are inseparable from his or her succeed-
> ing-as body politics teaches us. Responsibility also
> means being able to assume one's guilt and to reject
> blame for anything you have not caused yourself.
> *Homo generator* is a substantial beginning, unique
> but not original, self-care without egotism.[408]

The quantum artist cares for herself as the substance
of uncertainty in the way that one cares for the ocean; in
full awareness of its infinite nature and potential and of
the self's inability to hold it, know it, measure it, possess
it, keep it or otherwise turn it into truth, proof or cer-
tainty. The self cares for the ocean of potentiality, not out
of necessity or ethics but because the ocean is the self,
the world and the other. The quantum artist becomes the
world, becomes the other, becomes herself and in doing
so becomes the activity and substance of the entanglement.

5.10 Mimesis and Becoming Infinite

The quantum artist does not fear mimesis, imitation,
representation or observation. Mimesis is the being's
fundamental method of becoming. The quantum artist
creates her self, her world and her art, by acknowledging
her desire to observe, imagine and create an uncertain
world. Mimesis is a tool of the body, like the cell, the
organ or the eye. Deleuze and Guattari name this type of
observation "contemplation," which they relate to sensa-
tion. They write, "Sensation is pure contemplation, for
it is through contemplation that one contracts, contem-
plating oneself to the extent that one contemplates the
elements from which one originates. Contemplating is

creating, the mystery of passive creation, sensation. "[409] Deleuze and Guattari also recollect Plotinus, who argues that all things, not just humans or animals, contemplate. They write, "The plant contemplates by contracting the elements from which it originates—light, carbon, and the salts—and it fills itself with colors and odors that in each case qualify its variety, it composition: it is sensation in itself. "[410]

The quantum artist does not place mimesis below the realm of the real or the true (Plato, Hegel). But she also does not glorify mimesis by regarding it as a unique form of the real or the true (Badiou, Heidegger, Benjamin). Rather, the quantum artist attempts to forget the distinctions between the original, the real, the imitation and the simulacrum. These distinctions are based in an incomplete view of reality; a static, causal, finite, Newtonian Reality. The Quantum Artists gently lets go of the Platonic obsession of dividing the real from the fake. Deleuze writes,

> We are now in a better position to define the totality of the Platonic motivation: it has to do with selecting among the pretenders, distinguishing good and bad copies or, rather, copies (always well-founded) and simulacra (always engulfed in dissimilarity)...The great manifest duality of Idea and image is present only in this goal: to assure the latent distinction between the two sorts of images and to give a concrete criterion.[411]

Deleuze defines the Platonic distinction between idea, imitation and false imitation (simulacrum) in this way:

> The copy is an image endowed with resemblance, the simulacrum is an image without resemblance. The catechism, so much inspired by Platonism, has familiarized us with this notion. God made man in his image and resemblance. Through sin, however, man lost the resemblance while maintaining the image. We have become simulacra.[412]

Further, Deleuze writes:

> What does it mean "to reverse Platonism"? This is how Nietzsche defined the task of his philosophy or, more generally, the task of the philosophy of the future. The formula seems to mean the abolition of the world of essences *and* of the world of appearances. Such a project, however, would not be peculiar to Nietzsche. The dual denunciation of essences and appearances dates back to Hegel or, better yet, to Kant. It is doubtful that Nietzsche meant the same thing. Moreover, this formula of reversal has the disadvantage of being abstract; it leaves the motivation of Platonism in the shadows. On the contrary, "to reserve Platonism" must mean to bring this motivation out into the light of day, to "track it down"-the way Plato tracks down the Sophist.[413]

The quantum artist seeks to understand the motivations for Platonism so that she may separate her own desires from those of Platonism and its many reincarnations. That which is not her desire, she seeks to forget.

Spinoza regards the image or idea as the realization of the limit of our consciousness (a consciousness, which he directs toward the project of understanding). Deleuze defines Spinoza's approach to consciousness in this way:

> CONSCIOUSNESS.- The idea's property of du-
> plicating itself, of redoubling to infinity: the idea
> of the idea. Every idea represents something that
> exists in an attribute (objective reality of the idea);
> but it is itself something that exists in the attribute
> of thought (form or formal reality of the idea); so it
> is the object of another idea that represents it, etc.[414]

In Spinoza's understanding, consciousness is the ac-
tivity of mimesis put toward the purpose of understand-
ing. Further, Deleuze writes:

> What does Spinoza mean when he invites us to take
> the body as a model? It is a matter of showing that
> the body surpasses the knowledge that we have of
> it, *and that thought likewise surpasses the conscious-
> ness that we have of it.*[415]

The image or idea of which we are conscious is not
necessarily representative of the world. It simply represents
the boundary of our understanding of the world. None-
theless, Spinoza echoes Plato in that he regards the func-
tion of mimesis as the attempt to understand. From Plato
onward, the history of aesthetic philosophy is the history
of relating artifacts to being via understanding. Why?

Aesthetic philosophy is grounded in the relationship between image-production, being and understanding because there is a fundamental incongruity between the experience of observing reality and our scientific understanding of reality. Aesthetic philosophy attempts to reconcile the artist's instinct to observe, imagine and create *past, beyond, behind, around or otherwise other than* what is believed to be known. Aesthetic philosophy attempts to answer the following questions: Is the artist's image an accurate depiction of reality? If not, is the artist prescient? Is the artist lying? Is the artist confused? Does accurate mimesis infer understanding of reality?

The quantum artist claims that the instinct toward mimesis has little to do with understanding and even less to do with the attempt to accurately represent reality (even realistic work is not made with the express purpose of accurately representing reality). The project of Western aesthetic philosophy has been, at best, distracted from the artist's desires and at worst, a betrayal of the artist's desires. Aesthetic philosophy's derailment results from the inability to answer the following question: How does mimesis relate to the infinite and uncertain?

The Newtonian paradigm treats reality as a finite state. But observation, imagination and creation (mimesis) appear to be infinite. The more the artist observes the world, the more it expands, contracts, disappears, reappears, multiplies and changes. Giacometti expressed this sensation when he wrote, "The distance between one side of the nose and the other is like the Sahara. "[416] How can a finite reality relate to an infinite

contemplation? The infinite nature of mimesis and its mysterious function is such an unsolvable problem that aesthetic philosophy has created other functions for art *besides* mimesis (therapy, ethics, expression, communication, understanding and the creation of Truth or relative truths).

The quantum artist claims that mimesis is at the heart of art's being. Mimesis is simply the word for observation, imagination and creation, in a world that is not certain, (a world that is contrary to our Newtonian common sense). The artist does not play with mimesis in order to understand. Nor does she play with mimesis for the sake of truth, belief, ethics, therapy or communication. The artist's activity is far more basic. Mimesis is the way in which we become ourselves. And the artist plays with this ability. She plays with mimesis because it is her desire.

The desire to *play* with mimesis is the desire to allow for the observation, imagination and creation of reality in the form of uncertainty. Without uncertainty there is no room for choice, surprise or chance. Without uncertainty, play becomes impossible. In playing with mimesis she becomes herself, she becomes her environment and she becomes the other. The quantum paradigm shift suggests that reality itself is just as infinite and uncertain as the artist's experience of mimesis.

In letting go of Plato's concerns, the Quantum Artist lets go of the entirety of aesthetic philosophy and thus faces a new beginning. Deleuze writes:

> To impose a limit on this becoming, to order it according to the same, to render it similar—and, for that part which remains rebellious, to repress it as deeply as possible, to shut it up in a cavern at the bottom of the Ocean—such is the aim of Platonism in its will to bring about the triumph of icons over simulacra.[417]

The quantum artist claims that the activity of mimesis is not a rarity, a separation or an exception to everyday life. On the contrary, mimesis is constant. It is that which creates the material of everyday life. It is the activity that creates consciousness. We observe infinite possibilities. In choosing one, we create our reality as such. In this transient moment, we observe our self, in the process of observing our world. We name this moment "consciousness". It is time to pay attention to the powers and mysteries of mimesis, consciousness, and the quantum paradigm shift. Our world is an infinite, uncertain, simultaneous, potential world. And each time that the Quantum Artist observes it, she creates it. In the face of this uncertainty, she becomes herself.

Bibliography

Abdunner, Sharif and Harley, JS. *Laughter Under the Bombs.* Bloomington, Indiana: Author House, 2007.

Abdunner, Sharif. *The Necessity of Terrorism.* New York and Dresden: Atropos Press, 2010.

Abram, David. *The Spell of the Sensuous.* New York: Random House, 1997.

Adorno, Theodor. *Aesthetic Theory.* Ed and Trans. Robert Hullot-Kantor. Minneapolis: University of Minnesota Press, 1998.

__. *Negative Dialectics.* Trans. E.B. Ashton. New York: Continuum, 1973.

Agamben, Giorgio. *The Man Without Content.* Trans. Georgia Albert. Stanford: Stanford University Press, 1999.

__. *State of Exception.* Trans. Kevin Attell. Chicago: The University of Chicago Press, 2005.

__. *The Coming Community.* Trans. Michael Hardt. Minneapolis: University of Minnesota Press, 1993.

Agazzi, Evandro. *Scientific Objectivity and Its Contexts.* Mexico City: Springer, 2014.

Althusser, Louis. *Lenin and Philosophy.* Trans. Ben Brewster. London: NLB, 1971.

Anderson, Walter Truett (Editor). *The Truth about the Truth, Deconfusing and Re-constructing the Postmodern World.* New York: Putnam Publishing Group, 1995.

Anker, Michael. *The Ethics of Uncertainty.* New York and Dresden: Atropos Press, 2009.

Arendt, Hannah. *The Human Condition.* Chicago: University of Chicago Press, 1958.

Arendt, Hannah and Heidegger, Martin. *Letters 1925-1975. Hannah Arendt and Martin Heidegger.* Ed. Ursula Ludz. Trans. Andrew Shields. New York: Harcourt, Inc., 2004.

Aristotle. *Physics.* Trans. Waterfield, Robin. Oxford and New York: Oxford University Press, 1996.

__. *Poetics.* London: Penguin Books, 1996.

Asimov, Isaac. *Chronology of Science and Discovery.* New York: Harper and Row, 1989.

Badiou, Alain. *Being and Event.* Trans. Oliver Feltham. London and New York: Continuum, 2005.

__. *Deleuze, The Clamor of Being.* Trans. Louise Burchill, Minneapolis: University of Minnesota Press, 2000.

__. *Handbook of Inaesthetics.* Trans. Alberto Toscano. Stanford: Stanford University Press, 2005.

__. *Infinite Thought.* Trans. Justin Clemens. New York: Continuum, 2003.

Badiou, Alain and Zizek, Slavoj. *Philosophy in the Present.* Ed. Peter Engelmann. Trans. Peter Thomas and Alberto Toscano. Cambridge: Polity Press, 2009.

Bandini, Mirella. *L'estetico, il politico. Da Cobra all'Internazionale Situazionista 1948-1957.* Ancona: Costa & Nolan, 1977.

Barad, Karan. *Meeting the Universe Halfway, Quantum Physics and the Entanglement of Matter and Meaning.* Durham and London: Duke University Press, 2007.

Bataille, Georges. *Eroticism: Death and Sensuality.* Trans. Mary Dalwood. San Francisco: City Lights Books, 1982.

__. *The Cradle of Humanity. Prehistoric Art and Culture.* Ed. Stuart Kendall. Trans. Michelle Kendall and Stuart Kendall. New York: Zone Books, 2005.

Baudrillard, Jean. *Art and Artifact.* Ed. Nicholas Zurbugg. London and New Delhi: Sage Publications, 1997.

___. *Selected Writings.* Ed. Mark Poster. Stanford: Stanford University Press, 1988.

___. *Simulacra and Simulation,* Trans. Sheila Faria Glaser. The University of Michigan Press, 1994.

___. *The Conspiracy of Art.* Ed. by Sylvère Lotringer. Trans. Ames Hodeges. New York: Semiotexte(e), 2005.

___. *The Spirit of Terrorism,* Trans. Chris Turner, London: Verso, 2002.

___. *The Intelligence of Evil or the Lucidity Pact.* Trans. Chris Turner, Oxford and New York: Berg, 2005.

___. *The Spirit of Terrorism and Requiem for the Twin Towers.* Verso, 2002.

Beauvoir, Simone de. *The Second Sex.* Trans H.M. Parshley, New York: Bantam, 1952.

Behan, Tom. *See Naples and Die, The Camorra and Organized Crime,* London and New York: I.B. Tauris Publishers, 2002.

Benjamin, Walter. *Illuminations.* Trans. Harry Zohn. New York: Schocken Books, 1968.

Berger, John. *Bento's Sketchbook.* London and New York: Verso, 2011.

___. *Collected Essays.* New York: Vintage Books, 2003.

___. *Hold Everything Dear, Dispatches on Survival and Resistance.* London: Verso, 2007.

___. *Ways of Seeing.* London: British Broadcasting Corporation and Penguin Books, 1972.

Bergson, Henri. *Creative Evolution.* New York: Barnes and Noble Books, 2005. (Originally published in 1907)

Bible, John, 8:32

Bitbol, Michel. *Schrödinger's Philosophy of Quantum Mechanics.* The Netherlands: Kluwer Academic Publishers, 1996.

Blaisdell, Bob. Ed. *The Communist Manifesto and Other Revolutionary Writings.* New York: Dover Publications, 2003.

Boden, A. Margaret. Ed. *The Philosophy of Artificial Life.* Oxford and New York: Oxford University Press, 1996.

Bohm, David. *On Creativity.* Ed. Lee Nichol. London and New York: Routledge, 1998.

__. *Quantum Theory.* New York: Dover Publications, 1951.

__. *Science, Order and Creativity.* New York: Bantam Books, 1987.

__. *Wholeness and the Implicate Order.* London: Routledge, 1980.

Bohr, Niels. *The Philosophical Writings of Niels Bohr. Volume Three. Essays 1958-1962 on Atomic Physics and Human Knowledge.* Woodbridge, CT: Ox Bow Press, 1963.

Borges, Jorge Luis. *Ficciones.* Trans. Emece Editores. New York: Grove Press, 1962.

Born, Max. *The Born-Einstein Letters; Correspondence between Albert Einstein and Max and Hedwig Born from 1916 to 1955,* Walker, New York, 1971.

Boslough, John. *Stephen Hawking's Universe. An Introduction to the Most Remarkable Scientist of Our Time.* New York: William Morrow and Company, 1985.

Bricmont, Jean and Sokal, Alain. *Fashionable Nonsense: Postmodern Intellectuals' Abuse of Science.* New York: Picador, 1998.

Bray, Gregory. *Sovereignty and Singularity: Aporias in Ethics and Aesthetics.* New York and Dresden: Atropos Press, 2011.

Brentano, Franz. *Psychology From An Empirical Standpoint.* Trans. Antos Rancurello, D.B. Terrell, Linda McAlister. Ed. Linda McAlister. London and New York: Routledge, 1973.

Brunette, P. and Wills, D. Eds. *Deconstruction and the Visual Arts.* New York: Cambridge University Press, 1993.

Butler, Judith. *Gender Trouble: Feminism and the Subversion of Identity* New York: Routledge, 1990.

Butler, Judith, Ernesto, Laclau and Slavoj Zizek. *Contingency, Hegemony, Universality Contemporary Dialogues on the Left.* London and New York: Verso, 2000.

Capra, Fritjof. *The Tao of Physics.* Boston: Shambhala, 1991.

Carroll, David (Ed.). *The States of 'Theory'. History, Art, and Critical Discourse.* Stanford: Stanford University Press, 1990.

Chalmers, David J., Hameroff, Stuart R., Kaszniak, Alfred W. Eds. *Toward a Science of Consciousness III. The Third Tucson Discussions and Debates.* Cambridge, MA: MIT Press, 1999.

Chipp, Herschel B. Ed. *Theories of Modern Art.* Berkeley: University of California Press, 1968.

Choat, Simon. *Marx Through Post-Structuralism. Lyotard, Derrida, Foucault, Deleuze.* New York: Continuum, 2010.

Cixous, Helen and Catherine Clement. *The Newly Born Woman.* Trans. B. Wing. Minneapolis: University of Minnesota Press, 1986.

Critchley, Simon, *The Book of Dead Philosophers.* New York: Random House, 2008.

Dawking, Richard, *The Greatest Show on Earth: The Evidence for Evolution.* New York: Free Press, 2009.

Debord, Guy. *The Society of the Spectacle.* Trans. Donald Nicholson-Smith. New York: Zone Books, 1995.

Deleuze, Gilles. *Pure Immanence.* Trans. Anne Boyman, New York: Zone Books, 2001.

___. *Spinoza: Practical Philosophy.* City Lights Publishers; First Edition in English edition: 2001.

__. *The Logic of Sense,* trans. Mark Lester with Charles Stivale, Edited by Constantin V. Boundas, Columbia University Press, New York, 1990.

__. *Two Regimes of Madness.* Ed. David Lapoujade. Trans. Ames Hodges and Mike Taromina. New York: Semiotexte(e), 2006.

Deleuze, Gilles and Félix Guattari. *Capitalism and Schizophrenia, Volume 1:Anti-Oedipus.* Trans. Robert Hurley. London: Athlone Press, 1977.

__. *Capitalism and Schizophrenia, Volume 2: A Thousand Plateaus.* Trans. Brian Massumi, Minneapolis, University of Minnesota Press, 1987.

__. *What is Philosophy?* Trans. Hugh Tomlinson and Graham Burchell. New York: Columbia University Press, 1991.

Derrida, Jacques. *Of Grammatology.* Trans. Gayatri Chakravorty Spivak. Baltimore: Johns Hopkins University Press, 1976.

Derrida, Jacques, *The Truth in Painting.* Trans. Geoff Bennington and Ian McLeod. Chicago: University of Chicago Press, 1987.

Descartes, René, *The Philosophical Writings of Descartes, Volume 1.* Trans. John Cottingham, Robert Stoothoff and Dugald Murdoch. Cambridge: Cambridge University Press, 1985.

Dewey, John. *Art as Experience.* New York: The Berkley Publishing Group, 1934.

Diderot, Denis. *Thoughts on the Interpretation of Nature and Other Philosophical Works.* Manchester: Clinamen Press, 1999.

__. *On Art and Artists: An Anthology of Diderot's Aesthetic Thought.* Ed. Jean Seznec. Trans. John Glaus. New York: Springer, 2011.

Dreyfus, Hubert and Wrathall, Mark. *Heidegger Reexamined. Volume Four.* New York: Routledge, 2002.

Durantaye, Lelande de la. *Giorgio Agamben. A Critical Introduction.* Stanford: Stanford University Press, 2009.

Durham, Meenakshi Gigi and Kellner, Douglas. Eds. *Media and Cultural Studies Keyworks.* Malden and Oxford: Blackwell Publishers, 2001.

Dutton, Denis. *The Art Instinct. Beauty, Pleasure, and Human Evolution*, New York: Bloomsbury Press, 2010.

Einsten, Albert and Infeld, Leopold. *The Evolution of Physics. From Early Concepts to Realtivity and Quanta.* New York: Simon and Schuster, 1966.

Foucault, Michel, *Manet and the Object of Painting.* London: Tate Publishing, 2010.

___. *Madness and Civilization: A History of Insanity in the Age of Reason.* Trans. Richard Howard. London: Tavistock, 1967.

___. *Discipline and Punish: The Birth of the Prison.* Trans. Alan Sheridan. Harmondsworth: Penguin Books, 1979.

___. *The History of Sexuality Volume 1: An Introduction.* Trans. Robert Hurley. New York: Vintage Books, 1980.

___. *The History of Sexuality Volume 2: The Use of Pleasure.* Trans. Robert Hurley. New York: Vintage Books, 1985.

___. *The History of Sexuality Volume 3: The Care of the Self.* Trans. Robert Hurley, New York: Vintage Books, 1985.

___. *This is Not a Pipe.* Trans. and Ed. James Harkness. Berkley: University of California Press, 1986.

Freud, Sigmund. 1976. *The Interpretation of Dreams.* Trans. James Strachey, Harmondsworth: Pelican Books, 1976.

___. *General Psychological Theory.* New York: Touchstone, 1991.

Geulen, Eva. *The End of Art. Readings in a Rumor after Hegel.* Trans. James McFarland. Stanford: Stanford University Press, 2006.

Ghandi, Mohandas K. *An Autobiography The Story of My Experiments with Truth*. Trans. Mahadev Desai. Boston: Beacon Press, 1993.

Goldblatt, David and Brown, Lee B. *Aesthetics, A Reader in Philosophy of The Arts*. Upper Saddle River, New Jersey: Prentice Hall, 1997.

Golombok, Susan and Fivush, Robyn. *Gender Development*. Cambridge: Cambridge University Press, 1994.

Goswami, Amit. *The Self-Aware Universe. How Consciousness Creates the Material World*. New York: Penguin Putnam, 1993.

Greenberg, Clement. "Avant-Garde and Kitsch." Partisan Review. 6:5 (1939) 34-49.

Gribbin, John. *In Search of Schrödinger's Cat. Quantum Physics and Reality*. New York: Bantam Books, 1984.

Grigg, Russel. *Lacan, Language and Philosophy*. Albany: State University of New York Press, 2008.

Hagberg, G. L. *Art as Language: Wittgenstein, Meaning and Aesthetic Theory*. Ithaca: Cornell University Press, 1995.

Hallward, Peter. *Out of this World. Deleuze and the Philosophy of Creation*. London and New York: Verso, 2006.

Haraway, Donna. *Simians, Cyborgs, Women: The Reinvention of Nature*. London: Routledge, 1991.

Hardy, G.H., *A Mathematician's Apology*. Cambridge: Cambridge University Press, 1940.

Hardt, Michael and Negri, Antonio. *Empire*. Cambridge: Harvard University Press, 2001.

___. *Multitude. War and Democracy in the Age of Empire*. New York: Penguin Press, 2004.

Harvey, David. *Brief History of Neoliberalism*. Cambridge: Blackwell, 1990.

Hegel, G.W.F. *Phenomenology of Spirit.* Trans. A.V. Miller. Oxford: Clarendon Press, 1977.

__. *Introductory Lectures on Aesthetics.* Ed. Michael Inwood. Trans. Bernard Bosanquet. London: Penguin Books, 1993.

Heidegger, Martin. *Basic Writings.* Ed. David Farrell Krell. New York: HarperCollins, 1977, 1993.

__. *Being and Time.* Trans. John Macquarrie and Edward Robinson. New York: Harper & Row, 1962.

__. *On Time and Being.* Eds. J. Glenn Gray and Joan Stambaugh. Trans. Joan Stambaugh. New York: Harper & Row, 1969.

__. *The Basic Problems of Phenomenology.* Indiana University Press, 1988.

__. *The Question Concerning Technology and Other Essays.* Trans. William Lovitt, New York: Harper and Row, 1977.

__. *What is Called Thinking?* Trans. J. Glenn Gray. New York: Harper and Row, 1968.

Heisenberg, Werner. *Encounters with Einstein and Other Essays on People, Places, and Particles.* Princeton: Princeton University Press, 1983.

__. *Physics and Philosophy. The Revolution in Modern Science.* Amherst, NY: Prometheus Books, 1999.

Hickey, Dave. *The Invisible Dragon. Essays on Beauty.* Chicago and London: The University of Chicago Press, 2009.

__. *Air Guitar. Essays on Art and Democracy.* Los Angeles: Art Issues. Press, 1997.

Hoffman, Hans. *Search for the Real.* Ed. Sara Weeks and Bartlett Hayes, Jr. Cambridge: M.I.T. Press, 1967.

Hofstadter, Albert and Kuhns, Richard. Eds. *Philosophies of Art and Beauty Selected Readings in Aesthetics from Plato to Heidegger.* Chicago: The University of Chicago Press, 1964.

Hogart, William, *The Analysis of Beauty*. Ed. Ronald Paulson. London: Paul Mellon Centre BA, 1997.

Horkheimer, Max and Adorno, Theodor. *Dialect of Enlightenment*. Trans. John Cumming. New York: The Seabury Press, 1994.

Husserl, Edmund. *Ideas: General Introduction to Pure Phenomenology*. Trans. W.R. Boyce Gibson, Allen and Unwin. London: Press, 1969.

Irigaray, Luce, *'This Sex Which Is Not One'* published in *New French Feminisms: An Anthology*. Eds. Marks, Elaine and Isabelle de Courtivron. Amherst, Massachusetts: University of Massachusetts Press, 1981.

J. van Wezel and J. van den Brink, *Spontaneous Symmetry Breaking in Quantum Mechanics*, Am. J. Phys., 75, 635-638 (2007).

Jacquette, Dale. Ed. *Schopenhauer, Philosophy and the Arts*. Cambridge: Cambridge University Press, 1996.

Jameson, Fredric, *Postmodernism or The Cultural Logic of Late Capitalism*, Durham: Duke University Press, 1991.

Janaway, Christopher. *Reading Aesthetics and Philosophy of Art*. Malden: Blackwell Publishing, 2006.

Kant, Immanuel. *Critique of Pure Reason*. Trans. Max Muller. Garden City, NY: Dolphin Books, 1961.

___. *Critique of Judgment*. Trans. J.H. Bernard. Amherst, NY: Prometheus Books, 2000.

Kearny, Richard and Rainwater, Mara. Eds. *The Continental Philosophy Reader*. London and New York: Routledge, 1996.

, Richard and Rasmussen, David. Eds. *Continental Aesthetics. Romanticism to Postmodernism. An Anthology*. Malden, Ma: Blackwell Publishing, 2001.

Kelly, Michael. Ed. *Encyclopedia of Aesthetics,* City: Oxford University Press, 1998.

Kristeva, Julia, *Powers of Horror: An Essay on Abjection.* Trans. Leon S. Roudiez, New York: Columbia University Press, 1982.

Kroker, Arthur, Marilouise Kroker and David Cook. *Panic Encyclopedia: The Definitive Guide to the Postmodern Scene.* Montreal: New World Perspectives, 1989.

Kundera, Milan. *Immortality.* Trans. Peter Kussi. New York: HaperCollins, 1990.

___. *Laughter and Forgetting.* Trans. Aaron Asher. City: HarperCollins, 1999.

___. *The Art of the Novel.* Trans. Linda Asher. New York: Harper and Row Publishers, 1986.

___. *The Curtain. An Essay in Seven Parts.* Trans. Linda Asher. New York: HarperCollins, 2005.

___. *Unbearable Lightness of Being.* Trans. Michael Henry Heim. Ne York: Harper & Row, 2008.

Lacan, Jacques. *Écrits: A Selection.* Trans. Alan Sheridan, London: Press, 1977.

___. *Seminar II.* Ed. by Jacques-Alain Miller, New York: WW Norton:1991.

___. *The Four Fundamental Concepts of Psycho-Analysis.* Ed. Jacques-Alain Miller. Trans. Alan Shreidan. New York: W.W. Norton and Company, 1977.

Latour, Bruno. *Progress or Entanglement? Two Models for the Long Term Evolution of Human Civilization.* A lecture at the International Conference on World Civilizations in the New Century. Taiwan: Library Taipei, 2009.

Lindberg, David. *Science in The Middle Ages.* Chicago: University of Chicago Press, 1980.

Lindley, David. *The End of Physics. The Myth of Unified Theory.* New York: Basic Books, 1993.

__. *Uncertainty. Einstein, Heisenberg, Bohr and the Struggle for the Soul of Science.* New York: Anchor Books, 2007.

Lock, Margaret and Farquhar, Judith. Eds. *Beyond the Body Proper, Reading the Anthropology of Material Life.* Durham: Duke University Press, 2007.

Lotringer, Sylvère and Cohen, Sande. Eds. *French Theory in America.* New York: Routledge, 2001.

Luther, Martin, *Memoirs of the Lutheran Liturgical Association*, Volume I-VII, Pittsburg: Association Pittsburg, 1906.

Lyotard , Jean-François. *Toward the Postmodern,* Ed. Robert Harvey and Mark S. Roberts, London: Humanities Press, 1993.

__. *The Differend: Phrases in Dispute.* Trans. Georges Van Den Abbeele. Minneapolis: University of Minnesota Press, 1988.

__. *The Postmodern Explained.* Minneapolis and London: University of Minnesota Press, 1992.

__. *Postmodern Fables,* Trans. Georges Van Den Abbeele. Minneapolis and London: University of Minnesota Press, 1997.

__. *The Postmodern Condition: A Report of Knowledge*, Trans. Geoffrey Bennington and Brian Massumi. Manchester: Manchester University Press, 1984.

__. *Libidinal Economy.* Trans. Iain Hamilton Grant. Bloomington: Indiana University Press, 1993.

__. *Just Gaming.* Trans. Wlad Godzich. Minneapolis, University of Minnesota Press, 1985.

__. *Soundproof Room. Malraux's Anti-Aesthetics.* Trans. Robert Harvey. Stanford: Stanford University Press, 2001.

__. *The Lyotard Reader.* Ed. Andrew Benjamin. Oxford: Blackwell, 1989.

___. *The Assassination of Experience by Painting-Monory.* London: Black Dog Publishing Limited, 1998.

Magee, Bryan. *The Philosophy of Schopenhauer.* New York: Oxford Press, 1983.

Malin, Shimon. *Nature Loves to Hide. Quantum Physics and the Nature of Reality, a Western Perspective.* Oxford: Oxford University Press, 2001.

Mansfield, Nick. *Subjectivity Theories of the Self from Freud to Haraway,* New York: New York University Press, 2000.

Marcin, B, Raymond. *In Search of Schopenhauer's Cat. Arthur Schopenhauer's Quantum-Mystical Theory of Justice.* Washington, DC: The Catholic University of America Press, 2006.

Marinetti, F.T. 'The Foundation and Manifesto of Futurism' published in *Theories of Modern Art.* Herschel B. Schipp. Ed. Berkeley, University of California Press, Berkeley, 1968.

Massumi, Brian. Ed. *The Politics of Fear.* Minneapolis and London: University of Minnesota Press, 1993.

McCann, Colum. *Dancer.* New York: Picador, 2003.

___. *Zoli.* London: Weidenfeld & Nicolson, 2006

___. *Let the Great World Spin.* New York: Random House, 2009.

McEvoy, J.P. and Zarate, Oscar. *Introducing Quantum Theory.* London: Icon Books, 2007.

McGilchrist, Iain. *The Master and His Emissary: The Divided Brain and the Making of the Western World.* New Haven and London: Yale University Press, 2009.

___. *Against Criticism.* London: Faber and Faber, 1982.

Merleau-Ponty, Maurice. *The Visible and the Invisible.* Evanston, IL: Northwest University Press, 1968.

___. *The Primacy of Perception.* Evanston, IL: Northwest University Press, 1964.

Moore, A.W. *The Infinite*. London and New York: Routledge Press, 1990.

Moran, Dermot. *Edmund Husserl Founder of Phenomenology*. Cambridge, UK and Malden, MA: Polity Press, 2005.

Nancy, Jean-Luc. *The Muses*. Trans. Peggy Kamuf. Stanford: Stanford University Press, 1996.

___. *The Ground of the Image*. Trans. Jeff Fort. New York: Fordham University Press, 2005.

___. *The Sense of the World*. Trans. Jeffrey S. Librett. Minneapolis: University of Minnesota Press, 1997.

___. *Being Singular Plural*. Eds. Werner Hamacher and David E. Wellbery. Trans. Robert D. Richardson and Anne E. O'Byrne. Stanford: Stanford University Press, 2000.

Nietzsche, Friedrich. *On the Genealogy of Morals and Ecce Homo*. Ed. and Trans. Walter Kaufman. New York: Vintage Books, 1989.

___. *Basic Writings of Nietzsche*. Trans. Walter Kaufman. New York: The Modern Library, 1967.

___. *Thus Spoke Zarathustra*. Trans. Walter Kaufmann. New York: The Modern Library, 1995.

___. *Human, All-Too-Human. Beyond Good and Evil*. Trans. Helen Zimmern and Paul Cohn. Hertfordshire: Wordsworth Editions Limited, 2008.

___. *The Birth of Tragedy and The Genealogy of Morals*, Trans. Francis Golffing. Garden City and New York: Doubleday Anchor Books, 1956.

___. *Untimely Meditations*. Ed. Daniel Breazeale. Trans. R. J. Hollingdale. Cambridge: Cambridge University Press, 1997.

___. *The Nietzsche Reader*. Ed. Keith Pearson and Duncan Large. Malden, MA: Blackwell Publishing, 2006

___. *Human, All-Too-Human Parts 1 and 2. Beyond Good and Evil.* Trans. Helen Zimmern and Paul Cohn. Hertfordshire: Wordsworth Editions Limited, 2008.

___. *The Antichrist.* Trans. Anthony M. Ludovici. New York: Prometheus Books, 2000.

___. *The Gay Science: With a Prelude in Rhymes and an Appendix of Songs.* Trans. Walter Kaufman. New York: Vintage Books, 1974.

O'Doherty, Brian. *Inside the White Cube.* Berkeley: University of California Press, 1976.

Oretega y Gasset, Jose. *Phenomenology and Art.* Trans. Philip W. Silver. New York: W.W. Norton and Company, Year.

O'Sullivan, Simon. *On the Production of Subjectivity.* London: Palgrave Macmillan, 2012

___. *Deleuze and Contemporary Art.* Ed with Stephen Zepke. Edinburgh: Edinburgh University Press, 2010.

___. *Deleuze, Guattari, and the Production of the New.* Ed with Stephen Zepke. London: Continuum, 2008.

___. *Art Encounters Deleuze and Guattari: Thought Beyond Representation,* London: Palgrave Macmillan, 2006.

Peacock, Kent. *The Quantum Revolution. A Historical Perspective.* Westport, CT.: Greenwood Press, 2008.

Penrose, Roger. *Shadows of the Mind. A Search for the Missing Science of Consciousness.* Oxford: Oxford University Press, 1994.

Piel, Gerard, *The Age of Science. What Scientists Learned in the Twentieth Century.* New York: Basic Books, 2001.

Pierce, Gillian Borland. *"Lyotard's Anti-Aesthetics. Voice and Immateriality in Postmodern Art."* Project MUSE, Postmodern Culture, 13.3 (2004). Online.

Pfeil, Fred. *White Guys: Studies in Postmodern Domination and Difference*. London: Verso, 1995.

Plato. *Selected Dialogues of Plato*. Trans. Benjamin Jowett. Revised by Hayden Pellicia. New York: The Modern Library, 2000.

___. *Essential Dialogues of Plato*. Trans. Benjamin Jowett. Ed. And Revised Pedro De Blas. New York: Barnes and Noble Classics, 2005.

___. *The Symposium*. Trans. R.E. Allen. New Haven and London: Yale University Press, 1991.

___. *Phaedo*. Trans. G.M.A. Grube. Indianapolis, Indiana: Hacket Publishing Company, 1977.

___. *The Republic*. Trans. Benjamin Jowett. New York: Modern Library, 1982.

Plotinus. *The Essential Plotinus*. Selected and Trans. Elmer O'Brien. Indianapolis, Indiana: Hackett Publishing Company, Inc., 1964

P.W. Anderson, "More is Different," *Science,* (Aug. 4 1972), Volume 177, Number 4047.

Ranciere, Jacques. *Aesthetics and Its Discontents*. Trans. Steven Corcoran. City: Polity Press, 2009.

___. *Politics of Aesthetics*. Trans. Gabriel Rockhill. New York: Continuum, 2004.

___. *The Aesthetic Unconscious*. Cambridge: Polity Press, 2009.

___. *The Future of the Image*. Trans. Gregory Elliott. New York: Verso, 2007.

Rhees, Rush, Yorick Smythies, and Taylor, James. *L. Wittgenstein: Lectures and Conversations on Aesthetics, Psychology and Religious Belief*. Ed. Cyril Barrett. Los Angeles: University of California Press, 2007.

Rilke, Rainer Maria, *Letters on Cézanne,* Ed. Clara Rilke. Trans. Joel Agee. New York: Fromm International Publishing Corporation, 1985.

Ronan, Colin A., *Science Its History and Development Among the World's Cultures.* London: The Hamlyn Publishing Group Limited, 1982.

Roochnik, David. *Of Art and Wisdom. Plato's Understanding of Techne.* University Park: The Pennsylvania State University Press, 1996.

Rosenblum, Bruce and Kuttner, Fred. *Quantum Enigma. Physics Encounters Consicousness.* Oxford: Oxford University Press, 2006.

Rotzer, Florian. *Conversations With French Philosophers.* Trans. Gary E. Aylesworth. New Jersey: Humanities Press, 1995.

Rousseau, Jean-Jacques, *The Confessions.* Trans. J.M.Cohen. Harmondsworth: Penguin Books, 1953.

___. *The Social Contract.* Trans. Maurice Cranston. City: Penguin Classics, 1968.

elin, Remy. *"Paul Valery: The aesthetics of the Grand Seigneur".* Journal of Aesthetics and Art Criticism. 19.1 (1960): p. 47-52. Print.

Satrapi, Marjane. *Persepolis.* New York: Pantheon Books, 2000.

Schirmacher, Wolfgang, ed. *German 20th Century Philosophy The Frankfurt School.* Trans. Virginia Cutrufelli. City: Continuum Publishing Group Inc, 2000.

___. *Just Living. Philosophy in Artificial Life.* New York and Dresden: Atropos Press, Year.

___. *Homo Generator: Media and Postmodern Technology.* Ed. Gretchen Bender and Timothy Druckrey. Seattle: Bay Press, 1994.

___. *Culture on the Brink: Ideologies of Technology.* New York: The New Press, 1998.

___. (all articles) http://www.egs.edu/faculty/wolfgang-schirmacher/articles/

___. *Schopenhauer Lecture Series in New York City*, Fall 2008.

___. *Spinoza Lecture Series in New York City*, Fall 2009.

Schoonover, Carl, *Portraits of the Mind, Visualizing the Brain from Antiquity to the 21st Century*, New York: Abrams, 2006.

Schopenhauer, Arthur. *Essays of Schopenhauer.* Trans. T. Bailey Saunders. New York: Willey Book Company, 1965.

___. *Studies in Pessimism: The Essays of Arthur Schopenhauer.* Trans. T. Bailey Saunders. Whitefish, MT: Kessinger Publishing, 2004

___. *The World As Will and Representation, Volume 1.* Trans. E.F. Payne. New York: Dover Publications, 1966.

___. *The World As Will and Representation, Volume 2.* Trans. E.F. Payne. New York: Dover Publications, 1966.

___. *On the Fourfold Root of the Principle of Sufficient Reason.* Trans. E. F. J. Payne. La Salle, Illinois: Open Court Press, 1974.

___. *Philosophical Writings.* Ed. Wolfgang Schirmacher. New York: Continuum, 2003.

___. *The Essential Schopenhauer.* Ed. Wolfgang Schirmacher. New York: HarperPerennial, 2010.

___. *The Living Thoughts of Schopenhauer.* Presented by Thomas Mann. Ed. Alfred O. Mendel. Philadelphia: David McKay Company, 1939.

Schrödinger, Erwin. *Science and Humanism: Physics in Our Time.* London: Cambridge University Press, 1952.

___. *My View of the The World.* Ox bow Press, 1983.

Sedgwick, Eve Kosofsky. *Between Men: English Literature and Male Homosocial Desire.* New York: Columbia University Press, 1985.

Sepp, Hans Rainer and Embree, Lester. Eds. *Handbook of Phenomenological Aesthetics.* New York: Springer, 2010.

Shaviro, Steven. *Without Criteria: Kant, Whitehead, Deleuze and Aesthetics.* Cambridge: MIT Press, 2009.

Shlain, Leonard. *Art and Physics. Parallel Visions in Space, Time and Light.* New York: Harper Collins, 1991.

Smelik, Anneke and Lykke Nina. Eds. *Bits of Life Feminism at the Intersections of Media, Bioscience, and Technology.* Seattle and London: University of Washington Press, 2008.

Spinoza, Benedict de. *The Ethics and Other Works.* Ed. and Trans. Edwin Curley. Princeton: Princeton University Press, 1994.

___. *Ethics.* Trans. William Hale White. New York: Macmillan & Co., 1883.

Stecher, Robert. *Aesthetics and the Philosophy of Art: An Introduction.* Oxford: Rowman and Littlefield Publishers, 2005.

Stokstad, Marilyn. *Art, A Brief History, Third Edition.* Upper Saddle River, New Jersey: Prentice Hall, 2006.

Thaheld, Fred. *Does consciousness really collapse the wave function? A possible objective biophysical resolution of the measurement problem.* Ithaca: Cornell University Library, 2005.

Tolstoy, Leo. *What is Art?* Trans. Richard Pevear and Larissa Volokhonky. Penguin Books, 1995.

Tribe, Mark and Jana, Reena. *New Media Art: An Introduction.* City: Taschen, 2006.

Valery, Paul. *Aesthetics.* Bollingen Foundation; 1st edition, 1964.

Vasari, Giorgio. *The Lives of the Artists.* Trans. Julia Conaway Bondanella and Peter Bondanella. New York: Oxford University Press, 1991.

Vattimo, Gianni. *Belief.* Trans. Luca D'Isanto and David Webb. Stanford: Stanford University Press, 1996.

___. *Art's Claim to Truth*, Ed. Santiago Zabala. Trans. Luca D'Isanto. New York: Columbia University Press, 2008.

Virilio, Paul. *Art As Far as the Eye Can See*. Trans. Julie Rose. Oxford and New York: Press, 2005.

___. *Art and Fear*. Trans. Julie Rose. London: Continuum, 2003.

___. *the vision machine*, Trans. Julie Rose. Bloomington, Indiana: Indiana University Press, 1994.

___. *The Paul Virilio Reader*. New York: Columbia University Press, 2004.

___. *Unknown Quantity*. Tran. Chris Turner. Nantes: Foundation Cartier Pour L'Art Contemporain and Thames and Hudson, 2002.

___. *A Landscape of Events*. Trans. Julie Rose. Cambridge and London: Massachusetts Institute of Technology, 2000.

___. *The Art of the Motor*. Trans. Rose, Julie. Minneapolis and London: University of Minnesota Press, 1995.

Virilio, Paul and Lotringer, Sylvère. *Pure War*. Trans. Mark Polizzotti. New York: Semiotext(e), 1983.

___. *The Accident of Art*. Trans. Mike Taormina. New York: Semiotext(e), 2005.

Ward, Rachel. *All for Nothing*. New York and Dresden: Atropos Press, 2010.

Wark McKenzie. *Virtual Geography: Living with Global Media Events*. Bloomington: Indiana University Press, 1994.

Wilber, Ken. Ed. *Quantum Questions. Mystical Writings of the World's Great Physicists*. Boston: Shambhala Publications, 2001.

Wittgenstein, Ludwig. *Philosophical Investigations*. Trans. G. E. M. Anscombe. Englewood Cliffs: Prentice Hall Press, 1958.

___. *Tractatus Logico-Philosophicus*. Trans. D. F. Pears and B. F. McGuinness. New York: Routledge Press, 1961.

___. *Remarks on Colour.* Wiley-Blackwell, 1991.

___. *Lectures and Conversations on Aesthetics, Psychology, and Religious Belief.* Ed. Cyril Barrett. Oxford: Basil Blackwell , 1966.

Zizek, Slavoj. *Trotsky Terrorism and Communism.* London and New York: Verso, 2007.

___. *Violence.* New York: Picador, 2008.

___. *Enjoy Your Symptom! Jacques Lacan in Hollywood and Out.* New York and London: Routledge Press, 1991.

___. *The Plague of Fantasies.* London: Verso,1997.

Zohar, Danah. *The Quantum Self. Human Nature and Consciousness Defined by the New Physics.* New York: Quill/ William Morrow, 1990.

Online Sources, Movies and Comics

Brading, Katherine and Castellani, Elena, "Symmetry and Symmetry Breaking", The Stanford Encyclopedia of Philosophy (Spring 2013 Edition), Edward N. Zalta (ed.), http://plato.stanford.edu/archives/spr2013/entries/symmetry-breaking/

Dutton, Dutton. http://www.ted.com/talks/denis_dutton_a_darwinian_theory_of_beauty.html

Greenberg, Clement, Speech at Western Michigan University, January 18, 1983 http://www.sharecom.ca/greenberg/taste.html

Hawking, Stephen. http://www.hawking.org.uk/the-computer.html

Lee, Stan and Kirby, Jack. The X-Men Comics. New York: Marvel Comics. 1963

LeWitt, Sol.
 http://www.massmoca.org/event_details.php?id=27

O'Connell, Aaron.
 http://www.ted.com/talks/aaron_o_connell_making_
 sense_of_a_visible_quantum_object.html

PBS, "Einstein Among Geniuses"
 http://www.pbs.org/wgbh/nova/physics/einstein-
 genius-among-geniuses.html

Ramachandran,V.S
 http://www.edge.org/3rd_culture/ramachandran/
 ramachandran_p1.html

Scott, Ridely (Director), *Blade Runner* (1982)

Soloman, Deborah. *How to Succeed in Art*,
 New York Times Article, 1999.
 http://www.nytimes.com/1999/06/27/magazine/
 how-to-succeed-in-art.html

Williams, Gary, "*Heidegger's Direct Realism-Intentionality and
 Perception*", published in *Minds and Brains*, Feb. 17, 2010.

https://philosophyandpsychology.wordpress.com/2010/02/17/
 heideggers-direct-realism-intentionality-and-perception/

Endnotes

1 Wolfgang Schirmacher writes, "Yet *homo generator* in my understanding revokes a misconception of humanity. *Homo sapiens, homo faber, homo creator*—none touches our core any longer. We shall, of course, keep on thinking, continue to make tools, and imagine ourselves to be the originator of things, of our acts and thoughts. But all this pales in comparison with the immense ability to produce new forms of life and determine the biological as well as the spiritual future of the earth. This *homo generator* is no longer a gifted dilettante whose successes are owed principally to chance. *Homo generator* does not have to settle for what's given; he or she works instead, without any restrictions, with the fundamental building of life in all forms." in Schirmacher, Wolfgang. *Homo Generator: Media and Postmodern Technology.* Ed. Gretchen Bender and Timothy Druckrey. Seattle: Bay Press, 1994.

2 Plato. *The Republic.* Trans. Benjamin Jowett. New York: Modern Library, 1982, 206-207.

3 Berger, John. *The Success and Failure of Picasso.* (New York: Vintage International, 1965), 75.

4 Plato, *The Republic, Book V*, 205- 206.

5 Ibid., 206-207.

6 Ibid., 207.

7 Plato's, the *Allegory of The Cave,* describes a group of people who live in a cave. They are chained so that they can only face one wall of the cave. They know nothing other than the cave. Behind and above the cave, there is a road. On the road, a group of people, carrying objects, walks by. The light of a fire casts shadows of the people and objects onto the wall of the cave. The prisoners who live in the cave see the shadows and assume that they are real. One of the prisoners is freed and goes up into the world and into the light. At first, he is blind because the light is too bright. Eventually, he sees the real people and objects. He returns to the cave to tell the prisoners that the shadows are not real. There is great tension between the prisoners and the one who leaves the cave and returns.

8 Plato, *The Republic, Book VII*, 257.

9 Plato, *The Republic, Book X*, 363.

10 Ibid., 363-364.

11 Ibid., 364.

12 Plato, *The Laws, Book II*, in Plato. *Essential Dialogues of Plato*. Trans. Benjamin Jowett. Ed. And Revised Pedro De Blas. (New York: Barnes and Noble Classics, 2005), 532.

13 Plato, *The Republic, Book X*, 371.

14 Ibid., 360-397.

15 Ficino, "Commentary on Plato's Symposium, Third Speech: That Love is the Teacher and Ruler of the Arts," Trans. Sears Reynolds Jayne, in Hofstadter, Albert and Kuhns, Richard. Eds. *Philosophies of Art and Beauty Selected Readings in Aesthetics from Plato to Heidegger. (*Chicago: The University of Chicago Press, 1964), 214.

16 Ibid., 214.

17 Hegel, *G.W.F. Introductory Lectures on Aesthetics.* Ed. Michael Inwood. Trans. Bernard Bosanquet. (London: Penguin Books, 1993.)

18 Michael Inwood, "Introduction to Introductory Lectures on Aesthetics," Ibid., xxiv.

19 Kant, Immanuel. "First Division Analytic of the Aesthetical Judgment, First Book, Analytic of the Beautiful, First Moment, Of the Judgment of Taste According to Quality" *in Critique of Judgment.* Trans. J.H. Bernard. (Amherst, NY: Prometheus Books, 2000), 45-55.

20 Pearson, Heith and Duncan Large, eds. *The Nietzsche Reader.* (Malden, MA: Blackwell Publishing, 2006), 134-135.

21 Baudrillard, Jean. *Art and Artifact.* Ed. Nicholas Zurbugg. London and New Delhi: Sage Publications, 1997.

22 *Merriam-Webster Dictionary,* s.v. "artifact," accessed 2011, http://www.merriam-webster.com/dictionary/artifact.

23 Jean Baudrillard, "No Nostalgia for Old Aesthetic Values," in *The Conspiracy of Art*, 61.

24 Sylvère Lotringer, "The Piracy of Art" in Baudrillard, Jean. *The Conspiracy of Art.* Ed. by Sylvère Lotringer. Trans. Ames Hodges. (New York: Semiotexte(e), 2005), 10

25 Lyotard, Jean-François. *The Postmodern Condition: A Report of Knowledge*, Trans. Geoffrey Bennington and Brian Massumi. (Manchester: Manchester University Press, 1984), 10.

26 Lyotard, Jean-François. *The Differend: Phrases in Dispute.* Trans. Georges Van Den Abbeele. Minneapolis: University of Minnesota Press, 1988).

27 Ibid., 9.

28 Sylvère Lotringer and Virilio, Paul. *The Accident of Art.* Trans. Mike Taormina. (New York: Semiotext(e), 2005), XX.

29 Virilio, Paul. *Art and Fear.* Trans. Julie Rose. (London: Continuum, 2003), 71.

30 Jean-François Lyotard, *The Differend*, xi.

31 Though Formalism can be traced to Plato, the art world generally cites Clement Greenberg. His thoughts on Formalism can be found in Greenberg, Clement. "Avant-Garde and Kitsch." Partisan Review. 6:5 (1939) 34-49.

32 This observation arrives from my own experience working with children. For further research, see: Erik Erikson, *Childhood and society.* (New York: Norton, 1950), Jean Piaget. *The Language and Thought of the Child* (London, Routledge. 1926),Jean Piaget. *Studies in Reflecting Abstraction.* (Hove, UK: Psychology Press, 2001)

33 Jean-François Lyotard, *The Differend*, xiii.

34 Ibid., xiv.

35 Lindberg, David. *Science in The Middle Ages.* (Chicago: University of Chicago Press, 1980), 21.

36 Asimov, Isaac. *Chronology of Science and Discovery.* (New York: Harper and Row, 1989), 136.

37 Lindley, *David. Uncertainty. Einstein, Heisenberg, Bohr and the Struggle for the Soul of Science.* (New York: Anchor Books, 2007), 3.

38 Heidegger, Martin, "Letter on Humanism" in *Basic Writings.* Ed. David Farrell Krell. (New York: HarperCollins, 1977, 1993), 218.

39 Sylvère Lotringer and Paul Virilio, *The Accident of Art*, 68.

40 Reference to Wolfgang Schirmacher's concept *homo generator* in *"Homo Generator:* Media and Postmodern Technology."

41 Malin, Shimon. *Nature Loves to Hide. Quantum Physics and the Nature of Reality, a Western Perspective.* (Oxford: Oxford University Press, 2001),41.

42 Bricmont, Jean and Sokal, Alain. *Fashionable Nonsense: Postmodern Intellectuals' Abuse of Science.* New York: Picador, 1998.
43 Jean Baudrillard, "From Radical Incertitude, or Thought as Imposter," in Lotringer, Sylvère and Cohen, Sande. Eds. *French Theory in America.* (New York: Routledge, 2001), 59-69.
44 Ibid., 60.
45 Ibid., 59.
46 Jean Baudrillard, "Radical Thought" in *The Conspiracy of Art*, 162.
47 Giles Deleuze, "What is a Creative Act," published in *french theory in America*, 99-100.
48 Dutton, Denis. *The Art Instinct. Beauty, Pleasure, and Human Evolution*, (New York: Bloomsbury Press, 2010),136.
49 Ibid. 33.
50 Issac Asimov, *Chronology of Science and Discovery*, 19.
51 Reference to Wolfgang Schirmacher's concept *homo generator* in "*Homo Generator:* Media and Postmodern Technology."
52 Ibid.
53 Ibid.
54 Marcin, B, Raymond. *In Search of Schopenhauer's Cat. Arthur Schopenhauer's Quantum-Mystical Theory of Justice.* (Washington, DC: The Catholic University of America Press, 2006), 39.
55 Bohr, Niels. *The Philosophical Writings of Niels Bohr. Volume Three. Essays 1958-1962 on Atomic Physics and Human Knowledge.* (Woodbridge, CT: Ox Bow Press, 1963), 2.
56 "Einstein among geniuses" in http://www.pbs.org/wgbh/nova/physics/einstein-genius-among-geniuses.html
57 McEvoy, J.P. and Zarate, Oscar. *Introducing Quantum Theory.* (London: Icon Books, 2007), 3.
58 David Lindley, *Uncertainty*, 4.
59 Rosenblum, Bruce and Kuttner, Fred. *Quantum Enigma. Physics Encounters Consciousness.* (Oxford: Oxford University Press, 2006), 108.
60 Ibid., 100.
61 Bruce Rosenblum and Fred Kuttner, *Quantum Enigma*, 100.

62 Agazzi, Evandro. *Scientific Objectivity and Its Contexts*, (Mexico City: Springer, 2014),56
63 Ibid., 71.
64 Ibid., 70-80.
65 Ibid., 102-105.
66 Ibid., 74.
67 Ibid., 75.
68 Ibid., 80.
69 Ibid., 79.
70 Goswami, Amit. *The Self-Aware Universe. How Consciousness Creates the Material World.* (New York: Penguin Putnam, 1993), 9.
71 J.P. McEnvoy and Oscar Zarate, *Quantum Theory A Graphic Guide*, 8-9.
72 Ibid. 146-147.
73 Bruce Rosenblum and Fred Kuttner, *Quantum Enigma*, 151.
74 Brading, Katherine and Castellani, Elena, "Symmetry and Symmetry Breaking", The Stanford Encyclopedia of Philosophy (Spring 2013 Edition), Edward N. Zalta (ed.), URL = <http://plato.stanford.edu/archives/spr2013/entries/symmetry-breaking/>.
75 Descartes, René, *The Philosophical Writings of Descartes, Volume 1.* Trans. John Cottingham, Robert Stoothoff and Dugald Murdoch. (Cambridge: Cambridge University Press, 1985), 120.
76 Deleuze, Gilles. *Spinoza: Practical Philosophy.* (London: City Lights Publishers; First Edition in English edition: 2001), 110.
77 Spinoza, Benedict de. *The Ethics and Other Works.* Ed. and Trans. Edwin Curley. (Princeton: Princeton University Press, 1994), 132.
78 Ibid., 202.
79 Ibid., 115.
80 Baruch Spinoza writes, "By God I understand a being absolutely infinite, that is a substance consisting of an infinity of attributes, of which each one expresses an eternal and infinite essence." *The Ethics and Other Works*, p. 85
81 Ibid., 253.
82 Ibid., 257.
83 Ibid., 104.
84 Ibid., 105.
85 Spinoza, Baruch. *Ethics.* Trans. William Hale White. (New York: Macmillan & Co., 1883), 23.

86 Baruch Spinoza, *The Ethics and Other Works*, 261.
87 Ibid., 145.
88 Ibid., 260.
89 Schopenhauer, Arthur. *The World As Will and Representation, Volume 1.* Trans. E.F. Payne. (New York: Dover Publications, 1966), 15.
90 Ibid., 128.
91 Schopenhauer, Arthur. *Studies in Pessimism: The Essays of Arthur Schopenhauer.* Trans. T. Bailey Saunders. (Whitefish, MT: Kessinger Publishing, 2004), 26.
92 Heisenberg, Werner. *Encounters with Einstein and Other Essays on People, Places, and Particles.* (Princeton: Princeton University Press, 1983), 54.
93 Ibid., 35.
94 Ibid., 35.
95 Ibid., 36.
96 P.W. Anderson, "More is Different," *Science, (*Aug. 4, 1972), Volume 177, Number 4047, 393.
97 Ibid., 393.
98 Ibid., 394.
99 Werner Heisenberg, "The Debate between Plato and Democritus," *in* Wilber, Ken. Ed. *Quantum Questions. Mystical Writings of the World's Great Physicists.* (Boston: Shambhala Publications, 2001), 53.
100 Berger, John, *Ways of Seeing. (*London: British Broadcasting Corporation and Penguin Books, 1972), 18.
101 Deleuze, Gilles and Félix Guattari. *What is Philosophy?* Trans. Hugh Tomlinson and Graham Burchell. (New York: Columbia University Press, 1991), 35-60.
102 Ibid., 60.
103 Ibid., 45.
104 Ibid., 45.
105 Deleuze, Gilles. *Pure Immanence.* Trans. Anne Boyman, New York: Zone Books, 2001), 27.
106 P.W. Anderson, *More is Different*, 394.
107 J. van Wezel and J. van den Brink, "Spontaneous Symmetry Breaking in Quantum Mechanics," Am. J. Phys., 75, 635-638 (2007).

108 Fred Thaheld argues, "That wave function collapse is a *real physical process* of a discontinuous nonlinear nature, resulting when a superposed microscopic system interacts with a living macroscopic measuring instrument, in this instance the eye." Thaheld, Fred. *Does consciousness really collapse the wave function? A possible objective biophysical resolution of the measurement problem.* Ithaca: Cornell University Library, 2005. Retrieved from: http://arxiv.org/abs/quant-ph/0509042.

109 P.W. Anderson, *More is Different*, 395.

110 Baudrillard, Jean. *The Spirit of Terrorism and Requiem for the Twin Towers.* (Verso, 2002), 46.

111 Brentano, Franz. *Psychology From An Empirical Standpoint.* Trans. Antos Rancurello, D.B. Terrell, Linda McAlister. Ed. Linda McAlister. (London and New York: Routledge, 1973), 88-89.

112 Gary Williams, "Heidegger's Direct Realism-Intentionality and Perception", published in *Minds and Brains*, Feb. 17, 2010. Retrieved from http://philosophyandpsychology.com/?p=719

113 Heidegger, *Martin. The Basic Problems of Phenomenology.* (Indiana University Press, 1988), 64.

114 Heidegger, Martin. *Being and Time.* Trans. John Macquarrie and Edward Robinson. (New York: Harper & Row, 1962), 27.

115 Heidegger, "Letter on Humanism," published in *Basic Writings,* 230.

116 Sylvère Lotringer, "Doing Theory," in *french theory in America*, 127.

117 Plotinus, in *Nature Loves to Hide*, 125.

118 *Merriam-Webster Dictionary*, s.v. "materialism" 2001. http://www.merriam-webster.com/dictionary/materialism

119 Arthur Schopenhauer, *World as Will and Representation, Volume II*, 13.

120 Erwin Schrödinger, in *The Self-Aware Universe*, 97.

121 Heisenberg, Werner. *Physics and Philosophy. The Revolution in Modern Science.* (Amherst, NY: Prometheus Books, 1999), 54.

122 John Gribbin writes, "This collection of ideas-uncertainty, complementarity, probability, and the disturbance of the

system being observed by the observer—are together referred to as the "Copenhagen interpretation" of quantum mechanics, although nobody in Copenhagen (or anywhere else) ever set down in so man words a definitive statement labeled "the Copenhagen Interpretation," and one of the key ingredients, the statistical interpretation of the wave function, actually came from Max Born in Gottingen." in Gribbin, John. *In Search of Schrödinger's Cat. Quantum Physics and Reality.* New York: Bantam Books, 1984.

123 Werner Heisenberg, *Physics and Philosophy: the revolution in modern science,* 58.

124 Ibid., 55.

125 Kant, Immanuel. *Critique of Pure Reason.* Trans. Max Muller. (Garden City, NY: Dolphin Books, 1961), A383.

126 Arthur Schopenhauer, *On the Fourfold Root of the Principle of Sufficient Reason.* Trans. E. F. J. Payne. (La Salle, Illinois: Open Court Press, 1974), 21.

127 John Gribbin, *In Search of Schrödinger's Cat,* 237.

128 Ibid., 182.

129 Ibid., 182.

130 Bruce Rosenblum and Fred Kuttner, *Quantum Enigma,* 151.

131 John Gribbin, *In Search of Schrödinger's Cat,* 182.

132 Bruce Rosenblum and Fred Kuttner, *Quantum Enigma,* 125.

133 Letter from Albert Einstein to Max Born, March 3, 1947. Born, Max. *The Born-Einstein Letters; Correspondence between Albert Einstein and Max and Hedwig Born from 1916 to 1955,* Walker, New York, 1971.

134 Bitbol, Michel. *Schrödinger's Philosophy of Quantum Mechanics.* (The Netherlands: Kluwer Academic Publishers, 1996), 54.

135 John Gribbin, *In Search of Schrödinger's Cat,* 182-183.

136 Martin Heidegger, *Being and Time,* 80.

137 Nancy, Jean-Luc. *Being Singular Plural.* Eds. Werner Hamacher and David E. Wellbery. Trans. Robert D. Richardson and Anne E. O'Byrne. (Stanford: Stanford University Press, 2000), 43.

138 Jean Baudrillard, "From Radical Incertitude, or Thought as Imposter," in *french theory in america*, 68.

139 Schrödinger, Erwin. *Science and Humanism: Physics in Our Time*. (London: Cambridge University Press, 1952), 17.

140 Shimon Malin, *Nature Loves to Hide*, 69.

141 David Lindley, *Uncertainty*, 219.

142 Schopenhauer, Arthur. *Studies in Pessimism: The Essays of Arthur Schopenhauer*. Trans. T. Bailey Saunders. (Whitefish, MT: Kessinger Publishing, 2004), 33.

143 Schrödinger, Erwin. *My View of the The World*. Ox bow Press, 1983), 28.

144 Arthur Schopenhauer, *Studies in Pessimism*, 24.

145 Ibid., 36-37.

146 Ibid., 24.

147 Ibid., 26.

148 Ibid., Footnote 1: Translator's Note, 21.

149 Latour, Bruno. *Progress or Entanglement? Two Models for the Long Term Evolution of Human Civilization*. A lecture at the International Conference on World Civilizations in the New Century. (Taiwan: Library Taipei, 2009), 2-3.

150 Ibid., 2.

151 Lyotard, Jean-François.*The Assassination of Experience by Painting-Monory*. (London: Black Dog Publishing Limited, 1998), 86.

152 Martin Heidegger, *Being and Time*, p. 56

153 Bible, John 8:32

154 Arthur Schopenhauer, *World as Will and Representation, Volume II*, 467.

155 Plato, *The Republic, Book X*, 369.

156 Ibid., 371.

157 Ibid., 365.

158 Ibid., 373.

159 Wolfgang Schirmacher, "Homo Generator: Media and Postmodern Technology"

160 Ibid.

161 Hegel, *G.W.F., Introductory Lectures on Aesthetics*. Ed. Michael Inwood. Trans. Bernard Bosanquet. London: Penguin Books, 1993.

162 Ibid., 13.

163 Aristotle, *Poetics*. (London: Penguin Books, 1996), 27.
164 *Merriam-Webster Dictionary,* s.v. "technology", 2011. http://www.merriam-webster.com/dictionary/technology
165 *Merriam-Webster Dictionary,* s.v. "tools", 2011. http://www.merriam-webster.com/dictionary/tools
166 http://news.nationalgeographic.com/news/2007/02/070222-chimps-spears.html
167 Roochnik, David. *Of Art and Wisdom. Plato's Understanding of Techne.* (University Park: The Pennsylvania State University Press, 1996), 20.
168 Ibid., xi.
169 Plato, "Laws X ," *The Republic,* 899a ff.
170 Plato writes, 'Then the imitator, I said, is a long way off the truth.' *"Book X", Ibid.,* 365.
171 Mark Tribe and Reena Jana define New Media in their text, *New Media Art-An Introduction.* They write, "We locate New Media art as a subset of two broader categories: Art and Technology and Media art. Art and Technology refers to practices, such as Electronic art, Robotic art, and Genomic art that involve technologies which are new but not necessarily media-related. Media art includes Video art, Transmission art, and Experimental Film -- art forms that incorporate media technologies which by the 1990s were no longer new." Tribe, Mark and Jana, pro. *New Media Art: An Introduction.* (Taschen, 2006), 1.
172 Heidegger, Martin. *The Question Concerning Technology and Other Essays.* Trans. William Lovitt, New York: Harper and Row, 1977, 5.
173 Wolfgang Schirmacher, "Homo Generator: Media and Postmodern Technology"
174 Martin Heidegger, *Basic Writings,* 312.
175 Ibid., 311-312.
176 Martin Heidegger, *The Question Concerning Technology and Other Essays,* 12-13.
177 Donna Haraway, *"A Cyborg Manifesto" in Simians, Cyborgs, Women: The Reinvention of Nature.* London: Routledge, 1991.
178 Retrieved from: http://www.hawking.org.uk/the-computer.html

179 Deleuze, Gilles and Félix Guattari. *Capitalism and Schizophrenia, Volume 1:Anti-Oedipus.* Trans. Robert Hurley. (London: Athlone Press, 1977), 326.
180 Ibid., 327.
181 Martin Heidegger, "The Word of Nietzsche," in *The Question Concerning Technology and Other Essays*, 82.
182 Aristotle, *Metaphysics, Book XIII, in Philosophies of Art and Beauty*, 96.
183 Martin Heidegger, "The Word of Nietzsche" in *The Question Concerning Technology and Other Essays*, 83.
184 Ibid., 83.
185 Ibid., 11-12.
186 Martin Heidegger, "On the Essence of Truth," in *Basic Writings*, 125.
187 Ibid., 138.
188 Martin Heidegger, "The Origin of the Work of Art," in *Basic Writings*, 165.
189 Reference to Wolfgang Schirmacher concept, *Homo Generator.*
190 Wolfgang Schirmacher, "Homo Generator: Media and Postmodern Technology"
191 Jean Baudrillard, "Radical Thought," published in *The Conspiracy of Art,* 162.
192 Arthur Schopenhauer, *World as Will and Representation, volume II*, 309.
193 Bhagavad Gita 2.71
194 Nietzsche, Friedrich . *Basic Writings of Nietzsche*. Trans. Walter Kaufman. New York: The Modern Library, 1967), 393.
195 Nietzsche, Friedrich. *The Gay Science: With a Prelude in Rhymes and an Appendix of Songs.* Trans. Walter Kaufman. New York: Vintage Books, 1974), 184.
196 Lacan, Jacques. *Seminar II*. Ed. by Jacques-Alain Miller, (New York: WW Norton:1991), 223 – 224.
197 Zizek , Slavoj. *The Plague of Fantasies*. (London: Verso,1997), 39.
198 Sylvère Lotringer and Paul Virilio, *The Accident of Art*, 65.
199 Wolfgang Schirmacher, "Homo Generator: Media and Postmodern Technology"
200 Krushnamurti

201 *The Nietzsche Reader*. Ed. Keith Pearson and Duncan Large. (Malden, MA: Blackwell Publishing, 2006), 125 and 126.
202 Ibid., 130.
203 An example of scientific fiction that reference fear and cloning is the film *Blade Runner,* Dir. Ridley Scott (1982)
204 Plato, *The Republic, Book X*, 365.
205 Friedrich Nietzsche, *A Nietzsche Reader*, 125.
206 Ibid., 125.
207 Martin Heidegger, "On the Essence of Truth," in *Basic Writings*, 116.
208 Kant, Immanuel. *Critique of Pure Reason*. Trans. Max Muller. (Garden City, NY: Dolphin Books, 1961), B 730.
209 Benedict Spinoza, *The Ethics*, 110.
210 Nietzsche, Friedrich. *On the Genealogy of Morals and Ecce Homo*. Ed. and Trans. Walter Kaufman. (New York: Vintage Books, 1989), 714.
211 Nietzsche. "The Gay Science, " in *The Nietzsche Reader*, 227.
212 Martin Heidegger, "The Word of Nietzsche," in *The Question Concerning Technology and Other Essays*, 77.
213 Wolfgang Schirmacher, "Homo Generator: Media and Postmodern Technology"
214 Agamben, Giorgio. *The Man Without Content*. Trans. Georgia Albert. (Stanford: Stanford University Press, 1999), 15.
215 Sylvère Lotringer, "Introduction: Piracy of Art," in *The Conspiracy of Art*, 11.
216 Sylvère Lotringer, "Doing Theory, " published in *french theory in America*, 130.
217 Aude Lancelin and Jean Baudrillard, "The Matrix Revisited," published in *The Conspiracy of Art*, 203-204.
218 Sylvère Lotringer, "Introduction: Piracy of Art," in *The Conspiracy of Art*, 15.
219 Jean-François Lyotard, *The Differend*, xi.
220 Ibid., xii.
221 Ibid., xiii.
222 Issac Asimov writes, "The English philosopher Francis Bacon (1561-1626) published Novum Organum (New Organon) in 1620. The reference is to Aristotle's Organon, in which the rules of logic were drawn up. Bacon argued strenuously

that deduction might do for mathematics but it would not do for science. The laws of science had to be induced; that is, established as generalization drawn out of a vast mass for specific observation. Such experimental science had already been put into practice, but Bacon supplied the theoretical backing for it, describing what is today call the scientific method", *Asimov's Chronology of Science and Discovery,* 136.

223 Martin Heidegger, "The Age of the World Picture, " in *The Question Concerning Technology and Other Essays,* 121.

224 Martin Heidegger, "Science and Reflection," Ibid., 169.

225 Baruch Spinoza, *A Spinoza Reader,* 51 and 52

226 Sylvère Lotringer and Paul Virilio, *The Accident of Art,* 68.

227 Gilles Deleuze, "What is the Creative Act?" *in french theory in America,* 100.

228 David Lindley, *Uncertainty: Einstein, Heisenberg, Bohr and the Struggle for the Soul of Science,* 200.

229 Sylvère Lotringer, "Doing Theory," published in *french theory in America,* 151.

230 Chipp, Herschel B. Ed. *Theories of Modern Art.* (Berkeley: University of California Press, 1968), 264.

231 Wittgenstein, Ludwig . *Remarks on Colour.* (Wiley-Blackwell, 1991), 17e.

232 Ibid., 12e.

233 Ibid., 21e.

234 This information is gathered through experience as a painter and painting professor.

235 Ludwig Wittgenstein, *Remarks on Colour,* 32e.

236 Werner Heisenberg, *Encounters with Einstein,* 15.

237 Ludwig Wittgenstein, *Remarks on Colour,* 21e.

238 Martin Heidegger, "Letter on Humanism," published in *Basic Writings,* 223.

239 Ibid., 230.

240 Ibid., 237.

241 Jean Baudrillard, *"Radical Thought,"* published in *The Conspiracy of Art,* 174.

242 Merleau-Ponty, Maurice. *The Visible and the Invisible.* Evanston, IL: Northwest University Press, 1968, 171.

243 John Berger, *Ways of Seeing,* 7.

244 Ibid., 9.

245 John Armitage, "Introduction" in Virilio, Paul. *Art As Far as the Eye Can See*. Trans. Julie Rose. (Oxford and New York: Press, 2005), 15.
246 Lyotard, *The Differend*, xii.
247 Sylvère Lotringer and Paul Virilio, *The Accident of Art*, 37.
248 Giorgio Agamben, *The Man without Content*, 16.
249 Sylvère Lotringer and Paul Virilio, *The Accident of Art*, 65.
250 John Berger, *Ways of Seeing*, 21.
251 Sylvère Lotringer and Paul Virilio, *The Accident of Art*, 64.
252 Ibid., 64.
253 Ibid., 63.
254 Bible, John, 8:32
255 Plotinus, *Ennead I*, published in *Philosophies of Art and Beauty*, 143.
256 Werner Heisenberg, *Encounters with Einstein*, 10.
257 Werner Heisenberg, *Physics and Philosophy: the revolution in modern science,* 58.
258 Martin Heidegger, "Letter on Humanism," published in *Basic Writings*, 251.
259 Benjamin, Walter. *Illuminations*. Trans. Harry Zohn. (New York: Schocken Books, 1968), 221.
260 Ibid., 218.
261 Ibid., 224.
262 Mass MOCA states, "After nearly six months of intensive drafting and painting by a team of some sixty-five artists and art students, *Sol LeWitt: A Wall Drawing Retrospective* is fully installed. The historic exhibition opens to the public at MASS MoCA (Massachusetts Museum of Contemporary Art), in North Adams, Massachusetts, on November 16, 2008, and will remain on view for twenty-five years. Conceived by the Yale University Art Gallery, New Haven, Connecticut, in collaboration with the artist before his death in April 2007, the project has been undertaken by the Gallery, MASS MoCA, and the Williams College Museum of Art, Williamstown, Massachusetts." Retrieved from: http://www.massmoca.org/event_details.php?id=27
263 Jean Baudrillard, "Simulacra and Simulations," in *Selected Writings*. Ed. Mark Poster. (Stanford: Stanford University Press, 1988), 173.

264 Baudrillard, Jean. *Simulacra and Simulation,* Trans. Sheila Faria Glaser. (The University of Michigan Press, 1994), 1.
265 Ibid., 2.
266 Plato, *The Republic, Book X*, 361-362.
267 Note that in Luther's view, the artist is simply a middleman between God and people. This identity lends itself to the artist's spiritual authority during the Modern Age.
268 Luther, Martin, *Memoirs of the Lutheran Liturgical Association*, Volume I-VII, (Pittsburg: Association Pittsburg, 1906), 88.
269 John Berger, "*Art and Property Now,*" in *Collected Essays.* (New York: Vintage Books, 2003), 105.
270 Ibid., 103-104.
271 Sylvère Lotringer, "Doing Theory," published in *french theory in america*, 159.
272 Hegel, *Introductory Lectures on Aesthetics,* 13.
273 Sylvère Lotringer and Paul Virilio, *The Accident of Art*, 68.
274 John Berger, "Jackson Pollock, "published in *Collected Essays*, 16.
275 Sylvère Lotringer and Paul Virilio, *The Accident of Art*, 66.
276 Wolfgang Schirmacher, "Homo Generator: Media and Postmodern Technology"
277 Helle Hermyan writes, "Like several other art styles of the late 19th and early 20th centuries, impressionism was baptized by the press. And originally the name was - an insult." Retrieved from: http://www.suite101.com/content/how-art-styles-got-their-names---impressionism-a199782
278 John Berger, "Jackson Pollock, "published in *Collected Essays*, 16.
279 Ibid., 16.
280 Sylvère Lotringer and Paul Virilio, *The Accident of Art*, 65.
281 Paul Virilio, *Art and Fear*, 80.
282 Anker, Michael. *The Ethics of Uncertainty.* (New York and Dresden: Atropos Press, 2009), 106.
283 John Armitage, Introduction to *Art and Fear,* 24.
284 Giacomo Rizzolati and Laila Craighero, *The Mirror-Neuron System*, Di Pellegrino et al. 1992, Gallese et al. 1996, Rizzolatti et al. 1996a
285 Vilayanur Ramachandran, *Mirror Neurons and Imitation*

Learning as the Driving Force Behind "the great leap forward" in Human Evolution. Retrieved from: http://www.edge.org/3rd_ culture/ramachandran/ramachandran_p1.html

286 John Berger, *Selected Essays*, 8.

287 Arthur Schopenhauer, *World as Will and Representation, Volume I*, 354.

288 Heidegger, *Basic Writings*, 40.

289 Kant, *Critique of Judgment*, 45-100.

290 Ibid., 46-47.

291 Ibid., 47.

292 Ibid., 53-55.

293 Ibid., 54.

294 Hegel, *Introductory Lectures on Aesthetics*, 13.

295 Sylvère Lotringer, *Too Much is Too Much*, in *The Conspiracy of Art*, 75.

296 Jean Baudrillard, *Too Much is Too Much*, published in *The Conspiracy of Art*, 61.

297 Jean Baudrillard, *Radical Thought*, published in *The Conspiracy of Art*, 167.

298 Marilyn Stokstad, *Art, A Brief History, Third Edition*, 22.

299 Walter Benjamin, "The Work of Art in the Age of Mechanical Reproduction," published in *Illuminations*, 224.

300 Denis Dutton says (in his TED speech), "It is widely assumed that the earliest human artworks are the stupendously skillful cave paintings that we all know from Lascaux and Chauvet. Chauvet caves are about 32,000 years old, along with a few small, realistic sculptures of women and animals from the same period. But artistic and decorative skills are actually much older than that. Beautiful shell necklaces that look like something you'd see at an arts and crafts fair, as well as ochre body paint, have been found from around 100,000 years ago." Full speech retrieved from: http://www.ted.com/talks/denis_ dutton_a_darwinian_theory_of_beauty.html

301 Isaac Asimov, *Chronology of Science and Discovery*, 10, 19, 36.

302 http://www.ted.com/talks/denis_dutton_a_darwinian_ theory_of_beauty.html

303 Denis Dutton says, "I have in mind the so-called Acheulian hand axes. The oldest stone tools are choppers

from the Olduvai Gorge in East Africa. They go back about
two and a half million years. These crude tools were around
for thousands of centuries, until around 1.4 million years ago
when Homo erectus started shaping single, thin stone blades,
sometimes rounded ovals, but often in, what are to our eyes, an
arresting, symmetrical pointed leaf or teardrop form." Speech
retrieved from: http://www.ted.com/talks/denis_dutton_a_dar-
winian_theory_of_beauty.html
304 Speech retrieved from: http://www.ted.com/talks/de-
nis_dutton_a_darwinian_theory_of_beauty.html
305 Plato, *The Republic, Book X,* 362.
306 Ibid., 364.
307 Ibid., 365.
308 Plato, "The Sophist, " in *Philosophies of Art and Beauty,* 48.
309 Plato, *The Republic, Book X,* 360-397.
310 Aristotle, "Politics, Theory of Music," in *Philosophies of
Art and Beauty,* 131.
311 Badiou, Alain, *Handbook of Inaesthetics.* Trans. Alberto
Toscano. (Stanford: Stanford University Press, 2005), 2.
312 Albert Hofstadter and Richard Kuhns write (in regard to
Plotinus's aesthetics philosophy), "Artist's products are therefore
valuable chiefly as symbols. It is with Plotinus that the symbolic
nature of art receives its first comprehensive formulation."
313 Plotinus, *Ennead I,* published in *Philosophies of Art and
Beauty,* 141.
314 Plotinus, *Ennead I,* published in *Philosophies of Art and
Beauty,* 142.
315 Ibid., 143.
316 Ibid., 147.
317 Ibid., 147.
318 Albert Hofstadter and Richard Kuhns, Editors, *Philoso-
phies of Art and Beauty,* 140 and 141.
319 Ibid., 140 and 141.
320 Michael Inwood, "Introduction" G.W.F. Hegel, *Introduc-
tory Lectures on Aesthetics,* xi.
321 Immanuel Kant, *Critique of Judgment* and Shaftesbury,
Characteristics of Men, Manners, Opinions, Times.
322 Nietzsche, "Genealogy of Morals," in Giorgio Agam-
ben, *The Man Without Content,* 1.

323 Immanuel Kant, *The Critique of Judgment*, 45-100.
324 Immanuel Kant, *The Critique of Judgment*, 67.
325 Ibid., 70.
326 Ibid., 67.
327 Ibid., 55.
328 Ibid., 61.
329 Ibid., 96.
330 Ibid., 90.
331 Hegel, *Introductory Lectures on Aesthetics*, 7.
332 Ibid., 11.
333 Ibid., 11.
334 Ibid., 12.
335 Ibid., 12.
336 Ibid., 13.
337 Ibid., 13.
338 Ibid., 11.
339 Martin Heidegger, "The Origin of the Work of Art," published in *Basic Writings,* 182.
340 Ibid., 183.
341 Ibid., 143.
342 Ibid., 165.
343 Hofstadter and Kuhns write (in regards to Plato), " Only the man who understands the fundamental principle of measure can judge which imitations are worthy, which debased." *Philosophies of Art and Beauty*, 5.
344 Clement Greenberg, speech at Western Michigan University, January 18, 1983.
345 Clement Greenberg, "Avant-Garde and Kitsch."
346 John Berger, "Jackson Pollock," in *Collected Essays*, 16.
347 Ibid., 17
348 "Jackson Pollock," printed in Herschel B. Chipp, *Theories of Modern Art,* 548.
349 John Berger, "Jackson Pollock," published in *Collected Essays*, 17.
350 Lyotard , Jean-François. *The Postmodern Explained.* Minneapolis and London: University of Minnesota Press, 199), 12-13.
351 Ibid.,17 and 18.

352 Sylvère Lotringer and Paul Virilio, *The Accident of Art*, 30.
353 Sylvère Lotringer, Introduction to *The Conspiracy of Art*, 10.
354 Paul Virilio, *Art and Fear*, 92.
355 Sylvère Lotringer and Paul Virilio, *The Accident of Art*, 69.
356 Sylvère Lotringer, "Doing Theory" in *french theory in America,* 151.
357 Deborah Soloman, *How to Succeed in Art*, New York Times Article, 1999.
358 Paul Virilio, *Art and Fear*, 45.
359 Ibid., 80.
360 Sylvère Lotringer and Paul Virilio, *The Accident of Art*, 34.
361 Ibid., 35.
362 Jean François Lyotard, "Philosophy and Painting in the Age of Their Experimentation: Contribution to the Idea of Postmodernity," in *The Lyotard Reader*, 182.
363 *Merriam-Webster's Medical Dictionary*, s.v. "scientific method" Retrieved from: http://dictionary.reference.com/browse/scientific method
364 Sylvère Lotringer, "Doing Theory," published in *french theory in America*, 125.
365 Jean François Lyotard, "Philosophy and Painting in the Age of Their Experimentation: Contribution to the Idea of Postmodernity," in *The Lyotard Reader*, 181.
366 Ibid.,182.
367 Sylvère Lotringer, "Doing Theory, " in *french theory in america*, 148.
368 Jean Baudrillard, *The Conspiracy of Art*, 27.
369 Ibid., 27.
370 Sylvère Lotringer, "Doing Theory, " in *french theory in america*, 151.
371 Jean Baudrillard, "Radical Thought," published in *The Conspiracy of Art,* 177.
372 Ludwig Wittgenstein, *On Certainty*, 2e.
373 Sylvère Lotringer, "*Introduction, The Piracy of Art*, " in *The Conspiracy of Art*, 9.
374 Ibid., 27.
375 Ibid., 27.
376 Sylvère Lotringer, "Introduction, The Piracy of Art" in *The Conspiracy of Art*, 9.

377 Corriere della Sera, May 1 2001, re-published in *See Naples and Die, The Camorra and Organized Crime*, by Tom Behan, p. 5

378 Hegel, *Introductory Lectures on Aesthetics*, 3-26.

379 Immanuel Kant, *Critique of Judgment*, 45-100.

380 Martin Heidegger, "Origin of the Work of Art," published in *Basic Writings*, 142.

381 Agamben, *Man Without Content*, 93.

382 Walter Benjamin, "The Work of Art in the Age of Mechanical Reproduction," in *Illuminations*, 217-253.

383 Jean Baudrillard, *Simulacra and Simulacrum*, 10.

384 Agamben, *The man without Content*, 4.

385 Reference to Wolfgang Schirmacher concept, *Homo Generator*. Retrieved from: http://www.egs.edu/faculty/wolfgang-schirmacher/articles/homo-generator-media-and-postmodern-technology/

386 Plato, *The Republic, Book V, p. 209-210*

387 Aaron O'Connell says, "Physicists are used to the idea that subatomic particles behave according to the bizarre rules of quantum mechanics, completely different to human-scale objects. In a breakthrough experiment, Aaron O'Connell has blurred that distinction by creating an object that is visible to the unaided eye, but provably in two places at the same time. In this talk, he suggests an intriguing way of thinking about the result." Retrieved from: http://www.ted.com/talks/aaron_o_connell_making_sense_of_a_visible_quantum_object.html

388 Ibid.

389 Jean Baudrillard, "Radical Thought," in *The Conspiracy of Art*, 166.

390 Ibid., 177.

391 Rilke, Rainer Maria, *Letters on Cézanne*, Ed. Clara Rilke. Trans. Joel Agee. New York: Fromm International Publishing Corporation, 1985. 22-23.

392 Jean Baudrillard, "Radical Thought," in *The Conspiracy of Art*, 164.

393 Ibid., 177.

394 Amit Goswami, *The Self Aware Universe*, 112.

395 John Berger, *Ways of Seeing*, 146.

396 Sylvère Lotringer writes, "Whether one can think without words is a major controversy among semioticians. Some artists, at any rate, could do that." "Doing Theory, " published in *french theory in America*, 127.
397 Martin Heidegger, "Letter on Humanism" in *Basic Writings*, 218.
398 "Language Games" refers to Wittgenstein and Lyotard's concept.
399 Durantaye, Lelande de la. *Giorgio Agamben. A Critical Introduction.* (Stanford: Stanford University Press, 2009), 55.
400 "Differend" refers to Lyotard's concept.
401 Jean-François Lyotard, *The Differend,* 34.
402 Wolfgang Schirmacher, "Homo Generator: Media and Postmodern Technology"
403 Reference to The X-Men comics, created by Stan Lee and Jack Kirby.
404 Barad, Karan. *Meeting the Universe Halfway, Quantum Physics and the Entanglement of Matter and Meaning.* (Durham and London: Duke University Press, 2007), 174.
405 Wolfgang Schirmacher, "Homo Generator: Media and Postmodern Technology"
406 Bohm, David. *Science, Order and Creativity.* (New York: Bantam Books, 1987), 48.
407 Karen Barad, *Bits of Life, Feminism at the Intersections of Media, Bioscience, and Technology*, 174.
408 Wolfgang Schirmacher, "Homo Generator: Media and Postmodern Technology"
409 Deleuze and Guattari, *What is Philosophy?* 212.
410 Ibid., 212.
411 Deleuze, Gilles.*The Logic of Sense,* trans. Mark Lester with Charles Stivale, Edited by Constantin V. Boundas, (New York: Columbia University Press, 1990), 294.
412 Ibid., 295.
413 Ibid., 253.
414 Gilles Deleuze, *Spinoza: Practical Philosophy*, 58-59.
415 Ibid., 18.
416 Retrieved from: http://www.time.com/time/magazine/article/0,9171,833721,00.html
417 Deleuze, *The Logic of Sense*, 258.

Milton Keynes UK
Ingram Content Group UK Ltd.
UKHW022030180823
427121UK00010B/966